MASTERPIECES OF
JAPANESE PRINTS

GENERAL EDITOR
Muneshige Narazaki

EDITOR
Richard Lane

KODANSHA INTERNATIONAL
Tokyo • New York • London

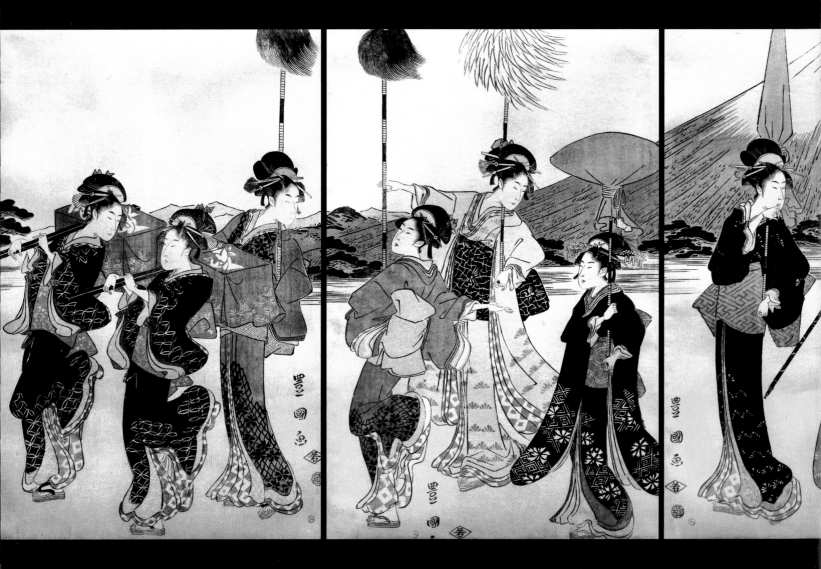

MASTERPIECES OF JAPANESE PRINTS

Ukiyo-e from the Victoria and Albert Museum

Rupert Faulkner
in consultation with B. W. Robinson

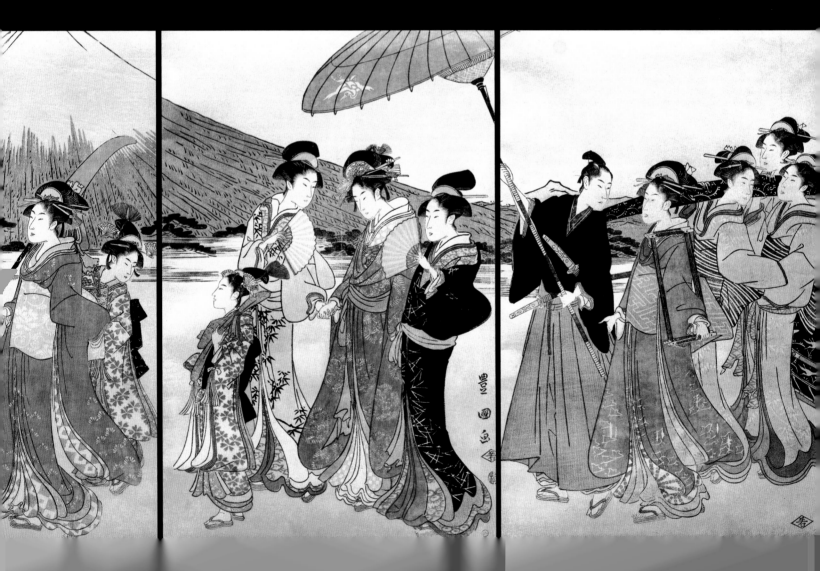

This volume was adapted in part from *Hizō ukiyo-e taikan*, volumes 4 and 5, published in Japanese by Kodansha Ltd. New text for this edition was supplied by Rupert Faulkner and Richard Lane.

Distributed in the United States by Kodansha America, Inc., 575 Lexington Avenue, New York, NY 10022, and in continental Europe by Kodansha Europe Ltd., 95 Aldwych, London WC2B 4JF. Published by Kodansha International Ltd., 17–14 Otowa 1-chome, Bunkyo-ku, Tokyo 112–8652, and Kodansha America, Inc.

First edition, 1991
First paperback edition, 1999
02 5 4
ISBN 4–7700–2387–1

CIP data available

www.thejapanpage.com

Contents

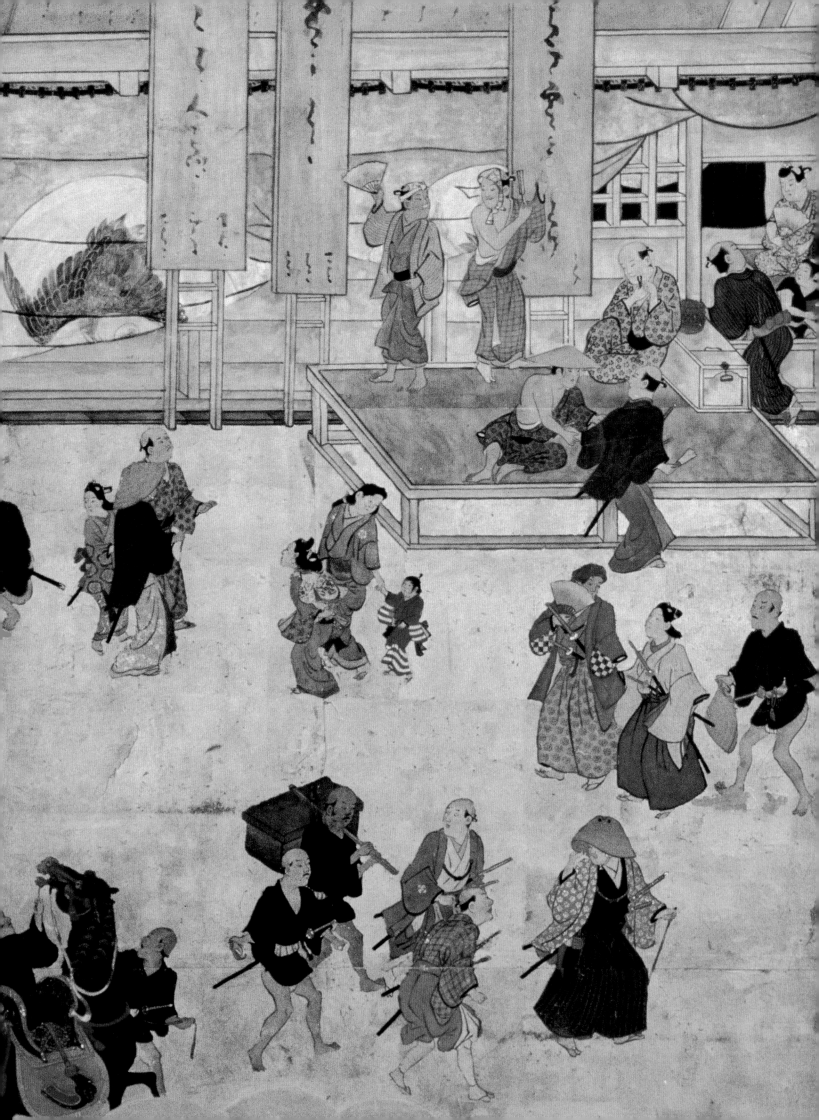

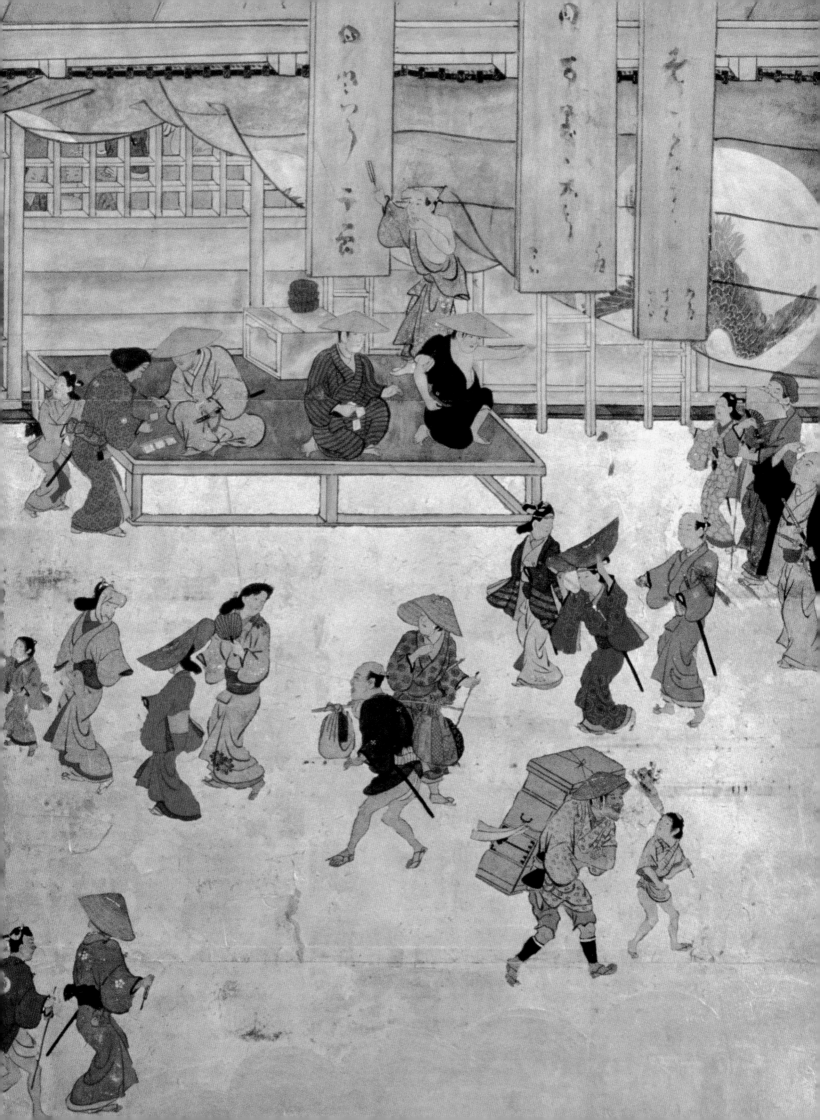

Original titles of ukiyo-e series appear in this volume in italics. Descriptive titles assigned for purposes of scholarship and clarity are given in roman type.

Foreword

Rupert Faulkner

Bold in composition, rich in color, and fascinating in their diversity, Japanese woodblock prints have long been admired and collected by enthusiasts in Japan and the West. The name by which they are known, ukiyo-e, or "pictures of the floating world," is a reflection of the fact that they were a popular art form made for and enjoyed by the common townspeople who flourished in the bustling urban centers of Japan during the Edo period (1615–1868). Their themes, which offer valuable insights into the preoccupations of their time, include the kabuki theater, courtesans and beautiful women, life in the licensed pleasure quarters, episodes from popular literature and history, nature studies, and views of famous sites. They are interesting, furthermore, for having been the products of a multi-stage process involving publisher, artist, woodblock engraver, and printer, each of whom contributed in a vital and unique way to the successful completion of the final image.

Ukiyo-e were not unknown outside Japan before the ending, during the 1850s, of her policy of self-imposed isolation from the outside world. At least four Europeans returning from Japan between the late seventeenth and early nineteenth century are known to have brought back collections of Japanese artifacts which included examples of ukiyo-e. The most extensive of these was that formed by Philipp Franz von Siebold (1796–1866), a German physician working in Nagasaki for the Dutch East India Company, the only Western organization permitted to conduct trade with Japan from the early seventeenth century onward. While von Siebold used some of the two thousand or more prints he had collected as the basis for the illustrations to his *Nippon*, a large-scale work published between 1832 and 1858, there is no evidence of more than limited interest in ukiyo-e during this early period.

Western awareness about Japan and her various art forms did not become widespread until after Commodore Perry's expedition of 1853 and the subsequent establishment of diplomatic and trading relations between Japan and the West, first with the United States in 1854, and

then with European nations such as Britain, France, and Russia in 1858. Once sparked off, however, and fueled by the increasing availability of Japanese artifacts brought back by visitors to Japan or exported to the West as trade commodities or as exhibits to be shown at the Great Exhibitions that were held across Europe and America during the second half of the nineteenth century, what had begun as a flicker of interest rapidly kindled into a blaze of enthusiasm for all things Japanese.

The term "Japonisme," coined by a French art critic in 1872, was used to refer to this remarkable phenomenon which saw, amongst much else, extensive borrowing and absorption of Japanese concepts of art and design. Ukiyo-e played a major role in the transmission of ideas from Japan to the West, and were avidly collected both as sources of artistic inspiration and as art objects in their own right. Among the many late nineteenth century artists who were influenced by what they found in ukiyo-e, Whistler, Manet, Degas, Monet, Gauguin, Seurat, Toulouse-Lautrec, and Van Gogh were some of the more important. The use of compositional devices derived from ukiyo-e is the most striking feature in their work, but the influence also extended to the use of color and, in some cases, to the choice of subject matter.

If ukiyo-e have become familiar to Western eyes through the paintings of the Impressionists and their successors, they were also the inspiration for much of what took place during the height of the vogue for Japonisme in fields such as ceramics, glass, metalwork, furniture, and textiles. As a museum primarily devoted to the decorative arts, the Victoria and Albert Museum embarked on the formation of its collection of ukiyo-e more out of consideration of their value as sources of subject matter and design motifs than as products of cultural or artistic interest. This being said, however, the size and heterogeneity of the collection means that it contains an enormous range of material which can be approached from a variety of different angles. In the texts that follow, exploration of the contribution of individual ukiyo-e artists is combined with a brief history of the museum's collection, an analysis of woodblock print-making techniques, and an examination of ukiyo-e subject matter. Together with the large number of color illustrations, it is hoped that these introductory essays will help to deepen the appreciation and understanding of ukiyo-e in general, as well as to make available to as wide an audience as possible a sample of the riches that the Victoria and Albert Museum is able to offer to its public.

Ukiyo-e: An Introduction to the "Floating World"

Richard Lane

Ukiyo-e were the "pictures of the floating world" which provided the Japanese urban middle classes with a major source of artistic pleasure during the period from the seventeenth through the nineteenth century.

Ukiyo was a Buddhist-related term of the Japanese Middle Ages, evoking images of the evanescence of life, the vanity of human passions, a longing for the idealized afterlife. In the seventeenth century, when the nation was finally at peace and enjoying a thriving economy that encouraged leisure activities and consumerism, the term ukiyo took on markedly hedonistic connotations. The newly created genre art called ukiyo-e depicted the then-current milieu of things fashionable, with particular attention to beautiful women and gallant young men, their pleasures, and their fads. Viewed in more detail, however, ukiyo-e is a rather complex school of art, peopled by several hundred artists (and an even greater number of artisans), and extending in range over the whole spectrum of Japanese genre art for nearly three hundred years: from the commencement of the Edo period (1615–1868) on through the middle years of Meiji (1868–1912), when photography and mechanical printing methods gradually snuffed out the life of this popular and eminently commercial art.

* * *

Ukiyo-e art evolved gradually from the genre paintings of the traditional schools of Japanese art. This development occurred in the old capital, Kyoto, during the transitional Momoyama period (1573–1615). It was from these traditional schools that ukiyo-e acquired its basic themes, its lovely and harmonious coloring, its sinuous, supple line, and its emphasis on the dramatic relationship between figures.

Among the most unusual products of this age were the so-called *namban-byōbu*, or "Southern Barbarian" screens, exemplified by Plate 1. These large painted folding-screens depicted the earliest Europeans to come to Japan: the Catholic missionaries and merchants of Portugal and

Spain who arrived from their colonies to the "South" during the Momoyama period. The style is basically that of the classical Kanō School, but in their childlike wonder the artists often depicted these strange visitors from abroad in an exaggerated manner in which the pantalooned Europeans sometimes seem more like dolls, or even bowling pins. This fascination with the foreign and exotic was to become one of the mainstays of Japanese art, a trend which continues to this day.

More typical of early genre painting is the depiction of Shimogamo Shrine, by an artist of the more decorative but less powerful and dramatic Tosa School. This tradition of genre painting continued into the nineteenth century in the form of screen paintings, panels, and albums, particularly in Kyoto and the provincial cities, even after the ukiyo-e woodblock print had gained precedence in the new capital, Edo (later renamed Tokyo).

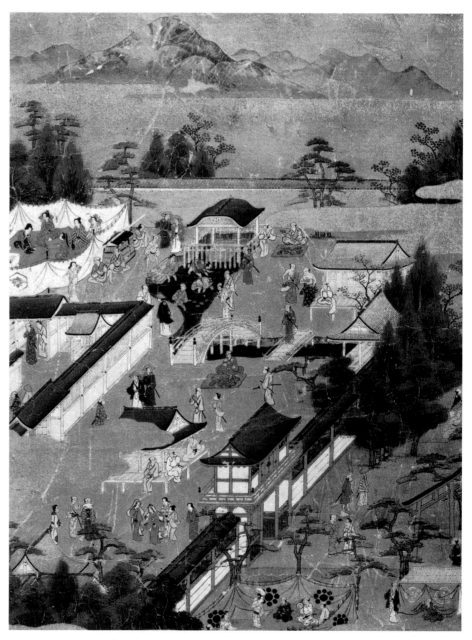

Unsigned: Scene at the Shimogamo Shrine in Kyoto. Unmounted panel, hand-painted colors on paper, ca. late seventeenth century.

Art began to flourish in Edo some decades after the transfer of political power in the early seventeenth century. From the middle of the century a period of political stability and relaxed social morality contributed to the development of a characteristically Edo style of ukiyo-e. Focusing on courtesans, heroes, and actors, this vital art form came to be associated especially with the urban middle classes.

I

The first major ukiyo-e artist known to us by name is Moronobu (fl. ca. 1670–94). He was, indeed, the consolidator of the form, the master who brought together the amorphous styles of the various early genre artists to create a recognizable school which was to dominate plebeian art for two centuries.

The large screen-painting of Plate 2 may well be a production of Moronobu's studio during his later years. While not as dynamic in design and conception as Moronobu's best works, it nevertheless provides a striking and colorful view of the vibrant kabuki theater in this early period.

The ukiyo-e school is, of course, best known for its woodblock prints which in effect provided, for the first time, art for the urban masses. Two early examples are shown in Plates 3–4, again by a Moronobu School artist—probably Tomonobu (fl. ca. 1687–1713). The works belong to a series of twelve prints depicting equestrian acrobatics performed by a Korean troupe before the shogun, on the occasion of a Korean mission to Japan. In comparison with the soft lines of the painting in Plate 2, these prints are characteristically bold in linear and other graphic qualities. With the reduced format, the composition and interrelation of figures become more concentrated, more graphically effective—qualities that were later to make the Japanese print one of the most popular forms of Asian pictorial art.

The earliest ukiyo-e prints were sometimes hand-colored by artisans in the employ of the publisher, and in the eighteenth century this fashion became the norm, as is the case in Plate 9 by Terushige (fl. ca. 1715–25), a late follower of the pioneer Moronobu. Due to their elaborate, decorative coloring, such pictures were often called *urushi-e*, or "lacquer prints."

Even after the woodblock print had become popular among the masses, the larger, ukiyo-e paintings continued to find favor with affluent collectors and connoisseurs. Particularly in demand were *bijin-ga*, or "pictures of beautiful women," exemplified by an unsigned painting (Pl. 5) probably by Moromasa (ca. 1712–72), another late follower of Moronobu. The subject is the popular heroine of the age, an elegant courtesan who is shown parading with her diminutive maidservants in the Yoshiwara, Edo's flourishing pleasure quarter. Compared to the style of Moronobu two generations earlier (Pl. 2), the manner has become formalized, even a little distorted, representing the new feminine ideal of the age.

By the 1740s, the elaborate hand-coloring of the lacquer prints had come to cost more than the prints themselves, and it was only natural

that the publishers should seek out a form of color printing that could be adapted to mass production. The result, based on earlier experiments in deluxe, privately issued book illustration, was the *benizuri-e*, or "pink print," so named from one of its predominant colors (the other being green). An example by Kiyonobu II (fl. 1720s–ca. 1760) is shown in Plate 11; it depicts a kabuki scene in which the young hero (at center) grapples with one samurai (at lower right), as another threatens him with a large and heavy cauldron. The tableau reflects the stylized ostentation of the kabuki theater, and features a style of depiction that was to remain popular until the decline of ukiyo-e in the late nineteenth century.

II

Once Japanese craftsmen had perfected the use of several overlapping woodblocks to effect precise and reliable polychrome printing, it was only one step further to produce the full-color print for which ukiyo-e has become famous. This invention came to be known as the *nishiki-e*, or "brocade print," from its multi-hued splendor. Its first and definitive master was Harunobu (ca. 1724–70), whose achievement was to wed a precise and masterly style with an evocative romanticism, combined with effective employment of the newly found palette of the brocade print.

This innovation is strikingly represented in Plate 14, in which a high-ranking courtesan is shown parading through the Yoshiwara, accompanied by two maidservants and an older attendant. Comparison with Plate 11 reveals how the change in pigmentation and the improvement in precision of delineation were instrumental in the realization of a jewel-like quality that was to characterize the full-color ukiyo-e print. It is also interesting to compare Plate 14 with Plate 5, a painting with similar subject matter. In effect, the brocade print attempted to emulate the gorgeous coloring of such paintings; and it succeeded very well, considering the limitation in size and in the type of pigments that could technically be employed in the medium of woodblock printing. A comparison of these two tableaux also underscores Harunobu's profound contribution to the continued development of the ukiyo-e figure-print: an enhanced harmony of coloring, and a balance of proportions that harks back to the pioneer Moronobu.

Rather more classical in mood is the Harunobu masterpiece in Plate 13. The subject is again a courtesan and her attendant, but the addition of a well-known poem and an atmospheric, moonlit background gives greater resonance to the scene. The interplay of figures is bewitching, and a lyrical mood is evoked by the distant cuckoo flying in front of the moon, the verse intoning "its cry echoing through the heavens." Only with effort does one realize that the courtesan, in dishabille, is pausing for only a brief moment to glance at the scene before returning to her lover who waits, unseen, behind the boudoir curtains.

Although the brocade print was a distinctively Japanese innovation, it must be acknowledged that it was influenced somewhat by color-

printed Chinese book illustration of the seventeenth century. And, occasionally, it even derived direct inspiration from late Ming and early Qing paintings and prints, which had been widely imported into Japan. In the unusual color print of Plate 15, unsigned but in the style of Harunobu, we see a plump cat beside begonias and chrysanthemums, looking up at two flitting butterflies. Whether the cat is readying itself for an attempt to catch the flying creatures, or whether—after the manner of the Chinese philosopher Chuang-tzu—it is simply enjoying the fantasy of identifying itself with them, is not clear. But certainly, the charm of the scene is obvious; and the omission of the artist's name would indicate that such prints were bought for their subject matter rather than for the signature. It is, indeed, only as an afterthought that we notice the unusual technique of the print: its rendering of forms as colored masses, without the usual black outline, and further, subtle embossing on the feline figure, which lend extra depth to the print.

Harunobu died suddenly in 1770 at the peak of his career. His position could not easily be filled, though several artists tried their best. One of these was Toyomasa (fl. 1770s), who specialized in scenes of children at play (Pls. 21, 22). From the series *The Twelve Months of the Year*, Plate 21 depicts the Doll Festival of the third month. In the background a boy and an older girl sit before a display of Imperial dolls and Shintō offerings, as three boys in the yard play at imitating a "daimyo procession," two of them carrying a miniature palanquin with a doll inside, while the third holds a broom in place of a tufted staff. Plate 22 depicts the seventh month, represented by two children entranced by a spinning lantern. The dancing and flickering of figures round the lantern caused by hot air rising from a candle within was a popular summer amusement in Edo Japan. As is often the case with Japanese prints, the peaceful activities and the harmonious coloring evoke an atmosphere of supreme tranquillity.

More important than Toyomasa is Bunchō (fl. 1760–92), who, though strongly influenced by Harunobu, possessed his own rather peculiar ideal of beauty. This characteristic is evident in Plate 23, in which a courtesan and attendant are seen on a balcony overlooking the Sumida River. The coloring is rather more restrained than that in Harunobu's work, and the figures themselves are less graceful and harmonious. Yet somehow, we nevertheless feel attracted to the print, sensing the artist's defiant spirit.

Harunobu's principal follower was Koryūsai (fl. mid-1760s–80s), who, unusually, was from a samurai family. This artist excelled particularly in that curious, elongated format, the *hashira-e*, or "pillar print," which, as the name implies, was designed for hanging on the interior pillars of Japanese rooms. With simple paper mountings attached and a wooden roller at bottom, they served, indeed, as a form of "poor man's scroll painting" (as seen in Pl. 5). Within the confines of this format, Koryūsai was able to create a veritable world of intricate, human pattern, even drama. We view this feat in Plates 18 and 19, both featuring traditional themes, but brought up to date by the magic of the ukiyo-e style.

Like Harunobu, Koryūsai occasionally dabbled in the field of *kachō-ga*, or "bird-and-flower prints" (Pl. 16), a genre derived directly from Chinese painting; but re-created in ukiyo-e as little gems of natural beauty to form one of the fascinating sub-divisions of this school of art. In his later years—after the death of his mentor Harunobu—Koryūsai followed the temper of the times and designed increasingly monumental prints depicting the beauties of the Yoshiwara (Pl. 17).

The "Harunobu reign" lasted only from 1765 to about 1772; within two years of his demise popular ideals of feminine beauty (and male, as well) had begun to move toward the massive and statuesque, marking the end of the fragile and pliant figure-print which had at one time represented the pinnacle of ukiyo-e art.

Other followers of Harunobu include Shigemasa (1739–1820). A sample of his early work is shown in Plate 20. He, too, organized a notable school of his own: among his pupils was the wit and literatus Kyōden (Kitao Masanobu, 1761–1816), one of whose rare prints we see in Plate 24.

With the new ideals of beauty, by the mid-1770s the figure-print began to feature more elongated human proportions and more monumental compositions. This new ideal culminated first in the work of Kiyonaga (1752–1815), whose prints are shown in Plates 34 and 35. This influential artist's prime follower was Shunchō (fl. late 1770s–late 1790s), whose work (Pls. 36, 37) is at times barely distinguishable from that of his master, one of many indications of the domination of Kiyonaga's style in the ukiyo-e world during the final decades of the eighteenth century.

Bijin-ga (female figure prints) from the 1740s to the 1820s.

FROM LEFT TO RIGHT
Style of Moromasa: Parading Courtesan with Attendants. (Plate 5)

Early Torii School: A Beauty Reading a Letter. (Plate 8)

Harunobu: Parading Courtesan with Attendants. (Plate 14)

Kiyonaga: Detail of prospective bride and attendant, from An Arranged Introduction at a Shrine. (Plate 34)

Shunsen: Parading Courtesan. (Plate 46)

Eisen: Courtesan, from the print The Kōya-Tama River. (Plate 53)

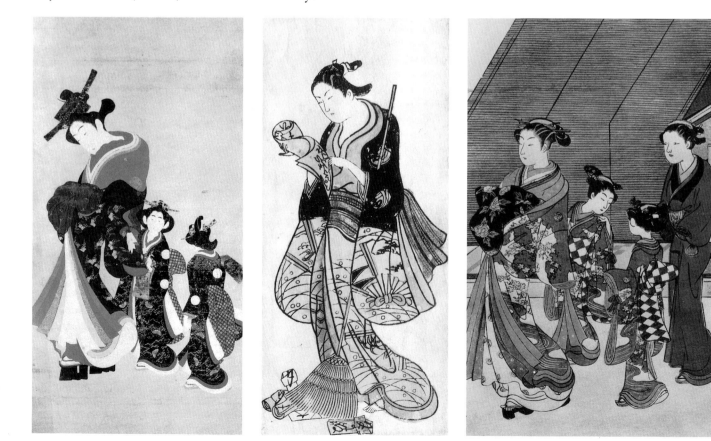

Edo plebeian tastes were fickle, however, and even the impeccable Kiyonaga could not maintain his supremacy forever. Thus, with the turn of the decade, popular taste turned more and more to Utamaro (1750–1806), the influential master who brought to the genre of figure prints a new and fresh vision of feminine beauty, as well as a special insight into female psychology that had hitherto been lacking (Pls. 38–42).

Both during his lifetime and in the decade following his death in 1806, Utamaro's followers, imitators, and pupils proved legion. Perhaps the greatest of all was Eishi (1756–1829), an artist of elevated samurai rank who abandoned his career as an official painter to descend to the fascinating "demi-monde" of ukiyo-e (Pl. 44). Eishi formed a sub-school of his own which produced such notable disciples as Eishō (Pl. 48), as well as the more obscure Gokyō (Pl. 45).

By the 1810s, a new crop of artists was actively producing *bijin-ga*. All commenced their work in the Utamaro manner, but gradually developed their own styles—always in accord with the popular tastes of the times, for ukiyo-e prints reflected popular trends and aspirations. Among the earliest of these masters was Shunsen (1762– ca.1830), whose monumental figures come close to equaling the best work of the preceding decade (Pl. 46). Even better known are Eizan (1787–1867) and his brilliant pupil Eisen (1790–1848), whose work all but dominated the field during the 1820s and 1830s (Pls. 49–53).

In this period, another major artist working in the field of feminine depiction was Kunisada (1786–1865). His work is a little less stylized, a little less relentlessly chic than that of Eisen, and hence rather more humanized (Pls. 60, 66–68).

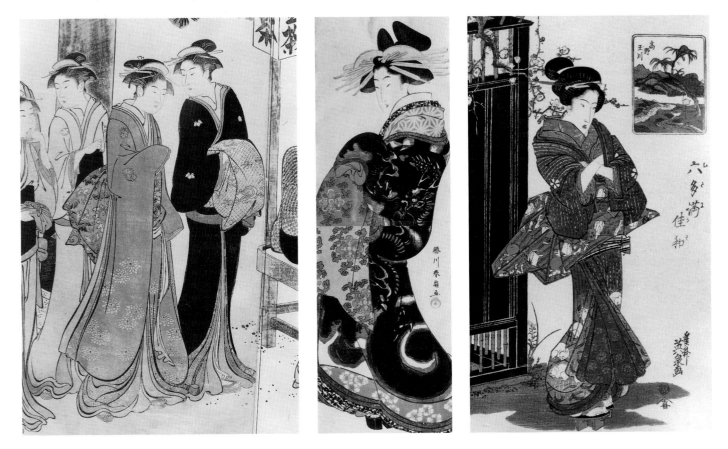

While landscape prints were produced in the first half of the eighteenth century, it was a half-century later before this genre expanded under the aegis of Toyoharu (1735–1814) to form one of the mainstreams of ukiyo-e. Representative works of this artist include the interior of one of the major Edo kabuki theaters, a view of the famed Mimeguri Shrine on the east bank of the Sumida River, and an evening view of that same river, further downstream, depicting people on boats enjoying a fireworks display (Pls. 31–33). All three prints, which exemplify a genre known as *uki-e*, or "perspective print," reveal the use of exaggerated, receding perspective, gleaned from studying examples of imported European art. With this device, which Masanobu and others had experimented with a generation earlier, Toyoharu brought a new and exotic flavor to the Chinese-derived landscape print which was to find magisterial amalgamation in the work of Hokusai a half-century later.

Hokusai (1760–1849) is well known not only for the sheer mass of his work, but also for the impressive length of his artistic career: a full 72 of his 89 years of life were spent in daily, frenzied bouts of painting, book illustration, and print designing. Indeed, both in style and output, Hokusai's work could well be treated as though it were the work of four or five different artists—all of first rank.

Plate 71 shows one of Hokusai's initial sketches for a planned set of prints, the publication of which was, for some reason, never completed. The series represents the artist's work of his mid-twenties, when he was still strongly under the direct influence of his teacher, Shunshō (1726–92). Within a decade (following the death of his mentor), Hokusai had abandoned the restrictions of the Shunshō atelier and set out on his own. Among his several artistic experiments in this period was the perspective print, done in emulation of European engravings. The rare Hokusai print in Plate 77 represents but an experiment, yet one which was to reach fruition a generation later, with the artist's outstanding *Thirty-Six Views of Mt. Fuji* series.

In the same period, Hokusai also developed his characteristic ideal of frail and delicate, eminently sentient female depiction (Pls. 72–76). Although this style was derived in part from a distillation of the essence of early Utamaro and Eishi, it represents a strikingly new creation in its own right.

Around 1830, following another two decades of concentrating mainly on painting and book illustration, Hokusai began what was to become his greatest and most fruitful half-decade of activity. In this short span of time he produced most of his major print series, including the *Splendid Views of Famous Bridges of the Provinces* (Pls. 78, 80), and the renowned *Thirty-Six Views of Mt. Fuji* series. The artist's final work in the print medium culminated in the massive *Hundred Poems by One Hundred Poets as Explained by a Wet Nurse* series, publication of which was unfortunately never completed. From this ill-fated series, one of the artist's initial, masterful block-sketches entitled Mountain Teashop is illustrated

in Plate 79. A famine in Edo in 1836 and a period of economic crisis in the later 1830s may explain the incomplete series, and thereafter he concentrated on painting rather than print production.

Despite his seven decades of unceasing artistic endeavor, Hokusai ended his days feeling his enormous "appointed task" had yet to be completed. Hokusai is quoted as saying, "If granted but ten years more of life...I could become a great artist...." Though he was not granted those additional ten years, he was alone in underrating the value of his enormous output of high-quality works.

Hokusai's style was kept alive by his pupils until the end of the nineteenth century. He was one of the great teachers, and his pupils, who numbered in the hundreds, included such notable masters as Shinsai (Pl. 82) and Hokkei (Pls. 84, 85). Interesting for the unique shading in his landscape prints is another disciple, Hokuju (Pl. 86), whose vision is also mirrored in the work of Shuntei (Pl. 87).

IV

Paintings depicting the kabuki theater and its actors, as noted previously, first appeared in the seventeenth century (Pl. 2). By the end of the century the production of kabuki-related prints came to follow closely the development of kabuki — both in popularity and in artistic style. The influential Katsukawa School which dominated the field in the latter half of the eighteenth century was founded by Shunshō. His early work was highly imitative of Harunobu's style, but he soon began to apply his own talents to the actor print.

Plates 27–28 and 29 clearly reveal Shunshō's innovative and realistic view of the Japanese stage, as does Plate 30, by his major pupil, Shunkō (1743–1812). It is particularly interesting to compare their work with the "old-fashioned" work of their predecessors two decades earlier, as in Plate 11, for example.

One of the most prolific artists producing kabuki-related prints in this period was Toyokuni (1769–1825). He began his work under the influence of Kiyonaga and Utamaro, as is revealed in the print "Representation of a Daimyo's Procession" (see frontispiece). A veritable master of imitation, Toyokuni reached his peak in the later 1790s with his kabuki portraits in the Sharaku manner (Pl. 57). He continued working, however, for a full quarter-century during a period in which the kabuki theater and actor print tradition flourished, his work forming a vivid testimony to this major theatrical tradition (Pls. 56–58).

Among the major pupils of Toyokuni was Kuniyoshi (1798–1861). Though his early training was in the late-kabuki tradition, it was to Hokusai that he turned for his major inspiration in the specialized field of the *musha-e*, or "warrior print." (Hokusai's work in this genre was extensive, and most influential among the artists of the time; but it was featured mainly in the field of book illustration and painting, hence it is not widely known today.) The rare work shown in Plate 89 shows Kuniyoshi's original sketch for a warrior print which well displays his innate artistic talents.

Kuniyoshi's major productions in this genre are in the triptych format (Pls. 90–93), in which a unified composition is printed on three vertical ōban sheets arranged side by side. Such an arrangement was necessary because, being made from cherry wood, a narrow-trunked tree, the width of the block was limited.

Curiously enough, among Kuniyoshi's major works are his several experimental series of landscape prints, in which he attempted, briefly, to compete with Hiroshige. Three examples of this genre are shown in Plates 95–97, in which Kuniyoshi's special, semi-realistic conception of the human figure is effectively posed against colorful landscapes, the two planes intriguingly juxtaposed by the employment of exotic perspective techniques. In Plate 94, features of the warrior print and the landscape print using techniques of perspective were adroitly combined to produce an impressive scene that was considered rather avant-garde for its time. The artist's skill at impromptu work is revealed in Plates 100–103, which show his amusing caricatures of actors.

<p style="text-align:center">V</p>

Hiroshige (1797–1858), along with Hokusai, is generally recognized as one of the masters of the landscape print. The present volume is fortunate in being able to include some of the artist's most arresting work in the rare uchiwa-e, or "fan print" format (Pls.111–115). Such fan prints are of great interest for several reasons. First, both artist and publisher took special pains to produce work of only the highest quality, for they knew that the prints, which were mounted on split-bamboo fan frames, would be used, viewed, and admired widely and so would act as an effective advertising device. Second, the format itself, with its rounded corners and provision for a bamboo handle at the bottom, forced the artist to concentrate his skills and to make the most effective use of the limited space available. Third, since fan prints were usually issued in limited editions, they were produced only with fresh blocks and without the degenerate later editions which were often the fate of other, more popular ukiyo-e formats.

Even within this limiting format, however, Hiroshige's achievement in the landscape print is immediately apparent. His mastery of harmonious composition, his effective employment of vivid, jewel-like coloring, and, above all, his romantic approach to subject and mood greatly appealed to the taste of his contemporaries, as it has to art lovers ever since.

Hiroshige's other main forte was the bird-and-flower print, a subject matter that had been popular the century before (Pls.15, 16). Earlier prints relied heavily on Chinese models for inspiration, but in Hiroshige's work the creation of a romantic, evocative atmosphere predominates, and the mood is effectively complemented by contemporary verses, either in Japanese or Chinese, relating to the theme of the print. Whether the subject was an elegant heron or a lowly pheasant, he managed to convey the intricate harmonies of nature in lush colors and with supreme skill in design and composition (Pls. 107, 108).

As a useful reminder that the ukiyo-e master's task was to devise the basic design, not complete the final print itself, a rare example of Hiroshige's initial brushwork is illustrated together with the final printed result. The sketches in question are contained in a small volume, *Ehon tebiki-gusa* (A Picture-Book Miscellany), of *chūbon* size, designed by Hiroshige in 1849.

This unique volume constitutes a manual for fledgling artists in the field of flowers and fishes, and at the same time forms a most satisfying picture book for the general art lover. (One of the final plates, featuring Mt. Fuji, represents a kind of pictorial advertisement for a projected "Second Series on Landscapes," which seems, however, never to have been published.)

The manual defines two means of artistic expression: "realistic depiction" (termed by the artist *shō utsushi [shashin]*, or *shinzu*), and "cursive depiction" (*sō hitsu, hitsui,* or *sō ga*). Hiroshige believed that a thorough knowledge of techniques of realistic depiction were necessary before the artist could apply his personal interpretation by means of "cursive depiction." Hiroshige's "realistic sketches" are themselves grounded in the impressionistic tenets of the Shijō School, and are thus already one stage removed from Western-style verisimilitude. The Western artist might well find a traditional Japanese artist's "realistic" sketches

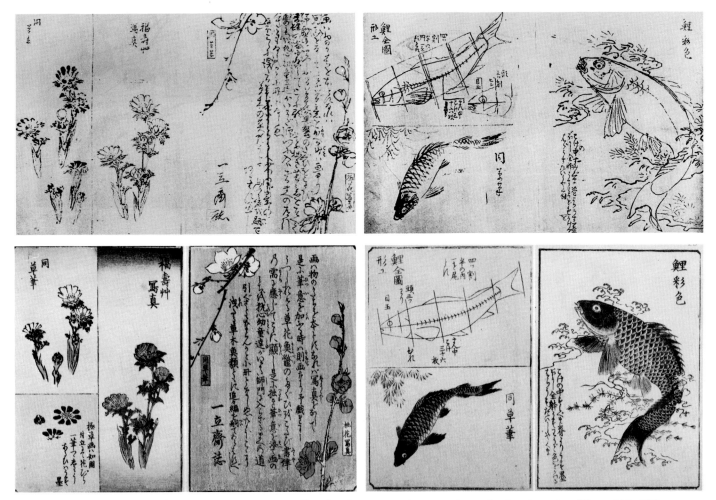

Hiroshige: Preface, Cherry Blossoms; Swimming Carp. Sketches from original manuscript and printed version (Plates 116–117) of *A Picture-Book Miscellany*.

to be quite impressionistic; whereas the Japanese might find Western "realism" too photographic in effect to be considered fine art.

Although Hiroshige was not an art theoretician, this little volume includes some rare comments by him that will strike a responsive chord in all those who know the artist's work. For example, his perceptive observations regarding another sketch of cherry blossoms: "It may be said of all flowers that it is rare for them to take shape in perfect order. The form of flowers might, indeed, be characterized as 'order in the midst of disorder.' "

The plates from the woodblock-printed, published version of the book can be compared with the manuscript work which seems to be Hiroshige's initial effort in the planning stages of the final book form; doubtless a clean and revised copy with coloring notations was made by the artist for the final engraved version. The differing flavor of the sketch and the color print are immediately apparent; in spite of all the looseness and freedom of the sketches, Hiroshige reveals himself as a master artist from the initial conceptual stage, owing less to his engravers and printers than is often supposed. He turns out, happily enough, to be a master designer and an artist of great intimacy and immediate rapport: qualities one senses, often in different ways, in his renowned prints.

VI

The emphasis of this volume so far has been on the prints and paintings of ukiyo-e artists working in Edo. It is important to remember, though, that other urban centers, especially Osaka and Kyoto, also had their own schools of plebeian art. Plate 119, for example, shows a notable work of Ryūkōsai (1772–1816), a leading theatrical artist of Osaka in the later eighteenth century; and in Plate 118 we can see the work of an equally renowned master of Kyoto ukiyo-e, Nagahide (fl. 1810s–30s).

In Osaka, too, the school of Hokusai took root — most notably due to the efforts there of his pupil and adopted son, Shigenobu (1787–1832), whose work is shown in Plate 120. Prints by Hokushū and Hokuei (Pls. 121, 122–124), other followers of Hokusai who specialized in the kabuki print, dominate the remainder of this book. In their works, one can glimpse that special, puppetlike, sometimes even deformed, vision of the kabuki actor and the kabuki stage which, although never really "natural," successfully captures the stylization and ostentation of Japanese theatrical performances. In contrast to the harmonious visions of nature that characterize Hiroshige's work during the same period, these prints tend toward bold drama, violence, and exaggeration.

At just what date ukiyo-e actually ended its long, varied history is difficult to pinpoint. Many artists of the later period (including even Hokusai) did much work that is far removed from the floating world of stylish, contemporary life. Active in the final phase of ukiyo-e were two troubled artists who typify the stormy transition from feudal Japan to modern times. The first, Yoshitoshi (1839–92), who might well be termed the last "pure" ukiyo-e master, was a talented pupil of Kuniyoshi. But the times were against him, the techniques of woodblock printing

were now geared to the needs of journalism and in strong competition with photography. The artist himself was of troubled mind, resulting in prints depicting excesses of violence, blood, and gore, which were consequently repressed by the conservative authorities. However, in his best work (Pls.132, 133), Yoshitoshi displays a genius for dramatic composition which arguably comes close to equaling the work of Hokusai.

A second artist representing this difficult transitional period into modern Japan is Kyōsai (1831–89), who was trained in both ukiyo-e (again, under Kuniyoshi) and in the semiclassical Kanō School. His work is not exactly of either school, and appears at its best in the impromptu sketches that avoid his characteristic mannerisms (Pls. 129, 131). Kyōsai was known for his eccentric humor, and, like Yoshitoshi, he had inevitable confrontations with the government watchdogs.

The final years of ukiyo-e are symbolically represented in the triptych by Kunichika (Pl.125) in which three famous kabuki actors are depicted at the site, south of Edo (by now, Tokyo), for the new steam train to Yokohama. Traditional Japanese culture and ways of life were no match for the coming age of steel and plastic and were soon disdained by many people as being redundant and inefficient.

In this volume we have viewed a cornucopia of representative treasures of ukiyo-e art, from its inception at the turn of the seventeenth century, through the gradual refinement and perfection of the figure print and the landscape print, to its ultimate decline toward the end of the nineteenth century. Faced with competition from mass-produced lithographs, collotype printing, and photography, the stylized depictions and complex techniques of ukiyo-e could not survive in the new age where demands for realism and efficiency were likewise to spell the doom of many more of Japan's finest crafts and traditions.

Japanese Woodblock Prints in the Victoria and Albert Museum

Rupert Faulkner

A BRIEF HISTORY OF THE COLLECTION

The collection of Japanese woodblock prints in the Victoria and Albert Museum is one of the most extensive in the world, with an estimated total of 25,000 images. Like other parts of the museum's holdings of Japanese art, it was largely assembled before 1920. More than 12,000 prints were bought as a single lot in 1886, and a further 6,000 were given to the museum in 1916. Much of the remaining quarter of the collection was acquired in the form of smaller gifts and bequests. No further acquisitions have been made since 1969.

The strength of the collection lies primarily in its coverage of the mid-nineteenth century. There are a number of earlier works, but they are very much in the minority. In this respect the collection complements that of the British Museum, the other great repository of Japanese prints in Britain, which has a wealth of primitive and classical period works of the seventeenth and eighteenth centuries. The paucity of earlier material in the V&A is paralleled by considerable unevenness of quality among the later prints. An explanation for the somewhat eclectic nature of the collection is given in the introduction to the *Handbook to Japanese Prints in the Victoria and Albert Museum* of 1908.

> The Library [at the museum] possesses very large numbers of prints by later men, who have not generally been deemed worthy of the attention of the collector. These prints are richer in color than those [earlier works] just referred to: they are filled with examples of costume, furniture, and all sorts of utensils; and, if they are inferior in absolute artistic merit, they are of inestimably greater utility for these reasons to the designer, the craftsman, and the student of the applied arts of Japan. While the endeavour has been made to secure such examples of the use of the art as will explain fully its development and technique, the greater part of the collection has been acquired for the sake of subject only; and this is the explanation of the apparently overwhelming preponderance given to the work of artists of less than the first rank.

Whatever the concerns may have been that guided successive generations of curators to develop the collection into its present form, its very size ensures the provision of substantial coverage of all periods of Japanese print making up to the end of the nineteenth century and the inclusion of many works, like those illustrated in this book, of considerable distinction and rarity.

The extent to which the collection has been made available to the public in the form of exhibitions and publications has varied over the years, the presence among the museum's staff of a curator with a particular interest in the subject having always been a key factor. The first and most important contributor to its development and understanding was Lt. Col. E. F. Strange, the author of the handbook quoted above. He joined the museum in 1889 and worked in the National Art Library, which at that time was responsible for the Japanese print collection. From 1900 to 1914 he served as Keeper of the Department of Engraving, Illustration, and Design, and from 1914 to 1925 as Keeper of the Department of Woodwork and Furniture. He published extensively, his 1925 monograph on Hiroshige being one of his best-known works, and was the driving force behind several important exhibitions.

Following Strange's retirement in 1925 it was A. J. Koop, a member of the curatorial staff since 1900, who upheld the museum's interest in Japanese art. Although Koop was responsible for making revisions to Strange's handbook in preparation for publication of the sixth edition in 1931, he was primarily concerned with the study of metalwork, Japanese sword fittings in particular, and did not involve himself in the print collection in the way that Strange had done. Acquisitions continued to be made on a modest scale throughout the late 1920s and 1930s, but it was not until B. W. Robinson joined the museum in 1939, two years after Koop's retirement, that the collection became the focus of enthusiastic attention again.

A widely recognized authority on Kuniyoshi, Robinson recatalogued the many works by this artist in the collection and published two important monographs on the subject. The first, *Kuniyoshi,* published in 1961, was written to coincide with the staging of an exhibition to mark the centenary of the artist's death. It drew largely on the author's own collection and that of the V&A, and to some extent on that of the British Museum. The second, *Kuniyoshi: The Warrior Prints,* published in 1982, was a detailed catalogue and study based on the author's extensive research in Europe and the United States.

As Keeper of the Department of Metalwork and, from 1972, as Keeper Emeritus of the newly formed Far Eastern Section, Robinson was also closely involved in the exhibition *The Floating World: Japanese Popular Prints 1700–1900,* organized by R. A. Crighton in 1973. This very successful exhibition, the catalogue of which has become a highly sought-after item, was the last time that large numbers of prints from the museum's collection were shown to the public.

Two further publications that appeared during this period were *Japanese Colour Prints,* an introduction to the museum's collection published in

1952 by A. W. Ruffy, Assistant Keeper of the Department of Engraving, Illustration, and Design, and L. G. Dawes's *Catalogue of Japanese Illustrated Books in the Department of Prints and Drawings* of 1972.

In terms of the showing of the print collection in the museum's permanent galleries, there were rotating displays in the Japanese Primary Gallery, which was set up in 1951 in Room 47E, and also in Room 38A, an additional space in which Japanese art was shown from 1981 onward. The contents of these two galleries were subsumed into the Toshiba Gallery of Japanese Art and Design, which was opened in December 1986 with the facility to show a small selection of prints in its central area. J. V. Earle, the curator in charge of setting up both Room 38A and the Toshiba Gallery, first as Assistant Keeper and then, from 1983 to 1987, as Keeper of the Far Eastern Department, was responsible for a useful guide, *An Introduction to Japanese Prints*, published in 1980. It was also during his keepership that the photographs were taken for the two sumptuous volumes published in Japanese by Kodansha in 1988 and 1989 as part of their *Ukiyo-e Masterpieces in European Collections* series, a selection of which has been used as the illustrations to the present book.

In recent years a number of further undertakings have been initiated to improve the organization of the collection and to make it more accessible to the public. A program of reboxing which has been in progress since 1986 is making handling of the prints both easier and safer. There is also a long-term aim to recatalogue the collection to improved standards of consistency and detail. To this end a simple but effective microcomputer database system has been designed and set up. At the time of writing a sample of nearly 1,000 Kunisada actor prints has been successfully entered onto this system. It is hoped that resources will be found to enable further parts of the collection to be recatalogued in the same way. A more ambitious scheme, though unlikely to be realized in the foreseeable future, is to create an automated image recall system that could be run in conjunction with the computerized catalogue to allow rapid and flexible access to the collection, obviating the present need to work laboriously through boxloads of prints to locate a required image.

THE TECHNIQUES OF UKIYO-E WOODBLOCK PRINTING

One aspect of Japanese prints that has always been of great interest is the process by which they were made, and from as early as 1913 the museum has had a permanent display demonstrating the techniques of woodblock printing. It was initially set up by E. F. Strange and was accompanied by a descriptive catalogue entitled *Tools and Materials Illustrating the Japanese Method of Colour Printing*. In addition to what is shown in this display, which is essentially the same today as it was nearly eighty years ago, the museum has a small collection of original woodblocks and a set of proofs taken from them by a Japanese printer in 1910.

Block-cutting and printing skills were originally developed in Japan in connection with the production of Buddhist texts and illustrative ma-

terial. In the early seventeenth century, when improving economic conditions and the emergence of a thriving urban culture sparked the growth of a secular publishing industry, these skills were adapted to the production of popular illustrated books. The majority were printed only in black and white, and when single-sheet prints first appeared in the 1660s, they were printed in the same way. Early prints of this sort are known as *sumizuri-e*, or "ink-printed pictures" (Pls. 3–4). Colors could be and often were added, but at this stage only by hand. Early hand-colored prints are known as *tan-e* after the red lead (*tan*) used as the main coloring agent. Later examples are called *beni-e* after the safflower (*beni*) from which their dominant pink color was obtained. Hand-colored prints from the 1720s to the early 1740s which have areas of intense black made from a mixture of glue and black pigment are known as *urushi-e*, or "lacquer pictures," on account of the resemblance to the glossiness of black lacquer (Pls. 6–10).

The earliest known use of color printing in Japan is in the illustrations to a mathematical treatise published in several editions in the 1630s and early 1640s. Color printing technology developed in the course of the seventeenth century, and by the 1720s and 1730s was being used with considerable sophistication to illustrate anthologies of poems and other books. Color printing of single-sheet prints started in the early 1740s. Initially only green and *beni* pink were used, giving rise to the term *benizuri-e*, or "pink-printed pictures" (Pls. 11, 12), but during the next two decades experiments were made with up to five colors. These experiments and the technical improvements of which they were a manifestation were a vital step toward the development of the full-color print, or *nishiki-e* ("brocade print") whose appearance in the middle of the 1760s marked the beginning of a new era in Japanese print making in which a remarkable and ever more dazzling diversity of effect was achieved.

The production of a woodblock print was a complex process in which the publisher orchestrated the separate activities of several different workshops, notably those of the artist, the block-cutter, and the printer. It began with the preparation by the artist of a preliminary design known as a *shita-e*. Sometimes this would be quite rough and would have to be worked on further in the publisher's studio. The *shita-e* or its more polished version was then used as the basis for the *hanshita-e*, a more elaborate drawing which had all the areas and lines of black as they would appear on the finished print (Pls. 71, 79, 89).

In the next main stage, the block-cutter took the *hanshita-e* and pasted it face down onto a wooden block, typically made from cherry wood cut in the direction of the grain. The upper layers of the paper were peeled off and oil was rubbed in. This made the paper transparent and the drawing more visible, facilitating the work of the block-cutter as he then proceeded to cut away the wood between the areas and lines of black. The keyblock, as this first block is known, was then furnished with *kentō*, or "registration marks," in the form of raised notches in one corner and an adjacent side. A number of pulls were taken from the

keyblock and were marked up and used like *hanshita-e* in the preparation of the color blocks, a separate pull being needed for each extra block required (Pl. 39). On this initial set of pulls, known as *kyōgō*, or "proofs," the *kentō* were printed along with the actual image so that they could be transferred to the color blocks. This ensured that the relative position of the *kentō* to the image was the same on all of the color blocks as on the keyblock. The number of color blocks used varied from print to print. Early *nishiki-e* have a relatively restrained palette, but the number of colors increased to as many as fifteen to twenty in the nineteenth century.

When the blocks were ready they were passed to the printer with instructions about colors and any special techniques to be used. As in the block-cutter's workshop, the skills practiced in the printer's studio were considerable, and the quality of the finished print often owed as much to the abilities of these craftsmen as to the talent of the artist responsible for the original design. The order of printing depended on the particular combination of colors to be used. The keyblock was printed in black, usually, though not necessarily, before the color blocks. In some cases, on so-called *musen-zuri* prints, part or all of the black outline was intentionally not printed (Pl. 15). Blocks for small areas of color were printed first, and the general principle was to proceed from lighter to darker colors. The pigment was scrubbed onto the block with a fat, short-bristled brush, and the sheet of paper, which had been sized and dampened in advance, was placed carefully onto the block with the appropriate corner and edge fitting exactly into the notches of the *kentō*. A special tool known as a *baren* was then used to rub the back of the paper, which, being made from the long-fibered inner bark of the *kōzo*, or paper mulberry tree, was strong enough to withstand the considerable pressure exerted by the printer. The *baren* was a flat disc about 13

Kunisada: The Stages of Woodblock Print Making. Triptych, three *ōban*-size sheets, 1857.

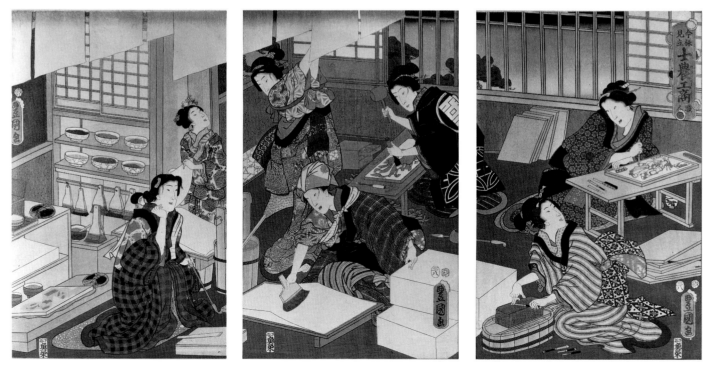

centimeters in diameter consisting of an inner core of tightly twisted and coiled bamboo-fiber cord sandwiched between a lacquered back-plate, and a bamboo sheath tied behind to provide a small grip. The smoothness of the bamboo sheath allowed it to move easily across the paper while the hard knottiness of the inner core ensured that the pigment was forced deep into the fabric of the paper. Printing proceeded block by block, and the paper was kept in stacks between printings. This ensured that the moistness of the paper was maintained at the same level throughout the printing process and that problems of inaccurate register that would have ensued had the paper been allowed to dry out and shrink were avoided.

In addition to these basic techniques, there were a number of secondary methods that the printer could use to enrich the quality of his product. One of the most important was *fukibokashi*, or "wiped tonal grading," whereby the printer would wipe away parts of the pigment so that there was a gradation of color across the area of the block. This was a widely practiced technique which gave particularly spectacular effects when used with *berorin-ai* ("Berlin" or "Prussian Blue"; see below) in the rendering of sky and water (Pls. 86, 96, 111).

Gauffrage, or embossing was another important technique. In *karazuri*, or "blind printing," the fully colored print was placed face down on a specially prepared block and rubbed from behind so that parts of the surface were pushed out in low relief (Pls. 15, 121, 130). *Kimedashi* was a related technique whereby a deeper gauffrage was achieved by hammering rather than rubbing the back of the print. In *nunomezuri*, or "textile-printing," the imprint from a piece of textile glued to a block was transferred onto the print (Pl. 128). *Shōmenzuri*, or "surface printing," though not strictly an embossing technique, was another way of achieving pictorial effect without the use of additional colors. The print, which had to be completely dry, was placed face up and burnished with a smooth, hard implement so that the areas in contact with the raised parts of the block took on a distinctive sheen (Pl. 132).

Various methods were also used to enrich the backgrounds of prints. The most common of these, *jitsubushi*, was a simple process involving the use of an extra block to add color to the background (Pls. 37, 40, 57, 120). In more lavish productions, particularly from the end of the eighteenth century, the colored *jitsubushi* ground was further enhanced by *kirazuri*, or "mica printing," whereby glue was printed on by block and then sprinkled with mica, or glue and mica were mixed together and applied by block or brush (Pl. 42). *Mokumetsubushi*, or "wood-grain ground," was a technique whereby the grain of the woodblock was made to show through on the print. It was used with particular effect on landscape prints (Pls. 97, 115). A less common technique known as *barensuji* made deliberate use of the marks caused by the *baren* to add drama to a composition (Pl. 63).

Kirazuri was also used in the same way as *kinginzuri*, or "gold and silver printing," a technique whereby metal dusts such as powdered tin, copper, and brass were used in imitation of silver and gold to enhance

specific details of a design (Pls. 122–124). Either the glue was applied by block and the metal dust then sprinkled on, or the glue and metal dust were mixed together and printed on by block. Greater richness was obtained by then reprinting with the same block using *karazuri* (Pl. 127), or by bringing out the metallic luster with *shōmenzuri*.

The precedent for using metal dusts on prints goes back to the time of hand-colored *urushi-e*, areas of which were frequently embellished with bronze or brass dust (Pls. 7, 8, 10). In these early prints the metal dust was usually sprinkled on. In some cases, however, it was sprayed on. Similar techniques were used on later prints, particularly in the rendering of snow, mist, or spray by so-called *gofunchirashi*, or "*gofun* spattering," *gofun* being made from either lead white or a mixture of pulverized shell and glue (Pl. 90).

The pigments used by the printer were water-based compounds derived from mineral and vegetable sources. The soft colors seen on eighteenth century prints were rather fugitive and often very expensive. They were used in the nineteenth century on *surimono*, or privately commissioned prints, but less so on commercial productions. There was, on the whole, a general move toward stronger and more stable colors, and new pigments were introduced from abroad. *Berorin-ai*, for example, was first imported in the mid-1820s and was widely used from the early 1830s onward. Synthetic aniline dyes were introduced during the 1860s. Although they tended to be harsh and garish, in the hands of a skilled printer they could be used to striking and by no means indelicate effect (Pl. 125).

UKIYO-E ARTISTS AND THEIR THEMES

The organization of the Japanese prints in the V&A reveals the concern with subject matter which Strange, in the passage quoted earlier, explains as having been the guiding principle behind the formation of the collection. At the first level, as would be expected, the prints are arranged by artist. They are then subdivided according to a list of subject classifiers. Some of these derive from established Japanese categories, "Actor Prints" from *yakusha-e*, for example, or "History, Legend, and Myth" from *musha-e*. Others, such as "Trades and Occupations" or "Festivals and Pageants," are borrowed from a system originally devised in the museum for the classification of European prints and drawings.

Along with the paintings and illustrated books that constitute the other main formats of the genre, woodblock prints document in considerable detail the interests of the urban society within which they were produced and consumed. The term ukiyo-e, or "pictures of the floating world," by which the genre as a whole is known, reflects the preoccupation shown during the seventeenth and eighteenth centuries with the exhilarating but faddish and transitory delights of the kabuki theater and the licensed pleasure quarters. Erotica, or *shunga* ("spring pictures"), constituted an integral and important area of concern in which most ukiyo-e artists were involved. From the late eighteenth century, and especially during the nineteenth century, there was a very substan-

tial increase in the range of subject matter depicted. *Kachō-ga*, literally "bird-and-flower pictures," refers to the various kinds of nature study that began to appear shortly after the development of the *nishiki-e* in the latter part of the 1760s (Pls. 15, 16). In some cases the style of depiction reflects a familiarity with European nature studies introduced by way of imported books and prints, but on the whole classical Chinese and Japanese modes of representation served as the models. More than natural subjects, however, it was landscapes and urban views that particularly caught the imagination of nineteenth century print artists and led them to produce, in the form of so-called *fūkei-ga*, some of the most delightful and inspired work of the time. The other main new area of interest was the illustration of heroic incidents in history, literature and legend as seen in *musha-e*, or "warrior prints." The search for alternative subject matter arose from the need to compensate for the increasingly repressive attitude of the authorities towards *yakusha-e* and *bijin-ga*, or prints featuring actors, and beautiful women, and, given the stagnant nature of much nineteenth century work on these themes, from the need for new avenues of artistic exploration. Landscape prints owed much of their popularity to increasing public involvement in travel during the first decades of the nineteenth century, especially in the form of pilgrimages to famous religious sites (Pls. 85, 104). In the case of *musha-e*, the severity of the Tempō Reforms, which in 1842 banned the depiction of theatrical subjects and almost caused the complete closure of the kabuki theaters, secured their position as a major print form.

The magnificent six-fold painted screen (Pl. 2) is an early depiction of kabuki actors performing in the Nakamura-za, a leading theater in Edo (now Tokyo). Although it is unsigned, it has been attributed on stylistic grounds to Moronobu (fl. ca. 1670–94), the artist who is generally regarded as the founder of the ukiyo-e school, or one of his followers. Tradition relates that kabuki was originated at the beginning of the seventeenth century by a dancer called Okuni, who, with her female company, put on performances in Kyoto featuring dancing and comic sketches which became popular all over the country. The dubious virtue of the women who made up the troupes of performers brought reproof from government officials, and in 1629 female artists were banned from the stage. Their place was taken by groups of boy actors, but in 1652 they too were banned over similar concerns about public morality. Mature kabuki developed during the second half of the seventeenth century with male actors belonging to strictly organized guilds playing both male and female roles. Permanent theaters such as the Nakamura-za were established, and actors came to enjoy the same degree of fame as popular entertainers do today.

During the first half of the eighteenth century, the production of actor prints was largely monopolized by the Torii School of artists (Pls. 7, 11). The sense of grandeur characteristic of many of these prints was achieved through emphasis on the actors' postures and the draping of their robes. Effective though this style of representation was, by the middle of the century it had become very overworked. The fortunes of

the actor print looked set to decline had it not been for the emergence in the early 1770s of a more realistic style pioneered principally by Shunshō (1726–92), in which emphasis was placed on the individual characterization of the actors portrayed. Shunshō and his pupils were dominant throughout the 1770s and 1780s (Pls. 27–28, 29, 30, 36), but other artists began to take the lead during the 1790s. Sharaku, a mysterious personality who produced a remarkable series of highly penetrating actor portraits over a period of ten months in 1794–95 before disappearing back into anonymity, was the most notable. As far as the long-term future of the actor print was concerned, however, Toyokuni (1769–1825) was the more influential figure. He established his reputation with a series of actor portraits in the mid-1790s, and led the field until his death some three decades later, working in a wide variety of styles and formats. The large-head portrait of Onoe Matsusuke is particularly striking (Pl. 57), as is the portrayal of Ichikawa Omezō I in *Shibaraku* (Pl. 58). The colorfully illustrated triptych (Pl. 56) is interesting for the way in which it shows not just one but a series of representative scenes from kabuki's most famous play. Among Toyokuni's numerous pupils, Kunisada (1786–1865) was the most active exponent of the actor print. He was particularly successful in capturing the sense of bustle and drama of the theater through the detailed rendering both of actors and their costumes (Pl. 63), and also of the scenery and props (Pl. 62). Like earlier artists'

Yakusha-e (prints featuring kabuki actors) from the late 1680s to the mid-1830s.

FROM LEFT TO RIGHT
Moronobu School: Detail from Scene at Kabuki Theater in Edo. (Plate 2)

Torii Kiyonobu II: Kabuki Scene (Plate 11)

Shunshō: Detail of the priests Saigyō and Mongaku, from Kabuki Scene. (Plate 29)

Toyokuni: The Kabuki Actor Ichikawa Omezō I. (Plate 58)

Hokuei: The Kabuki Actor Nakamura Shikan II. (Plate 126)

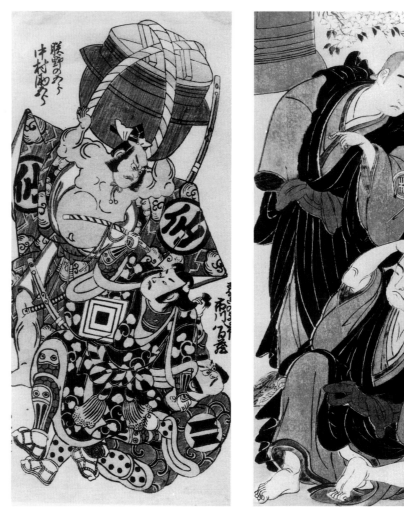

studies of theater interiors (Pl. 31), his depiction of backstage scenes at a kabuki theater in Osaka (Pl. 61) provides important insights into theater architecture and the day-to-day realities of kabuki life. The striking colors and fineness of detail in his work reflect the improvements in block-cutting and printing techniques that had occurred during the early part of the nineteenth century. While Edo-based artists continued to design theatrical prints well into the late nineteenth century (Pl. 125), some of the most impressive work was being executed in Osaka. Osaka prints, many of which were made with materials and techniques usually reserved for privately commissioned *surimono*, display a richness of detail not often found on the more commercial productions from Edo (Pls. 121–124, 126–128).

Although, as stated earlier, it was the Tempō Reforms of 1842 and the suppression of *yakusha-e* and *bijin-ga* that secured the position of warrior prints as a major ukiyo-e form, their history goes back at least as far as the middle of the eighteenth century. The imposing *benizuri-e* depiction of the twelfth century hero Yoshitsune on horseback is an early example by a Torii School artist dating from the late 1750s (Pl. 12). The genre was further explored by various artists, Shuntei (1770–1820) in particular (Pl. 88), before being taken up by its greatest exponent, Kuniyoshi (1798–1861). Like Kunisada, Toyokuni's other important pupil, Kuniyoshi was a prolific artist working across the full range of

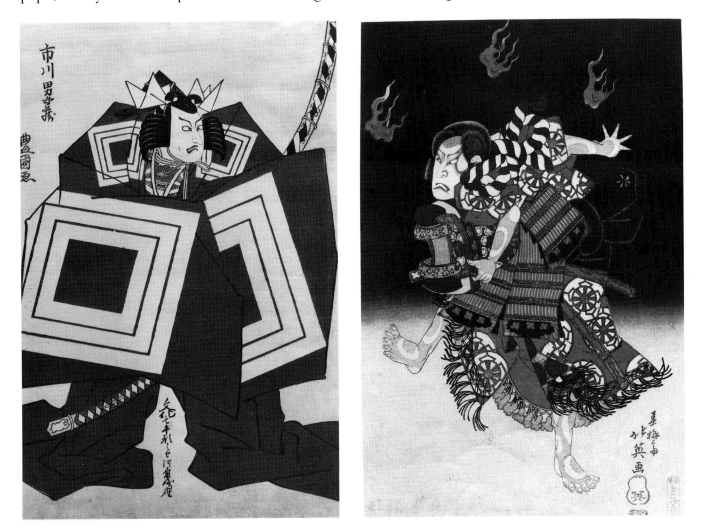

ukiyo-e subject matter (Pls. 94, 98, 100–103). From an early stage in his career, however, he showed a strong predilection for the romance and mystery of history and legend. After an initial period working in the manner of Shuntei, he developed his own style in the late 1820s and 1830s, starting with the publication of a series of prints depicting heroes from the *Suikoden* (The Water Margin), a semi-historical romance adapted from the Chinese by the popular novelist Takizawa Bakin (1767–1848). In addition to producing a great many single-sheet prints, Kuniyoshi designed a large number of triptychs in which he explored in a characteristically dramatic style the compositional possibilities afforded by the larger format. His subjects were many and varied, and included incidents from the dawn of Japanese history through to the recent past. He was particularly interested in the medieval period, much of his work centering on the conflict between the Taira and Minamoto clans in the late twelfth century, the rivalry of the Northern and Southern Courts in the early fourteenth century, and the pacification of the country in the late sixteenth century following decades of anarchy and civil war (Pls. 89–93). Kuniyoshi's contribution to the art of ukiyo-e is reflected not only in his own impressive oeuvre, but also in the way in which his powerful style of composition was widely emulated by his pupils and contemporaries, and in the fact that his themes were constantly reworked during the latter part of the nineteenth century (Pls. 105, 132, 133).

If Kuniyoshi can be given credit for some of the most stirring designs in the history of ukiyo-e, he was also responsible for a number of landscape prints of sublime serenity (Pls. 95–97). As with *musha-e*, *fūkei-ga* had a history of slow and gradual development before becoming widely popular during the second quarter of the nineteenth century. Landscape elements are found in eighteenth century theatrical prints (Pl.

Fūkei-ga (landscape prints) from the 1720s to the mid-1850s.

Kiyomasa II: Dusk at Mii Temple, from the series *Eight Famous Views in Ōmi*. Monochrome woodblock print with hand-coloring (*urushi-e*), *hosoban* size, 1720s.

Toyoharu: View of Mimeguri. (Plate 32)

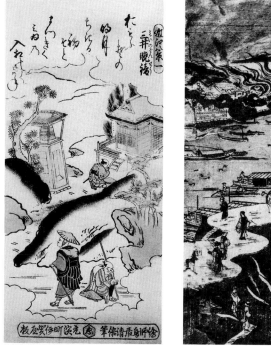

10), while series of views of famous places were being published from as early as the Kyōhō era (1716–36). The depiction of famous places is found in an early set of designs (Pl. 71) by Hokusai (1760–1849), the artist who, toward the end of a long and diverse career, was responsible for developing the landscape print into a major ukiyo-e form. The Western style of representation seen in his view of Gyōtoku (Pl. 77) is reminiscent of the work of Toyoharu (1735–1814), the founder of the Utagawa School of artists and a pioneer in the use of vanishing-point perspective in depictions of both exterior and interior views in so-called *uki-e*, or "floating picture" (Pls. 31–33). Hokusai's mature landscape style, which first manifested itself in the early 1830s in his renowned *Thirty-Six Views of Mt. Fuji*, can be seen in the two examples from his series of *Splendid Views of Famous Bridges of the Provinces* (Pls. 78, 80) and in the *hanshita-e* from the *Hundred Poems by One Hundred Poets as Explained by a Wet Nurse* series (Pl. 79). His influence is reflected in the use of color, the style of drawing and the compositional grandeur of the work of many of his pupils (Pls. 84–86). While the human dimension is rarely lacking from Hokusai's landscapes, the formalization of the designs sometimes results in a sense of coolness and detachment. In this respect Hokusai's work differs from that of Hiroshige (1797–1858), the other great exponent of the landscape print, which displays uninhibited wonderment at the marvels of nature and warm concern for the human condition. Hiroshige's achievement in the field of *fūkei-ga* is represented here by a small selection from the V&A's large and extremely important collection of fan prints dating mainly from the 1840s and 1850s (Pls. 111–115). The extensive use of *berorin-ai* seen in these and the work of other artists suggests that its introduction in the 1820s was an important stimulus to the development of the landscape print. Examples whereby the designs are executed almost exclusively in different tones of blue are known as *aizuri-e*, or "blue-printed pictures" (Pls. 112, 114).

In addition to the examples of his achievement in the field of *kachō-ga* (Pls. 106–108), an area in which he excelled along with Hokusai (Pl. 81), Hiroshige's work is also represented by two prints from the series

Hokusai: View at Gyōtoku. (Plate 77)

Kuniyoshi: *The Night Attack*. (Plate 94)

(continued on next page)

Six Famous Rivers with the Name Tama (Pls. 109, 110). This theme and its associations with classical poetry was a favorite with ukiyo-e artists. It was most commonly explored in conjunction with the depiction of beautiful women, as in the examples by Hokusai (Pls. 74, 75) and Eisen (1790–1848; Pl. 53), one of the best-known *bijin-ga* artists of the nineteenth century. A knowledge of poetry and literature, as well as accomplishment in other fields such as music (Pl. 70), was expected not only of high-born ladies but also of professional courtesans. This is reflected in the widespread use in *bijin-ga* of what is known as *mitate*, a device whereby classical themes were represented by or alluded to through the depiction of contemporary scenes. In the early Torii School portrait of a beauty reading a letter, for example, reference is made to the Chinese Tang dynasty Daoist monks Hanshan and Shide (Pl. 8). Japanese themes were generally more common, however, as can be seen in the work of Harunobu (1724–70; Pl. 13) and the successors to his style such as Bunchō (fl. 1760–92; Pl. 23), Shunshō (Pl. 26), and Kiyonaga (1752–1815; Pl. 35). *Mitate* was also used by artists such as Utamaro (1753–1806; Pl. 40), Eishi (1756–1829; Pl. 44), and well on into the nineteenth century by artists such as Kuniyoshi (Pls. 98, 99). The famous Heian period (794–1185) novel, the *Tale of Genji*, became such a popular subject for *mitate* that it gave rise to a genre of its own in the form of so-called *Genji-e*, or "Genji pictures" (Pl. 25).

The monumental though not unlyrical style of depiction seen in the early Torii School print (Pl. 8) is typical of many early eighteenth century Edo *bijin-ga*, parallels with actor portraiture of the same period being evident. The mood is very different from what one finds in the work of Harunobu (Pls. 13, 14), Isoda Koryūsai (fl. mid-1760s–1780s; Pl. 17) and their contemporaries, in which graceful maidens go about their daily lives in a state of apparently serene innocence. If Harunobu owed much of his inspiration to the work of the Kyoto artist Sukenobu (1671–1750), the mature work of Kiyonaga (1752–1815), the next great *bijin-ga* artist, combined stateliness with aristocratic elegance in his portrayal of characteristically haughty and statuesque beauties (Pl. 34). In the work of Eishi (Pl. 44) and his followers (Pls. 45, 47, 48), one finds

Hokusai: Mt. Gyōdō, Ashikaga. (Plate 80)

Hiroshige: *Enoshima Island.* (Plate 114)

a highly refined but slightly gentler mode of portrayal. During the 1780s and 1790s many other gifted artists, including members of the Katsukawa School (Pl. 37), applied their talents to the depiction of beautiful women. The most notable among these, and possibly the most renowned of all ukiyo-e artists, was Utamaro. A devotee of women in every sense of the word, Utamaro's genius lay in his ability to capture the subtle nuances of his subjects' emotional and psychological states (Pls. 40–42). Similar characterization of mood is seen in some of the work of Utamaro's successors (Pls. 54, 69). On the whole, however, psychological insight was sacrificed in the interests of ever greater emphasis on the sumptuousness of costumes and coiffures (Pls. 46, 66). In the case of artists such as Eisen and Kunisada, one also finds the tendency to make repeated use of the same harshly featured models in the exploration of a somewhat decadent and earthy sensuality (Pls. 52, 53, 68).

Many of the women who figure in *bijin-ga* were courtesans employed in the Yoshiwara in Edo, or in similar licensed pleasure quarters in Kyoto and Osaka. The Yoshiwara was established in 1617, and was moved in 1657 to the site in the northeastern part of Edo where it continued to operate until 1958. Entry to the complex of several hundred brothels and teahouses was through a single gate known as the *Ōmon*, or "Great Gate" (Pl. 67). With several thousand courtesans and their attendants, and a large supporting population of musicians, cooks, and other professionals, it was like an independent city with its own way of life. Ukiyo-e artists, in addition to portraying courtesans and other beautiful women in the ways we have seen, took an interest in the day-to-day activities of the Yoshiwara and its equivalents and also in the festive events of the urban calender (Pls. 20–22, 39, 60, 118, 120). The intimate scene of two lovers sitting at a *kotatsu* is an early and particularly delightful example (Pl. 9). A similar sense of tranquillity pervades the depiction of a poet on a visit to the pleasure district (Pl. 24). A more formal occasion is recorded in the triptych illustrating the celebrations surrounding the displaying of new bedclothes received from a wealthy actor patron (Pl. 43). The triptych, especially as exploited by nineteenth century artists, was a highly effective format for the depiction of interior and exterior scenes of courtesans, actors, and others enjoying the lively pleasures of city life (Pl. 49). In the scene of fireworks at Ryōgoku Bridge (Pl. 55), Toyokuni went a step further than usual and used the equivalent of two triptychs to create a massive composition of enormous vitality. A similar device was used in Kunisada's splendid depiction of three huge sumo wrestlers on a bridge (Pl. 65).

In a general survey such as this one can only begin to suggest the wealth of interest to be found in the study of Japanese woodblock prints. The artists referred to in the paragraphs above are but a few among many dozen that could be mentioned. Many were long-lived, prolific, and masters of several styles. Hokusai had been active for fifty years when he produced his famous *Thirty-Six Views of Mt. Fuji*, for example, and Kunisada, reputedly the most prolific of all ukiyo-e artists, is said to

have executed over 40,000 designs in the course of his career.

If the discussion of subject matter and the major artists of each genre has been written in necessarily broad terms, the description of wood-block printing techniques has been more detailed. The extraordinary craftsmanship that formed such an essential part of the ukiyo-e tradition is no less startling today than it was to Westerners arriving in Japan as she opened her doors to the outside world in the 1850s and 1860s. It is hoped that the splendid illustrations in this book and an understanding of how the original images were created will stimulate among readers the sense of wonder and excitement felt by the curators and collectors who have been responsible over the years for the formation of collections such as that at the Victoria and Albert Museum.

COLOR PLATES

*All plates in this volume are polychrome prints (*nishiki-e*) unless otherwise stated.*

TABLE OF PRINT SIZES

	centimeters	inches
aiban (intermediate) size	34 x 22.5	13 x 9
chūban (medium) size	26 x 19	10 x 7
hashira-e (pillar print) size	73 x 12	28 x 4
hosoban (narrow) size	33 x 14.5	13 x 5 1/2
large *hosoban* size	39 x 17	16 x 7
kakemono-e (hanging scroll) size	76.5 x 23	30 x 9
nagaban (long) size	50 x 20	19 x 8
ōban (large) size	38 x 25.5	15 x 10
large *ōban* size	58 x 32	22 x 12
ō-tanzaku (large poem card)	38 x 17	15 x 7
chū-tanzaku (medium poem card)	38 x 13	15 x 5
large *surimono* (privately commissioned print)	35 x 20	14 x 8
koban-size *surimono*	12–19 x 9–13	4–7 x 3 1/2–5

NOTE: Sizes are approximate and based on the size of the sheet before printing. After printing, excess paper was often trimmed, altering the original measurements slightly. Sizes also varied according to the period in which the print was produced.

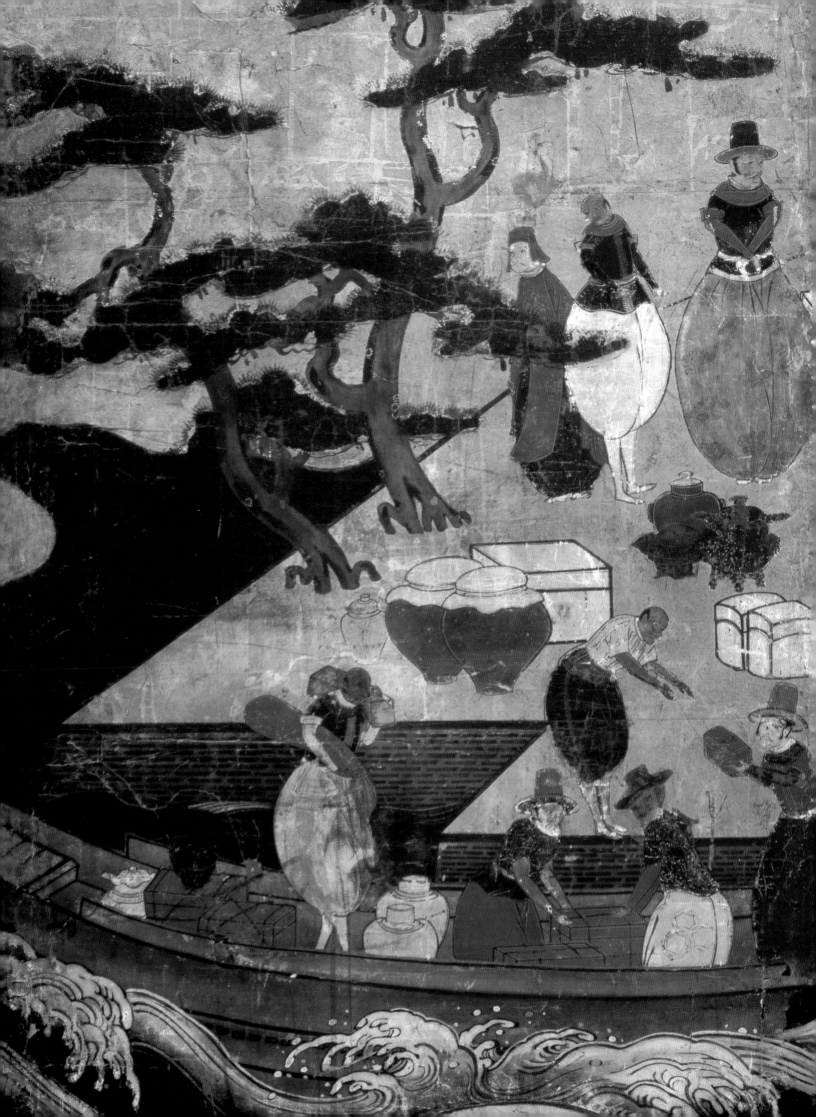

PREVIOUS PAGE: Detail of Plate 1.

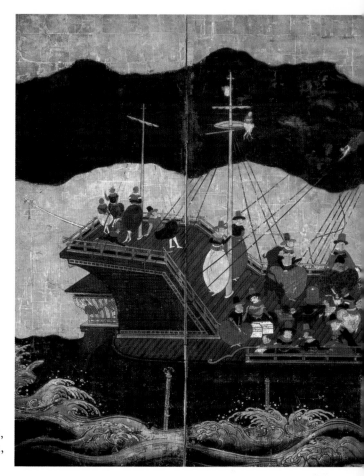

1 Unsigned: The Arrival of Europeans in Japan. Six-fold *namban* screen, hand-painted colors on paper and gold-leaf, total dimensions 142 x 350 cm, early seventeenth century.

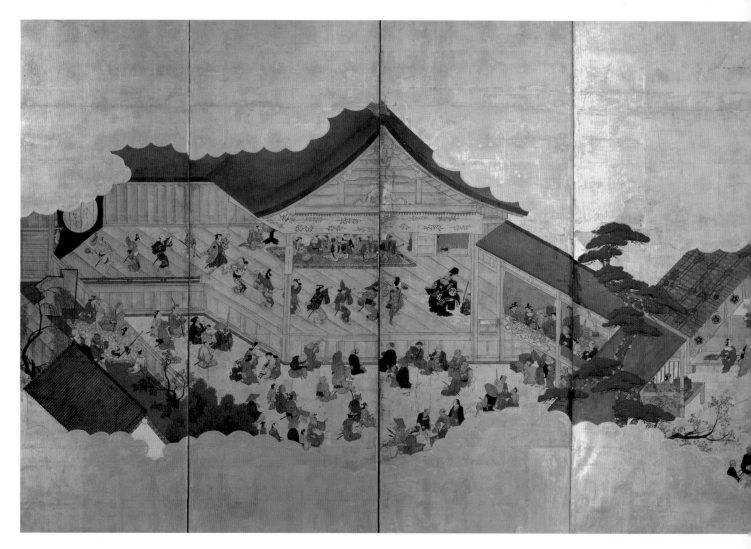

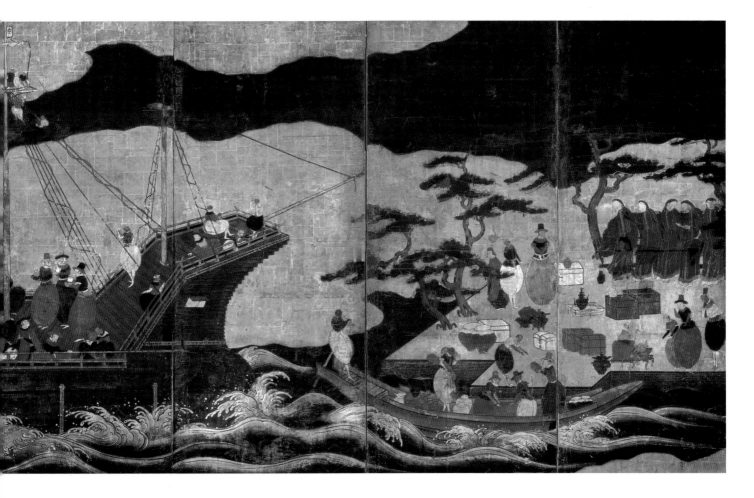

2 Moronobu School: Scene at Kabuki Theater in Edo. Detail of a six-fold screen, hand-painted colors on paper and gold-leaf, total dimensions 157 x 350 cm, late 1680s.

FOLLOWING PAGE: Detail of Plate 2.

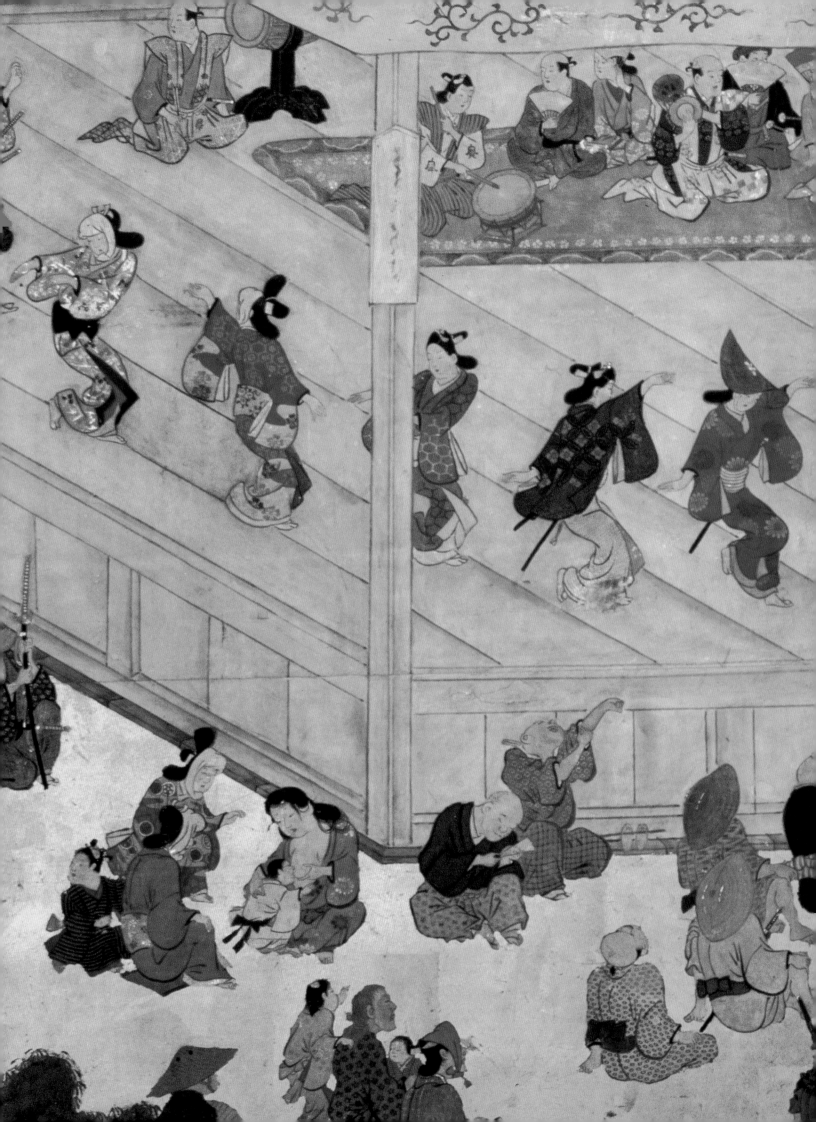

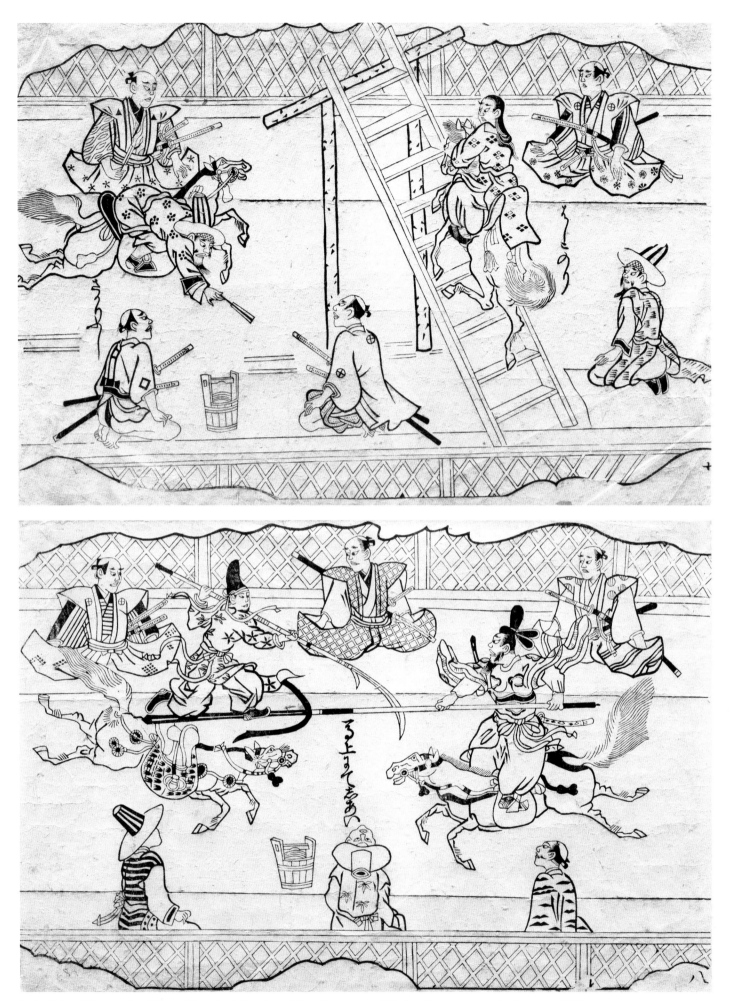

3–4 Style of Tomonobu: Korean Horseback Acrobats. Monochrome woodblock prints (*sumizuri-e*), *ōban* size, 1683.

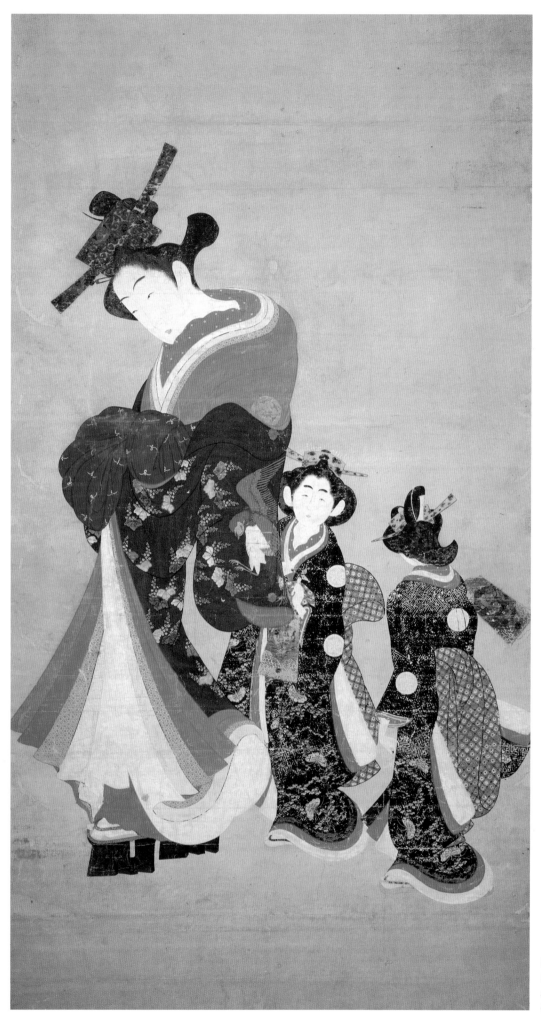

5 Style of Moromasa: Parading Courtesan with Attendants. Hanging scroll (*kakemono*), hand-painted colors on paper, 103 x 56 cm, 1740s.

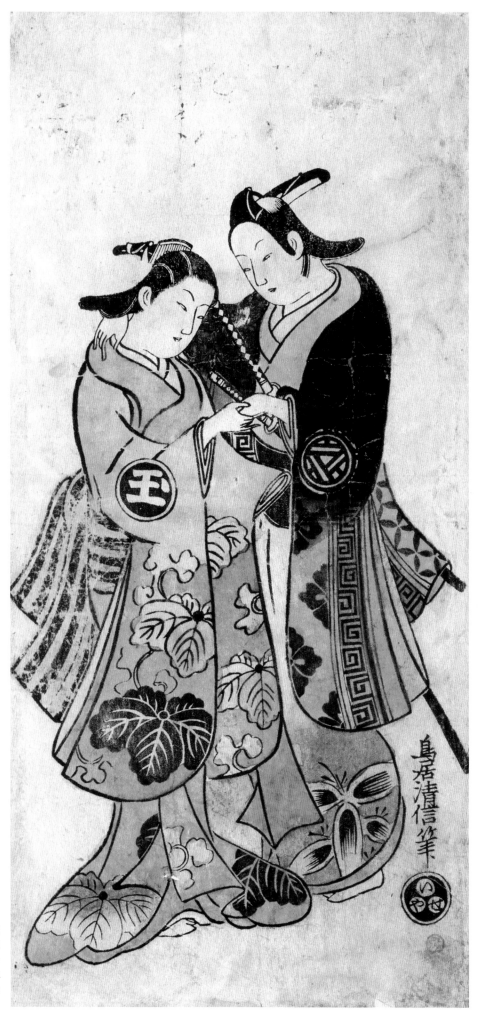

6 Torii Kiyonobu II: The Kabuki
Actors Ogino Isaburō I and Sodezaki
Iseno as Young Lovers. Mono-
chrome woodblock print with
hand-coloring (*urushi-e*), *hosoban*
size, mid-1720s.

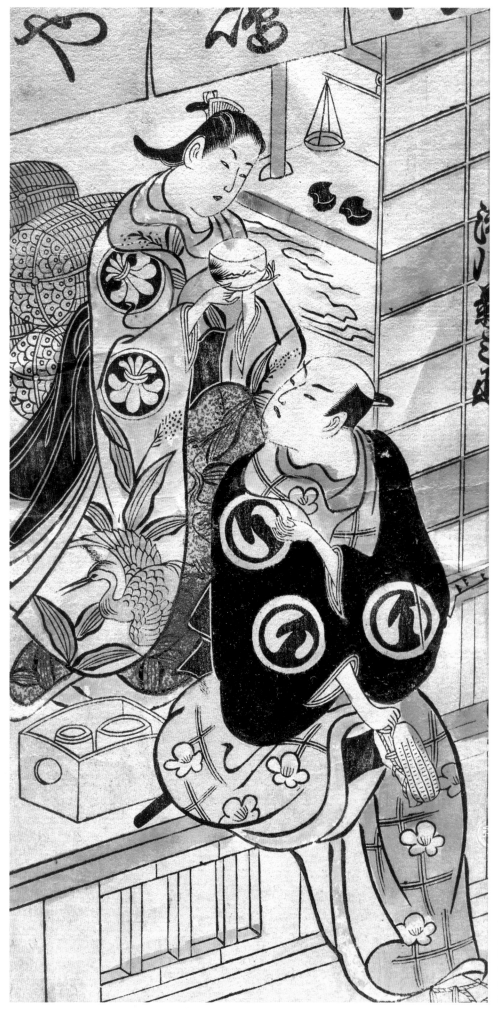

7 Early Torii School: The Kabuki Actors Sawamura Sōjūrō I and Segawa Kikunojō I. Monochrome woodblock print with hand-coloring (*urushi-e*), *hosoban* size, ca. 1730.

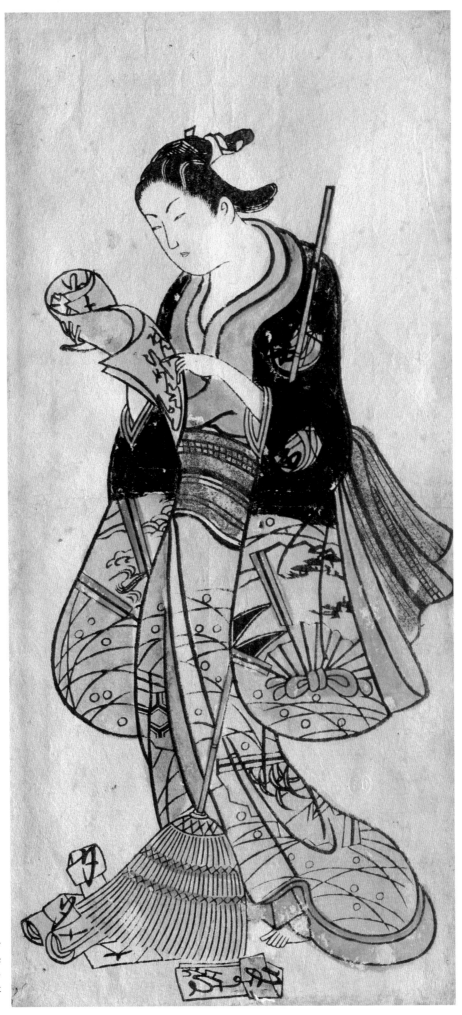

8 Early Torii School: A Beauty Reading a Letter. Monochrome woodblock print with hand-coloring (*urushi-e*). Allusion print (*mitate-e*), *hosoban* size, ca. 1730.

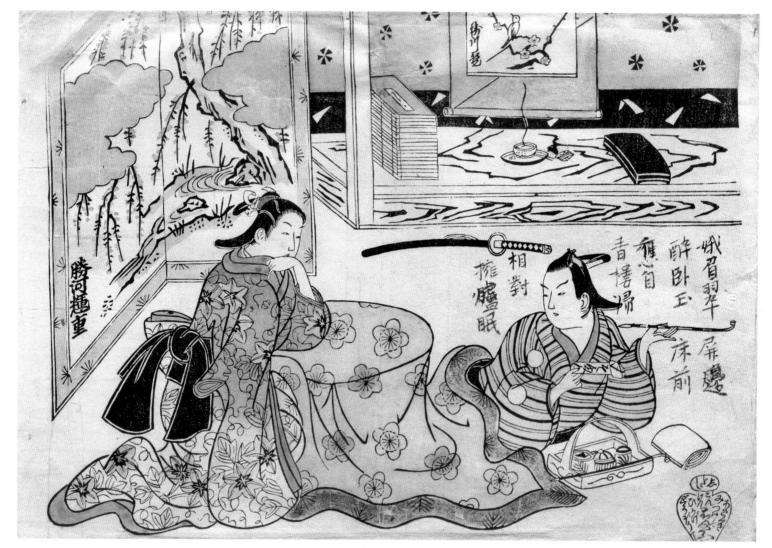

9 Terushige: Young Lovers Sitting at a *Kotatsu*. Monochrome woodblock print with hand-coloring *(urushi-e)*, *chūban* size, ca. 1720.

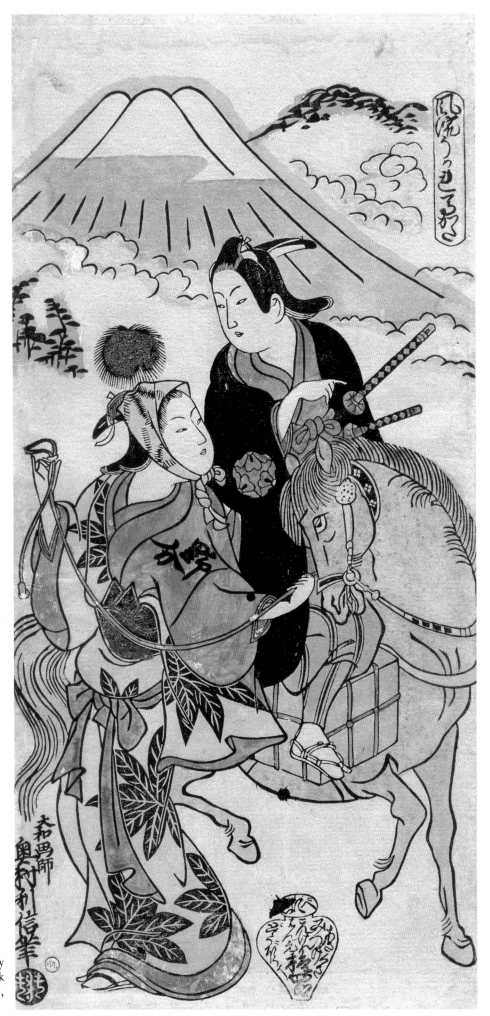

10 Toshinobu: Young Lovers by Mt. Fuji. Monochrome woodblock print with hand-coloring (*urushi-e*), *hosoban* size, ca. 1720.

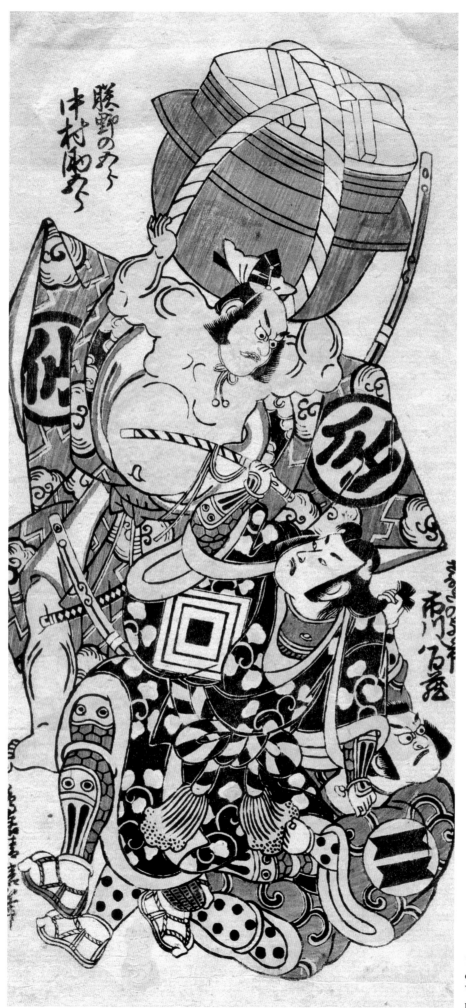

11 Torii Kiyonobu II: Kabuki Scene
of a Young Hero Battling with Two
Warriors. Limited color woodblock
print (*benizuri-e*), *hosoban* size, 1752.

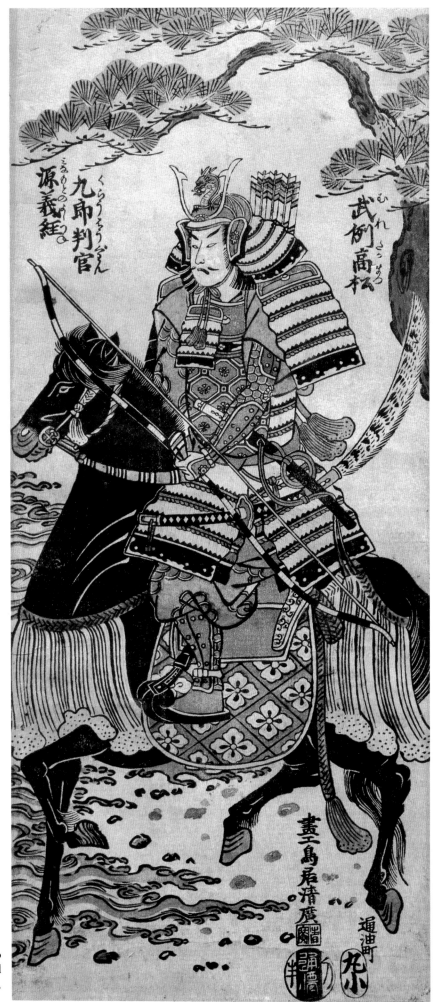

武列高松
むれたかまつ

九郎判官
くらうほうぐわん

源義経
みなもとのよしつね

畫工 鳥居清廣

通油町 丸小

12　Torii Kiyohiro: The Warrior Hero
Minamoto no Yoshitsune. Limited
color woodblock print (*benizuri-e*),
large *hosoban* size, late 1750s.

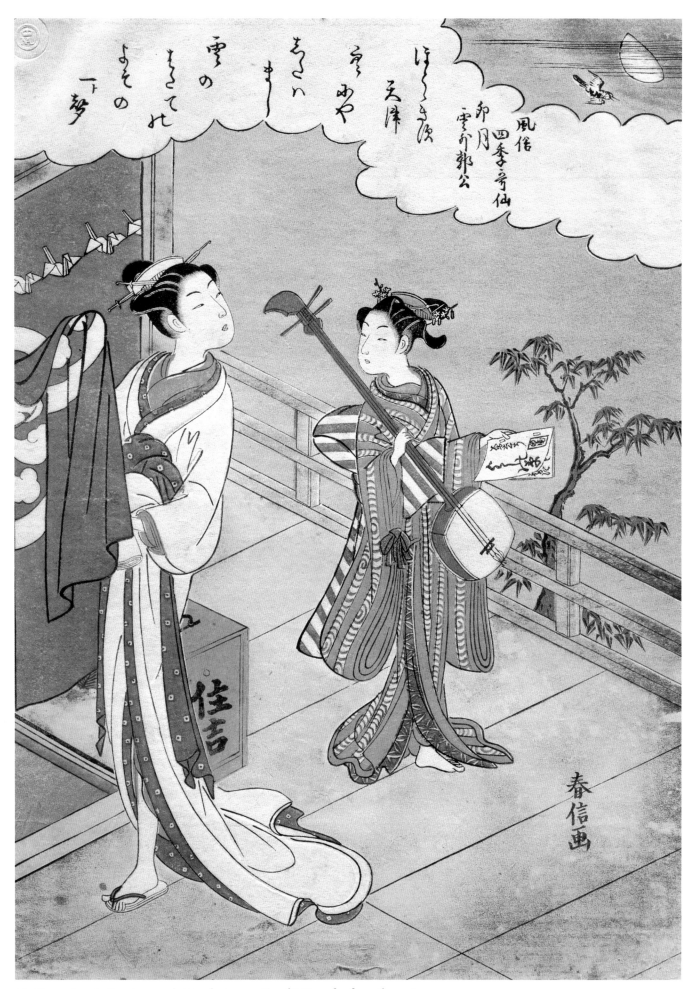

13　Harunobu: A Courtesan and Attendant on a Moonlit Veranda, from the series
Genre Poets of the Four Seasons. Allusion print (*mitate-e*), *chūban* size, late 1760s.

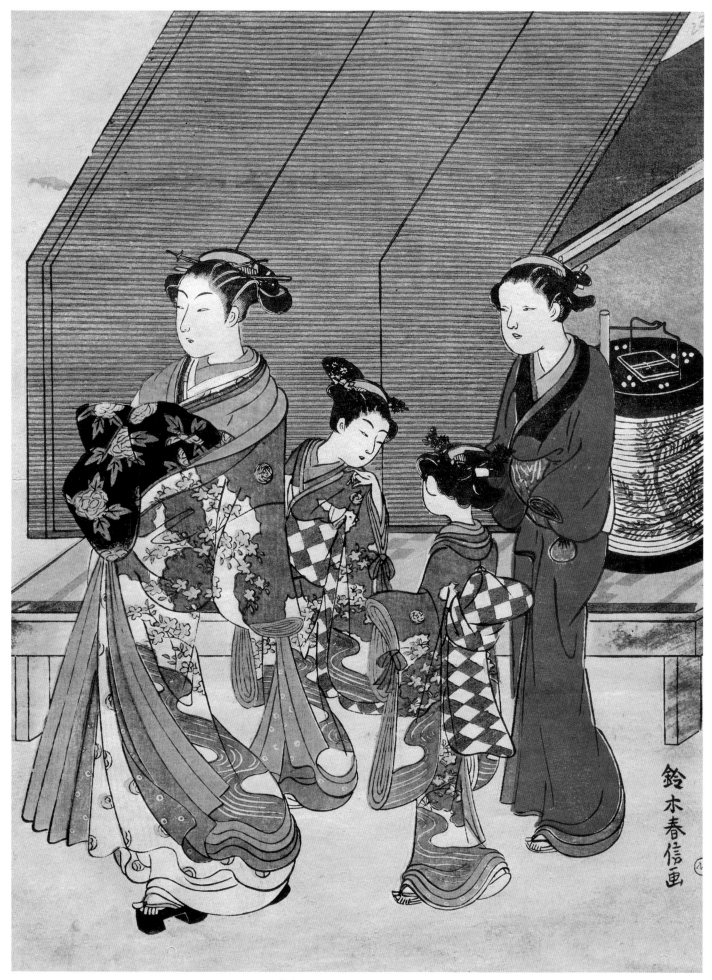

14 Harunobu: Parading Courtesan with Attendants. *Chūban* size, late 1760s.

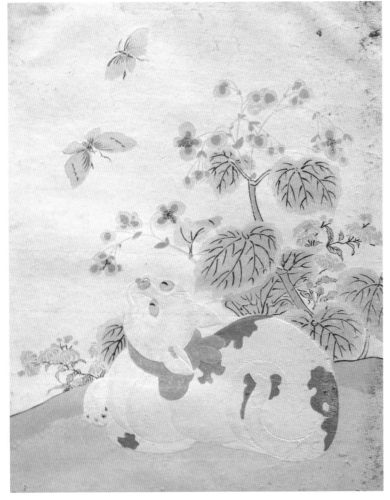

15 Style of Harunobu: A Cat Watching Butterflies.

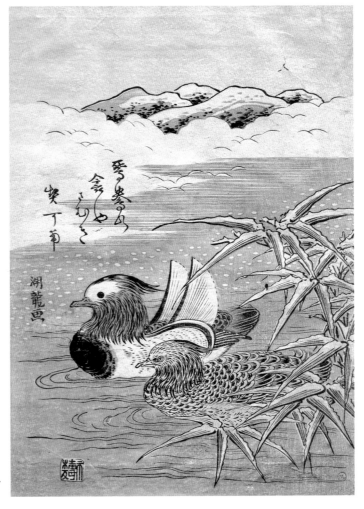

16 Koryūsai: Mandarin Ducks in Winter.
Chūban size, early 1770s.

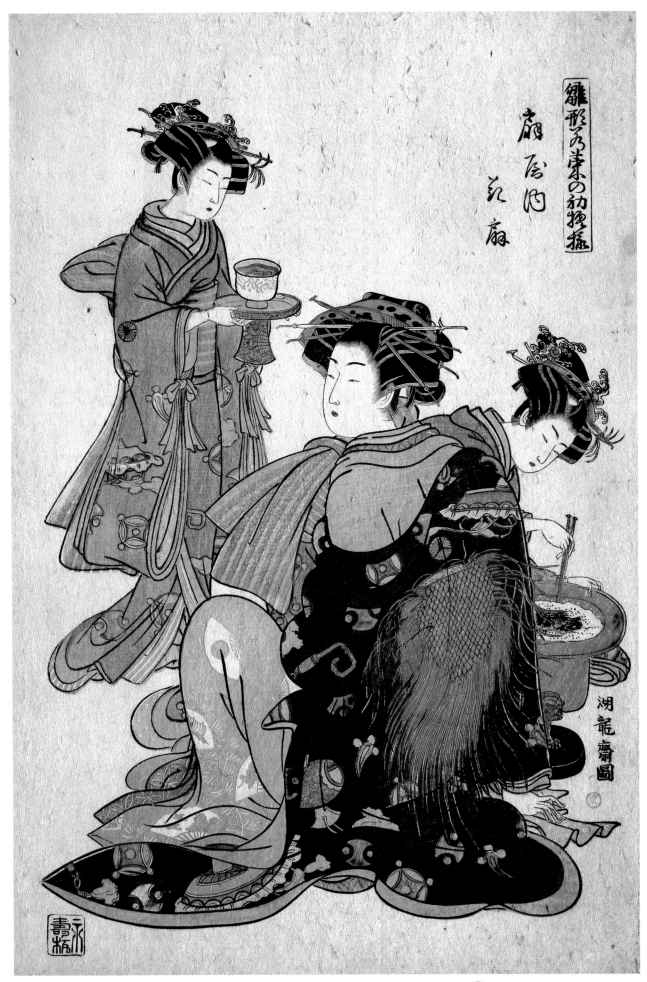

雛形若葉の初模様

扇屋内
花扇

湖龍齋圖

17 Koryūsai: The Courtesan Hanaōgi with Attendants, from the series *New Fashion Designs*. Ōban size, mid-1770s.

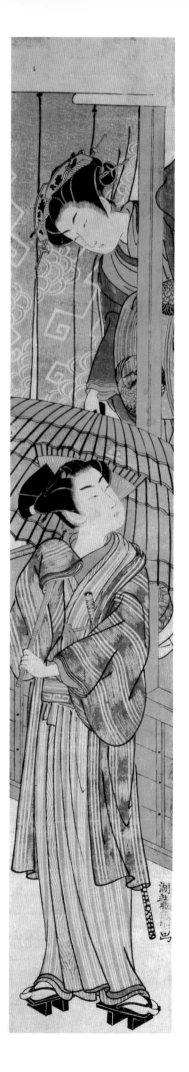

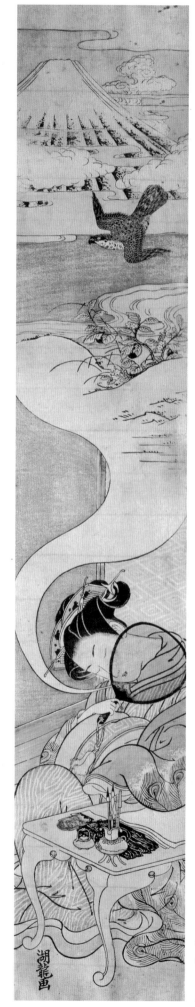

18 Koryūsai: Young Man Accosted by a Courtesan. Allusion print (*mitate-e*), *hashira-e* size, early 1770s.

19 Koryūsai: Beauty Dreaming of Good Luck. *Hashira-e* size, early 1770s.

20 Style of Shigemasa: Boys Carrying a Portable Shrine in the Gion Festival, *The Sixth Month*, from the series *Mimicry in the Twelve Months*. Chūban size, mid-1770s.

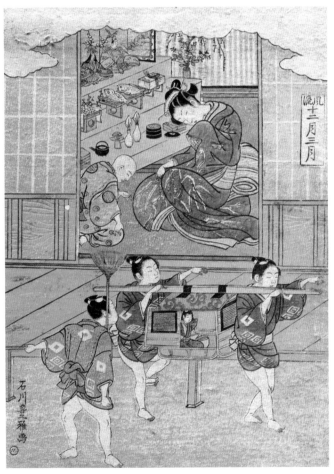

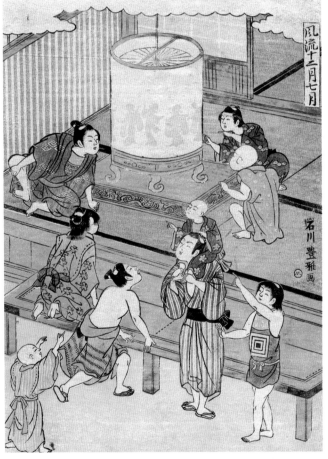

21 Toyomasa: The Doll Festival, *The Third Month*, from the series *The Twelve Months of the Year*. Chūban size, early to mid-1770s.

22 Toyomasa: The Spinning Lantern, *The Seventh Month*, from the same series as plate 21. Chūban size, early to mid-1770s.

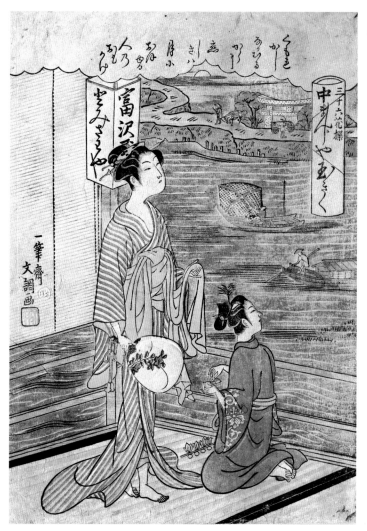

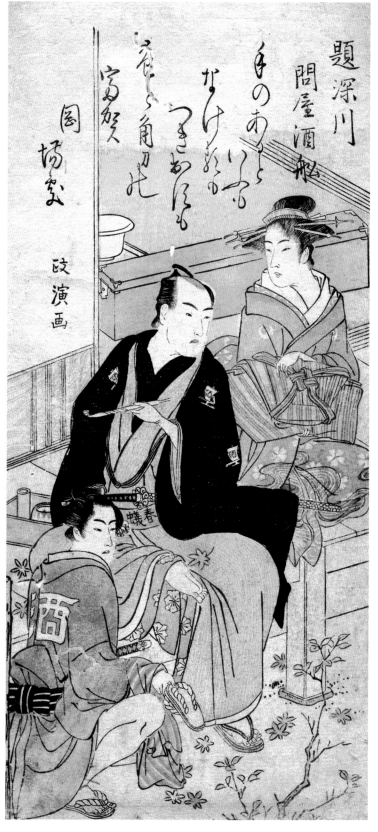

23 Bunchō: A Courtesan and Attendant by the Sumida River, from the series *The Thirty-Six Poets.* Allusion print (*mitate-e*), *chūban* size, ca. 1770.

24 Kitao Masanobu (Kyōden): The Poet Ton'ya no Sakefune Visiting the Pleasure District, from the series Portraits of *Kyōka* Poets. *Hosoban* size, mid to late 1780s.

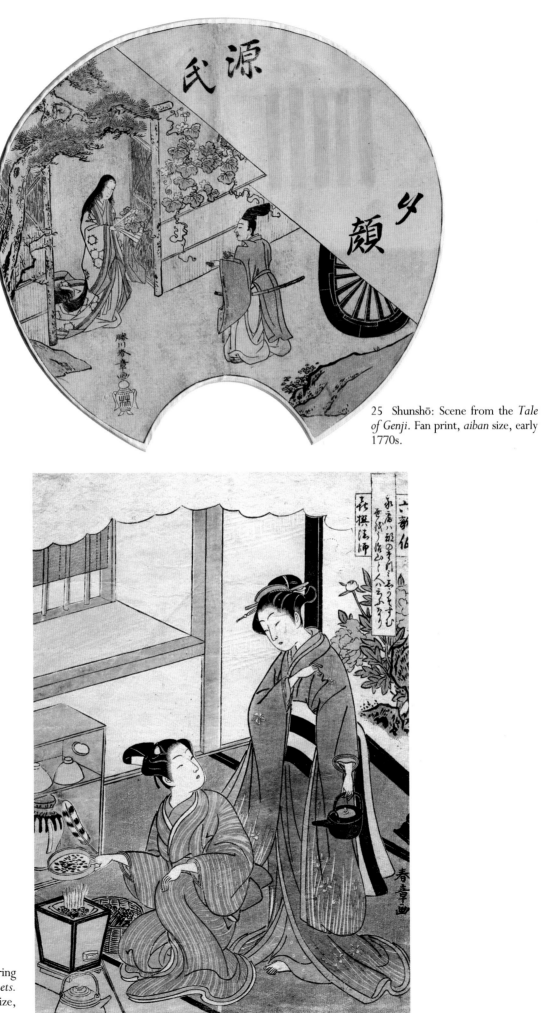

源
氏

夕
顔

勝川春章画

25 Shunshō: Scene from the *Tale of Genji*. Fan print, *aiban* size, early 1770s.

六歌仙

喜撰法師

春章画

26 Shunshō: Young Lovers Preparing Tea, from the series *The Six Poets*. Allusion print (*mitate-e*), *chūban* size, early 1770s.

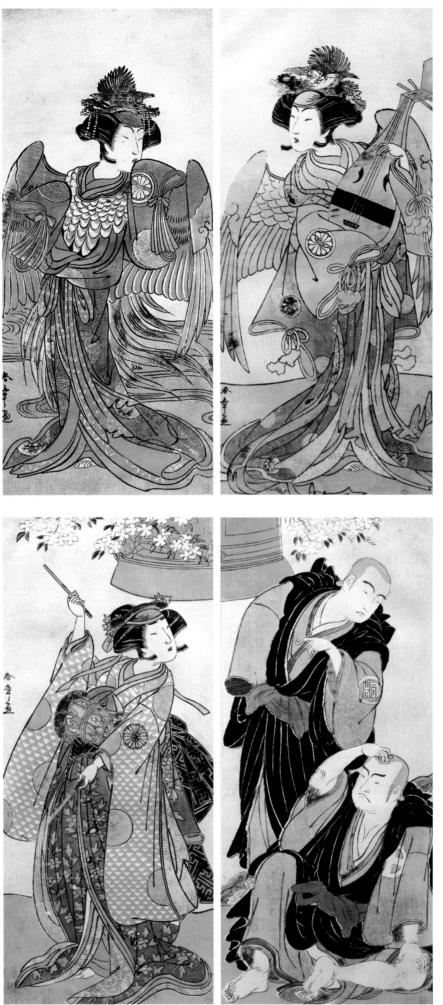

27–28 Shunshō: The Kabuki Actor Segawa Kikunojō III as a Mandarin Duck Spirit. *Hosoban* size, 1775.

29 Shunshō: Kabuki Scene with Yokobue and the Priests Saigyō and Mongaku. Diptych, two *hosoban*-size sheets, 1777.

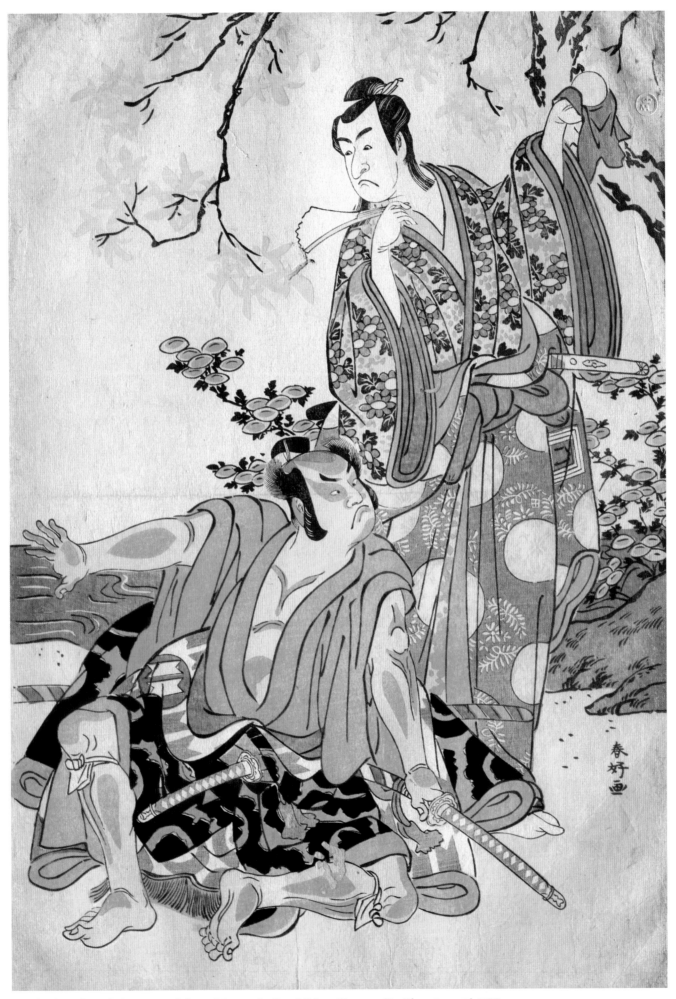

30 Shunkō: The Kabuki Actors Ichikawa Monnosuke II and Sakata Hangorō III. *Aiban* size, mid-1780s.

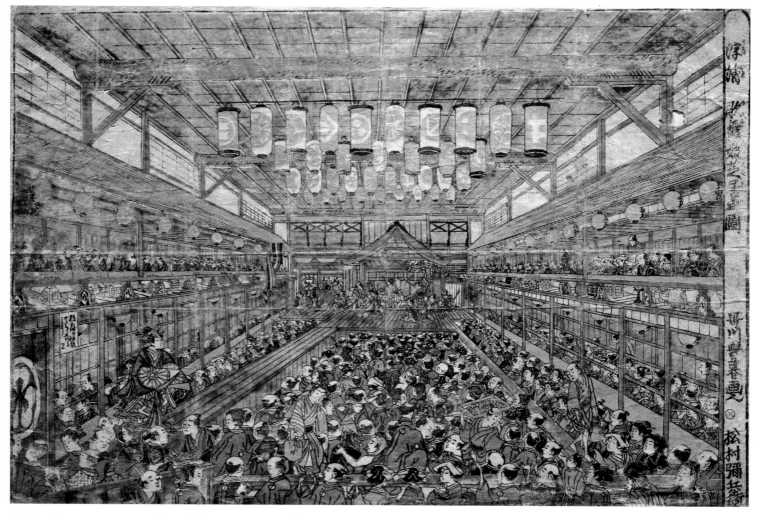

31 Toyoharu: Interior View of a Kabuki Theater in Edo. *Ōban* size, early 1770s.

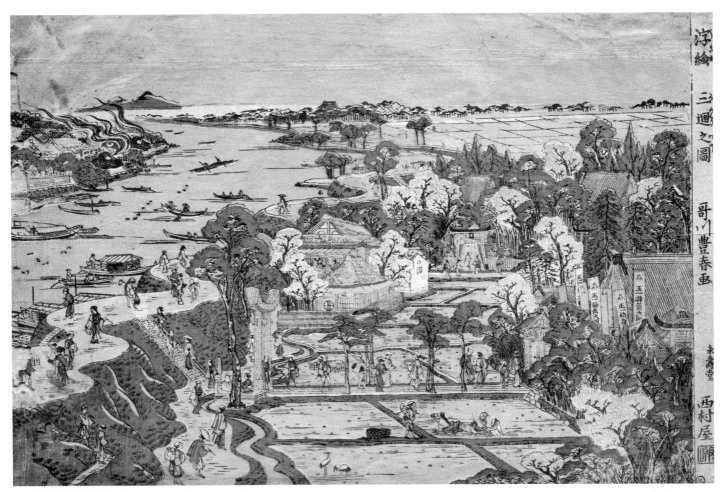

32 Toyoharu: View of Mimeguri. *Ōban* size, ca. 1780.

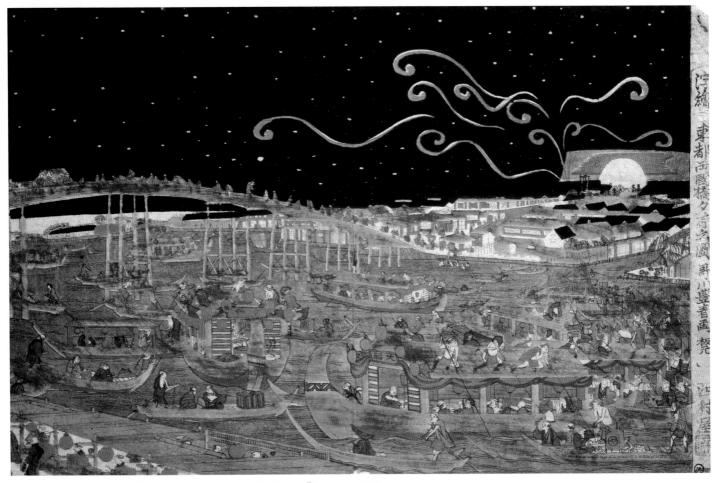

33 Toyoharu: Boating and Fireworks on the Sumida River. *Ōban* size, 1770s.

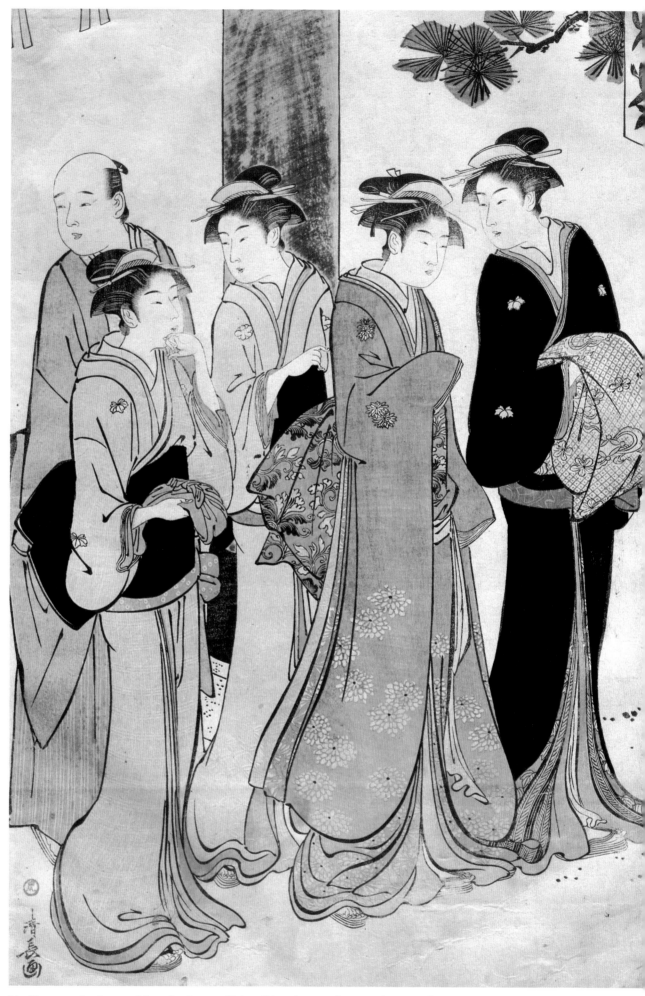

34 Kiyonaga: An Arranged Introduction at a Shrine. Diptych, two *ōban*-size sheets, mid-1780s.

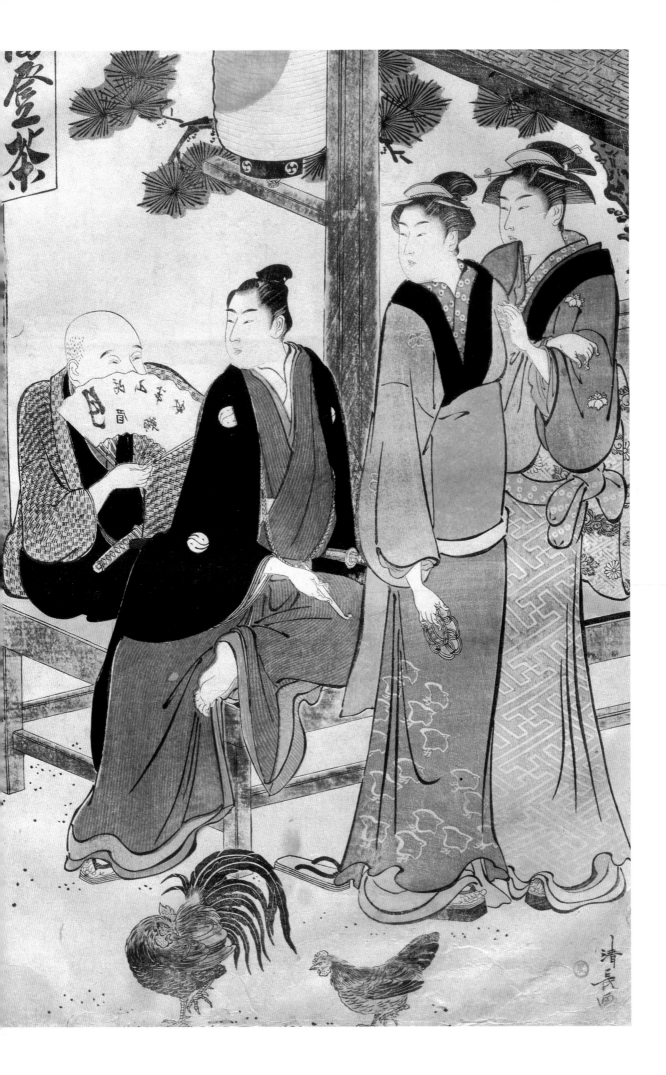

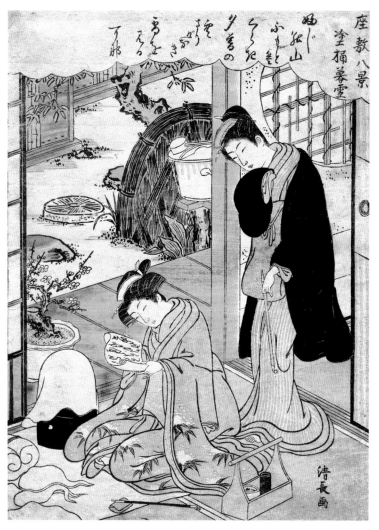

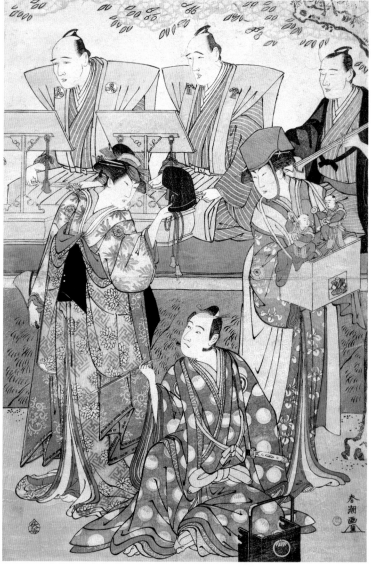

35 Kiyonaga: A Young Girl Reading a Letter as a Woman Looks On, from the series *Eight Famous Interior Scenes.* Allusion print (*mitate-e*) *chūban* size, mid-1770s.

36 Shunchō: The Kabuki Actors Hanshirō IV, Sōjūrō III, and Kikunojō III. *Ōban* size, 1789.

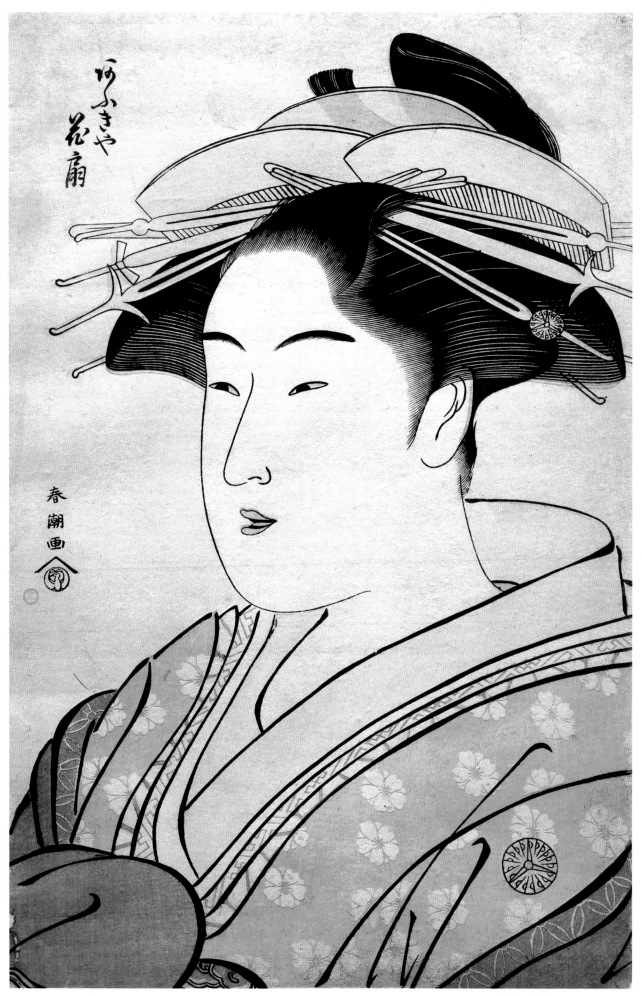

37 Shunchō: The Courtesan Hanaōgi. *Ōban* size, ca. 1790.

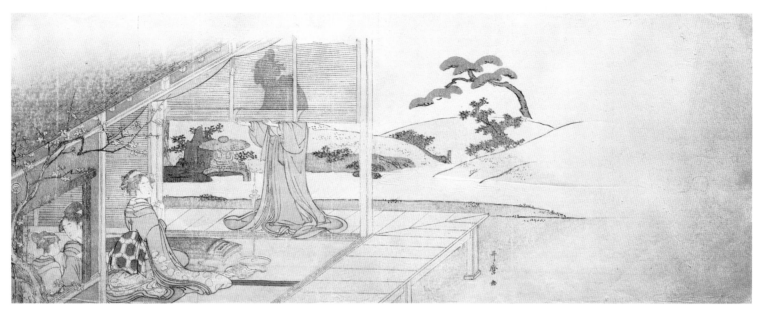

38 Utamaro: Rolling Up a Blind for Plum-Blossom Viewing. Privately commissioned woodblock color print (*surimono*), *nagaban* size, late 1790s.

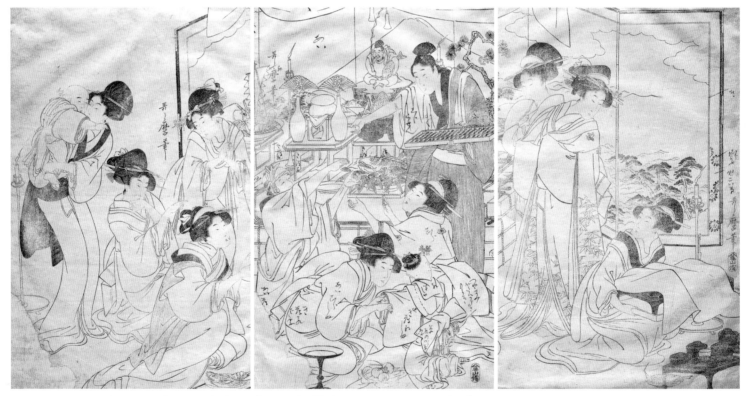

39 Utamaro: The Ebisu Festival. Triptych, three *ōban*-size keyblock impressions, or "proofs" (*kyōgōzuri*), 1790s.

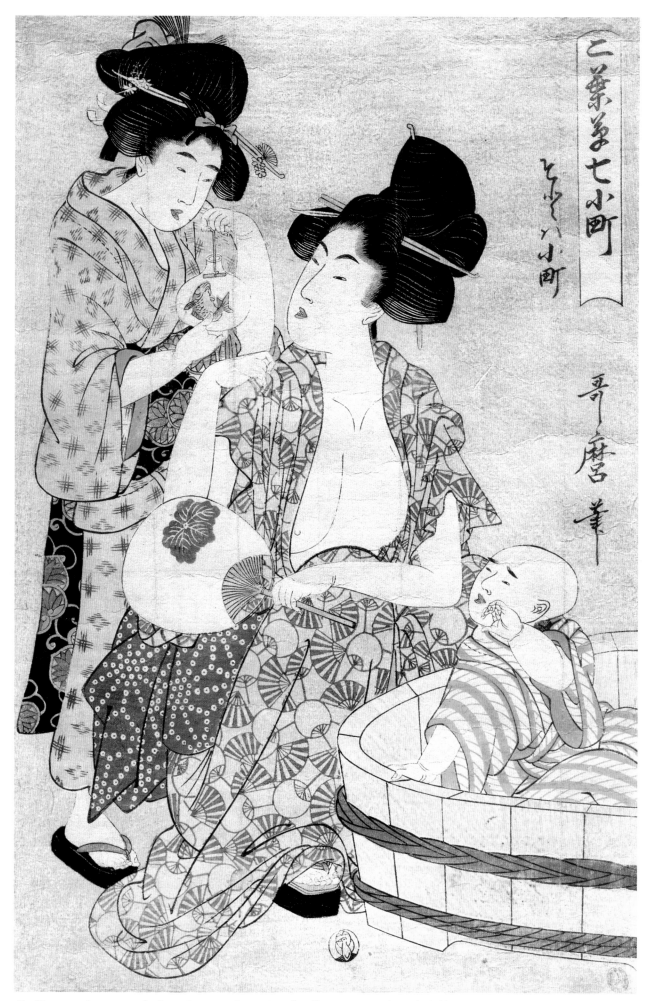

40 Utamaro: Summer Bath, from the series *Seven Episodes of Ono no Komachi and Children*.
Allusion print (*mitate-e*), *ōban* size, early 1800s.

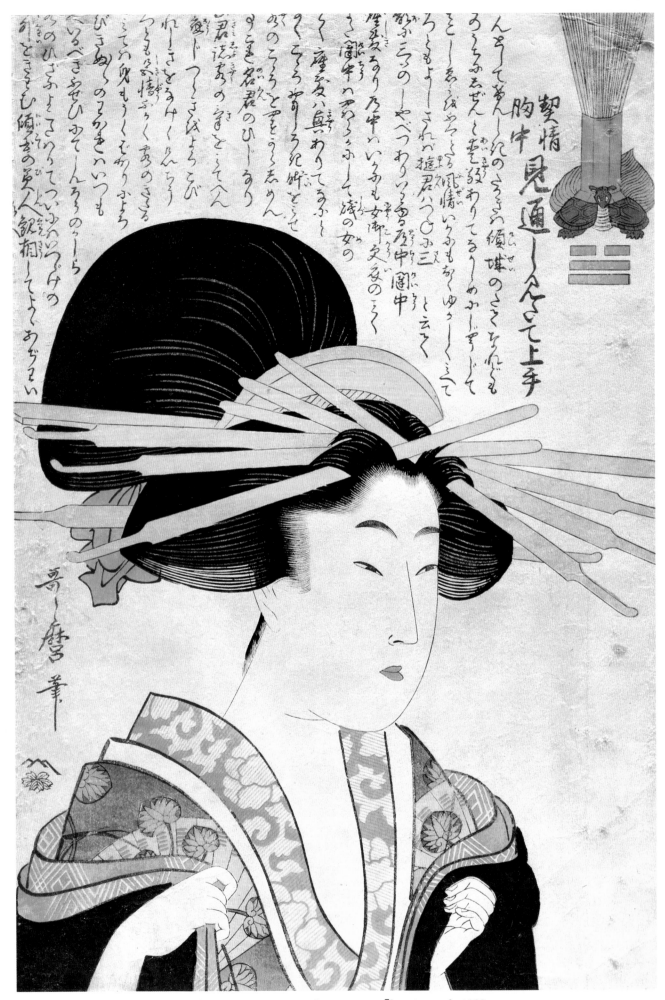

契情　胸中見通　さて上手

んうして美しく紀のさゝらの傾城の
ろうふもぜんと妻を發わりてるらしめふーどどて
とし我よーされざ
ろともよーされざ
くかうこのやべつわりつる
のうへ座女は鯨あつてるふ
て座女は鯨あつてるふ

41 Utamaro: The Prim Type, from the series Physiognomy of Courtesans. *Ōban* size, early 1800s.

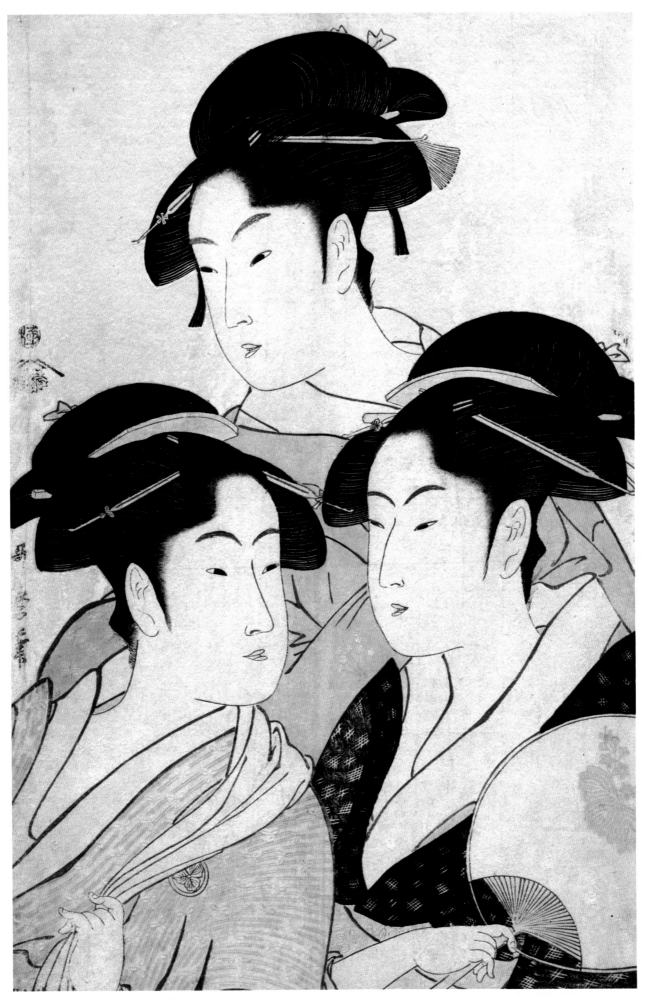

42 Utamaro: Three Beauties. *Ōban* size, mid-1790s.

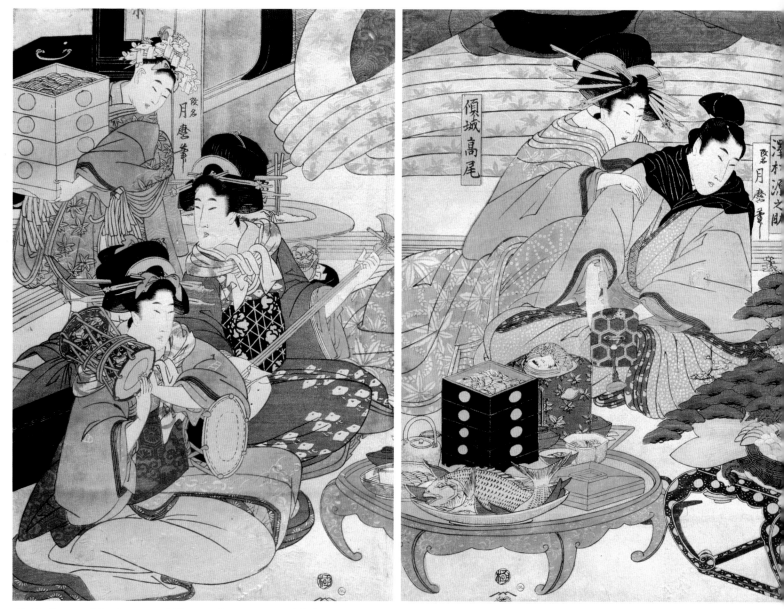

43　Tsukimaro: The Courtesan Takao Displaying New Bedclothes. Triptych, three *ōban*-size sheets, 1804.
AT RIGHT: Detail of the courtesan Takao.

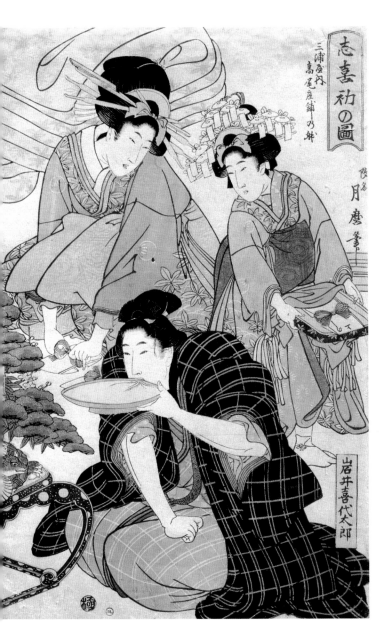

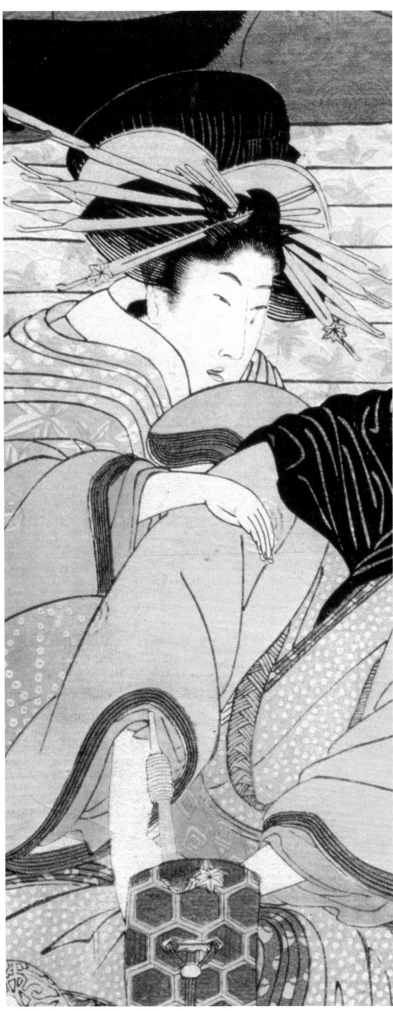

志喜初の圖

三浦屋内
高尾座舗の躰

仮名
月麿筆

山岸井喜代太郎

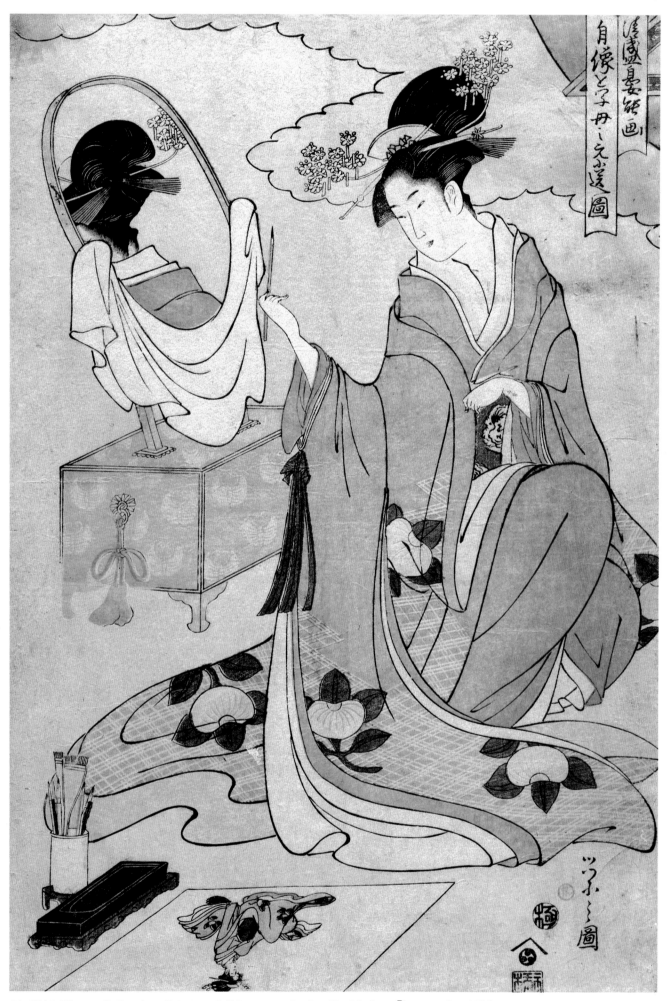

44 Eishi: Kiyomori's Daughter Painting a Self-Portrait to Send to Her Mother. *Ōban* size, late 1790s.

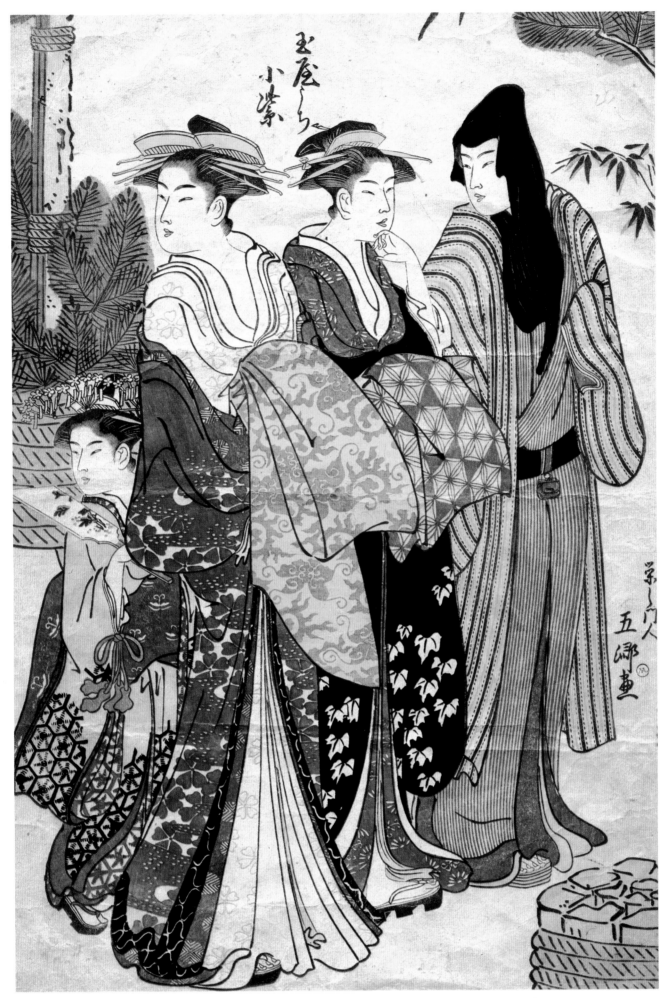

45 Gokyō: Courtesans on Promenade at New Year. One sheet of a triptych, *ōban* size, late 1780s.

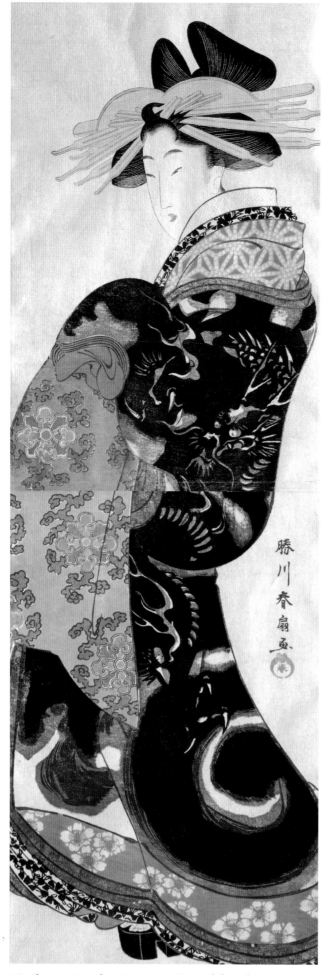

46 Shunsen: Parading Courtesan. Vertical diptych, two ōban-size sheets, ca. 1810.

47 Style of Eishō: In Front of a Toothbrush Shop. Hashira-e size, ca. 1800.

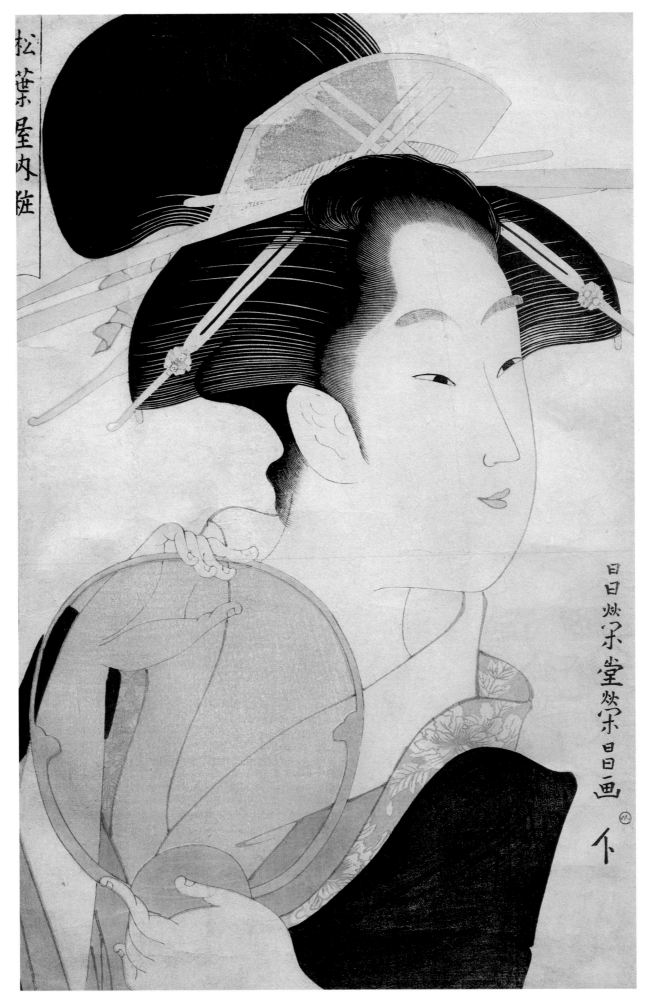

48 Eishō: The Courtesan Yosooi. *Ōban* size, late 1790s.

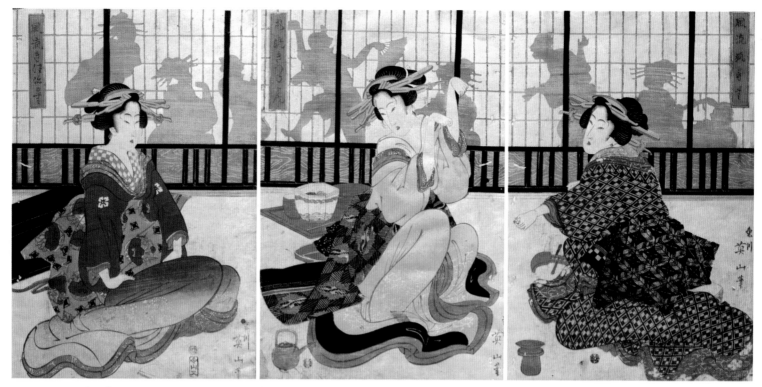

49 Eizan: Geisha Playing the Hand-Game *Kitsune-ken*. Triptych, three *ōban*-size sheets, ca. 1820.

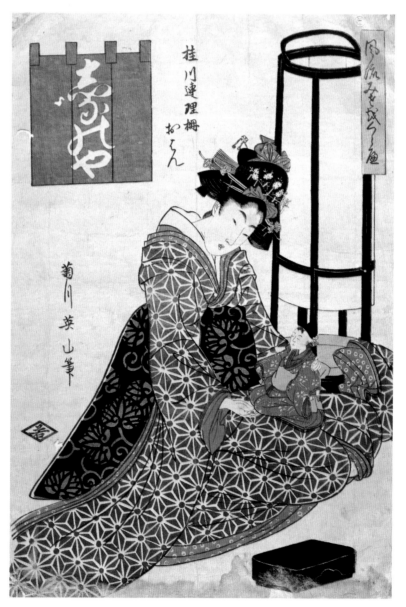

50 Eizan: The *Jōruri* Character Ohan with a Doll, from the series Heroines of Double-Suicide Stories. *Ōban* size, ca. 1810.

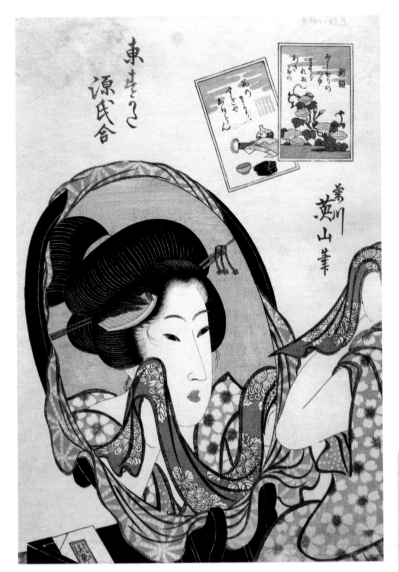

東をつ
源氏合

菊川
英山筆

51 Eizan: Woman at a Mirror, from the series Edo Beauties.
Ōban size, ca. 1820.

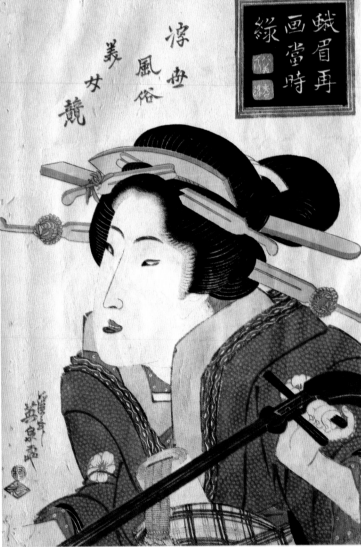

52 Eisen: Geisha with *Samisen*, from the series *Beauties of the
Floating World*. *Ōban* size, early 1820s.

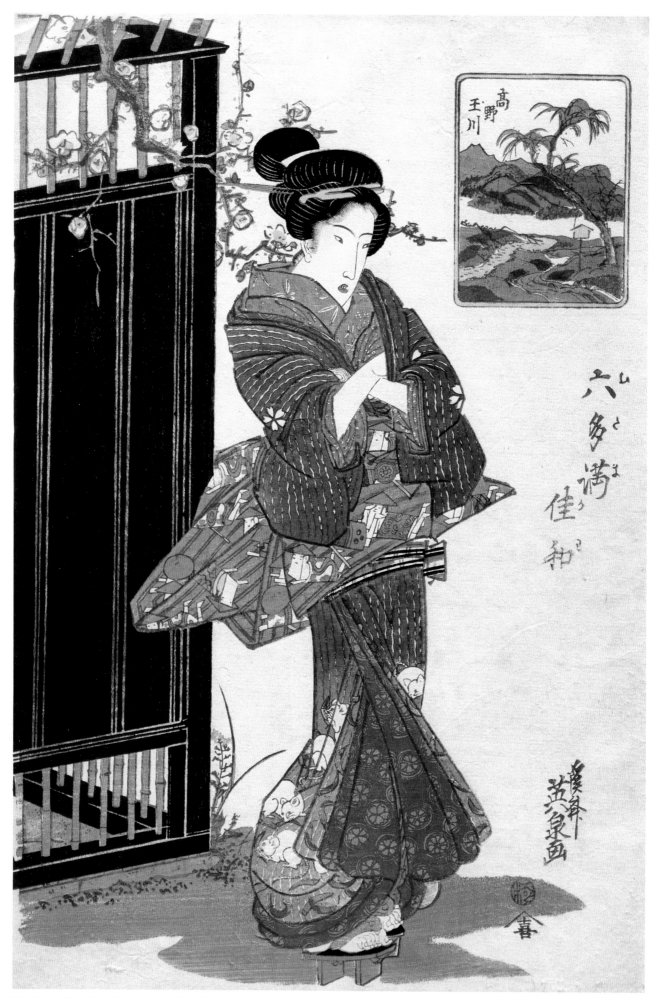

53 Eisen: *The Kōya-Tama River*, from the series *Six Famous Rivers with the Name Tama*. *Ōban* size, early 1820s.

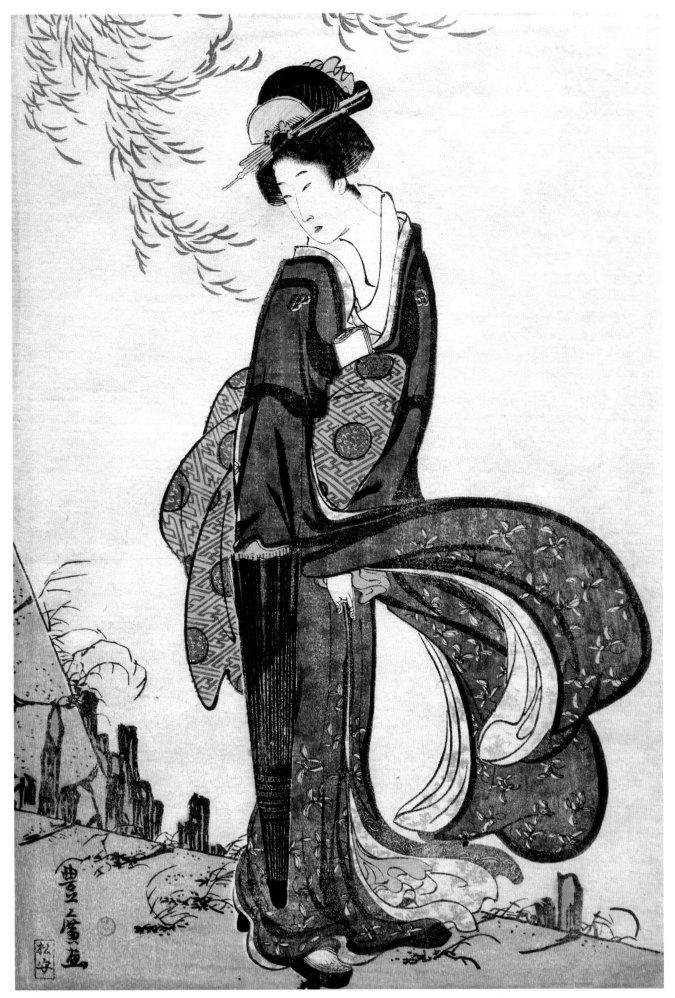

54 Toyohiro: Geisha Standing in the Wind. *Aiban* size, ca. 1805.

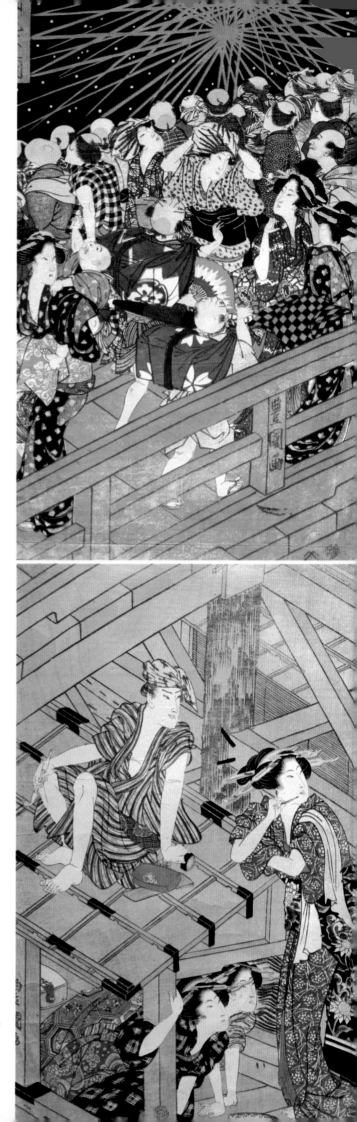

55 Toyokuni: Fireworks at Ryōgoku Bridge. Double triptych, six *ōban*-size
sheets, mid-1820s.

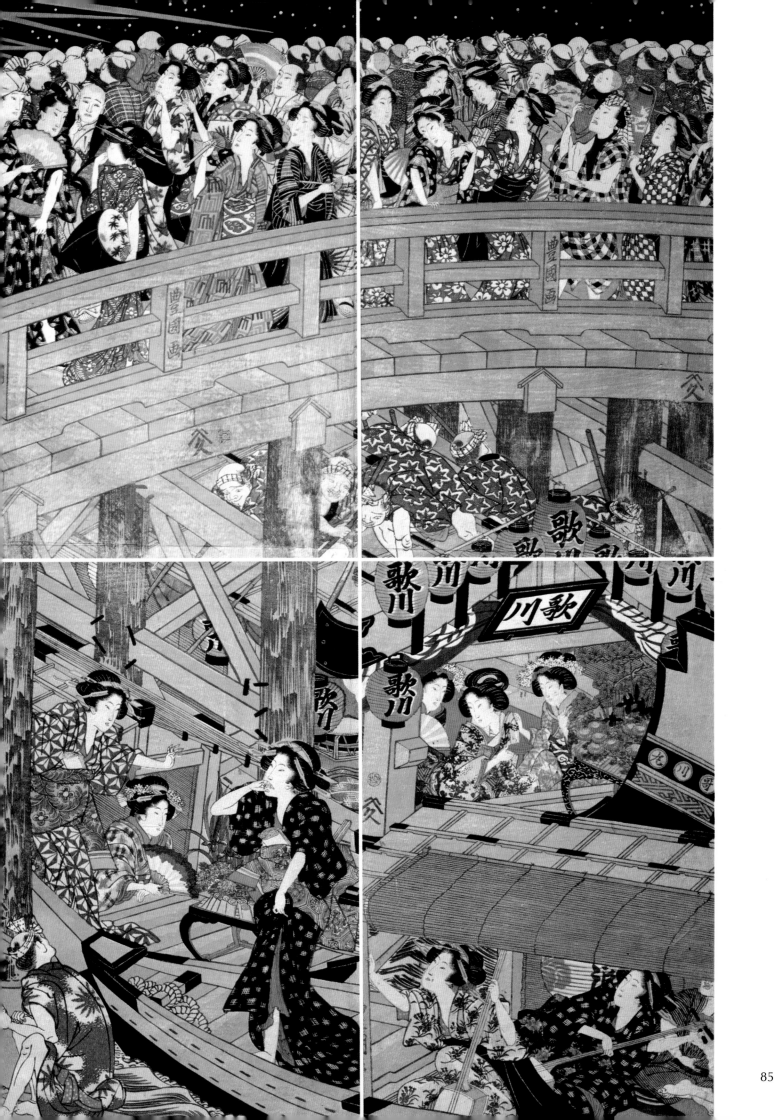

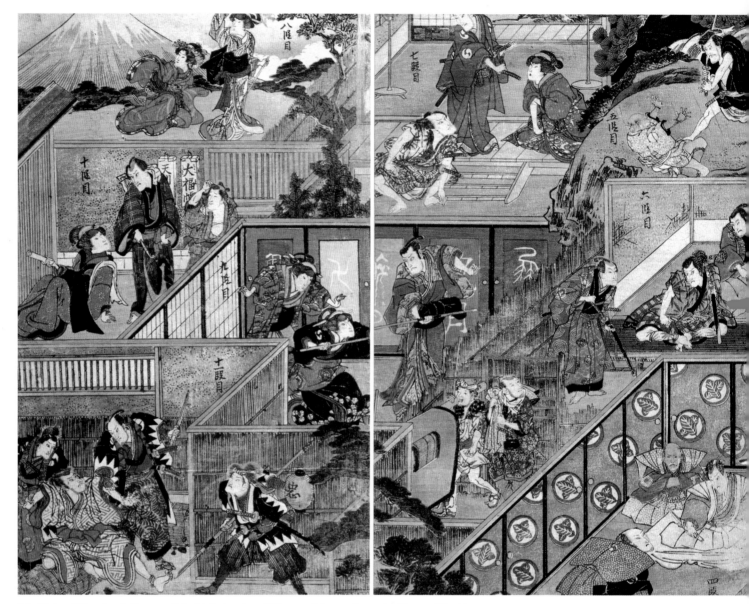

56 Style of Toyokuni: Famous Kabuki Actors in a Mélange of Scenes from the Drama *Chūshingura*.
Triptych, three *ōban*-size sheets, mid-1810s.

57 Toyokuni: The Kabuki Actor Onoe
Matsusuke I. *Ōban* size, ca. 1799.

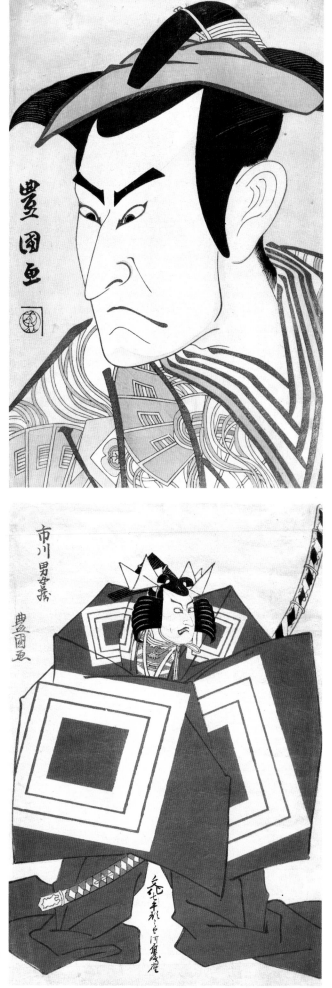

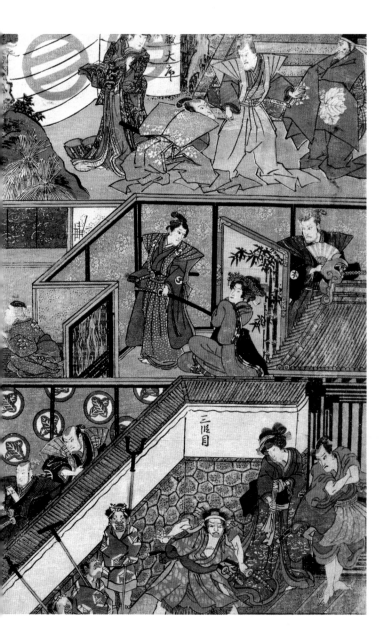

58 Toyokuni: The Kabuki Actor Ichikawa
Omezō I in the Drama *Shibaraku*. *Ōban*
size, ca. 1810.

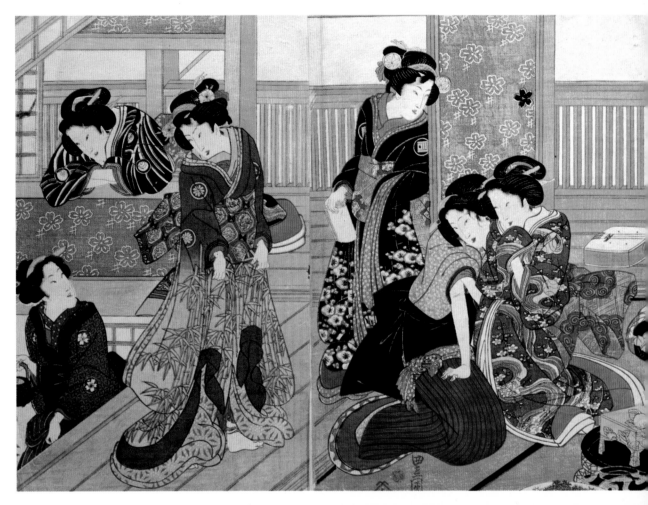

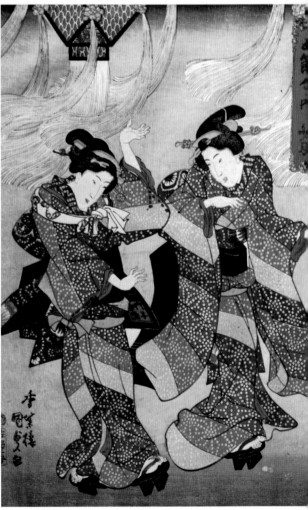

60 Kunisada: Girls Dancing, *The Seventh Month,* from the series *The Five Festivals.* Ōban size, 1830s.

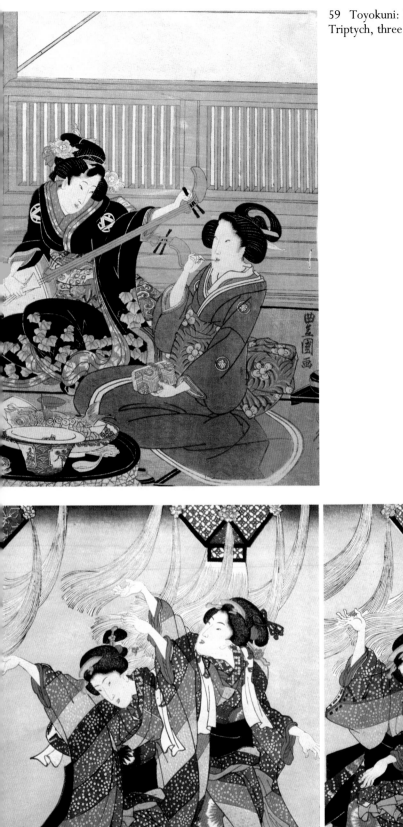

59 Toyokuni: Ladies-in-waiting with Male Entertainers in Female Attire. Triptych, three ōban-size sheets, ca. 1825.

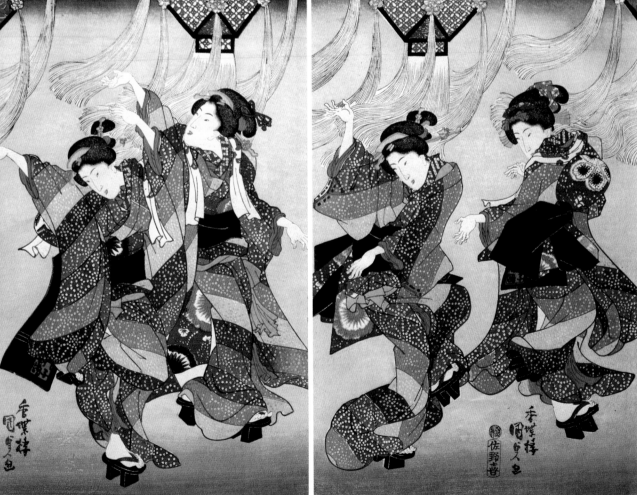

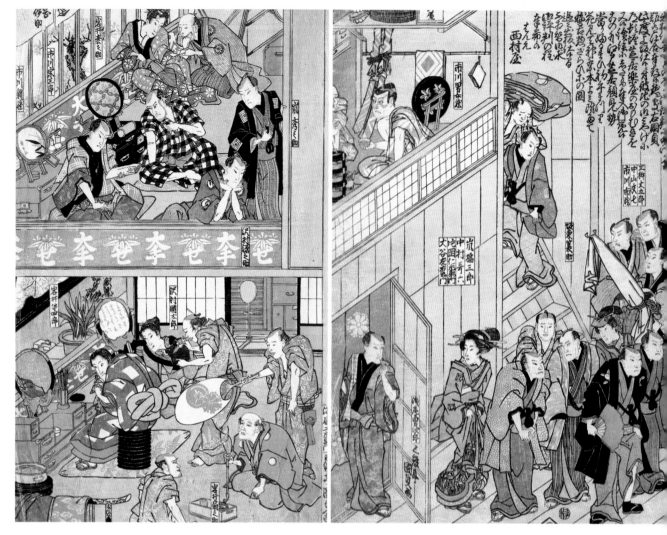

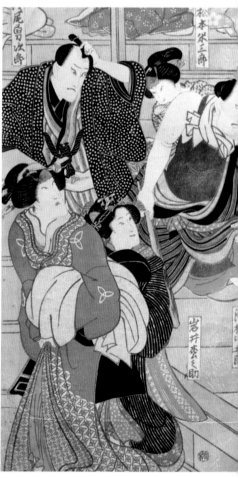

62 Kunisada: A Kabuki Scene of Women at a Bathhouse.
Triptych, three *ōban*-size sheets, 1815.

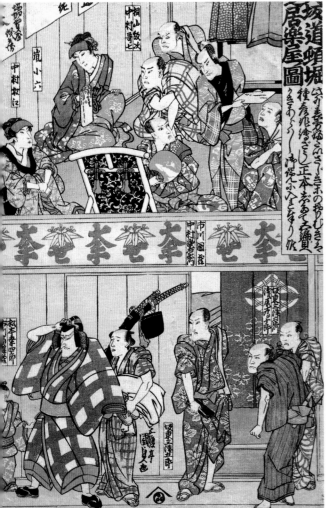

61 Kunisada: Backstage View of Kabuki Theater in Osaka.
Triptych, three *ōban*-size sheets, early 1820s.

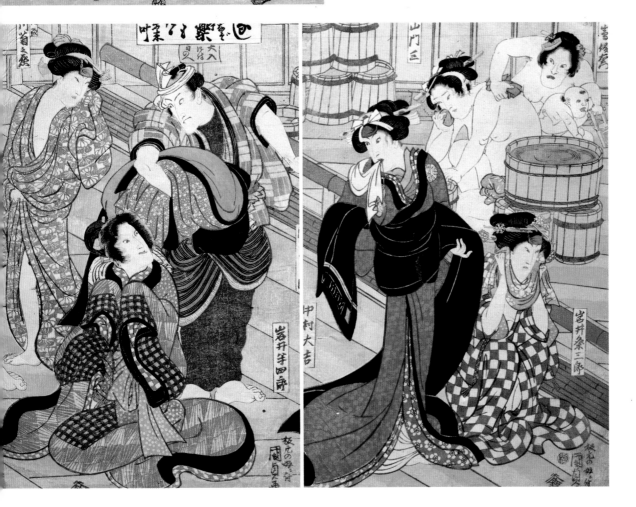

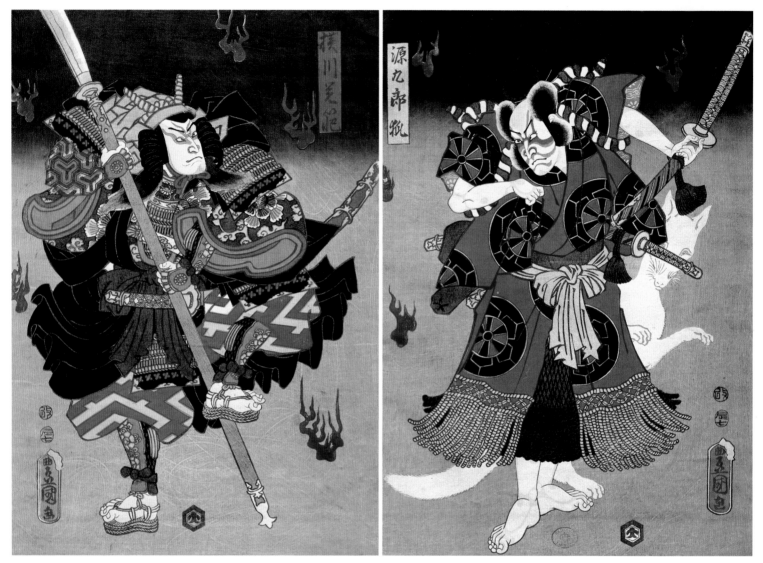

63 Kunisada: The Kabuki Actors Ichikawa Kodanji IV and Bandō Kamezō. Diptych, two *ōban*-size sheets, 1856.

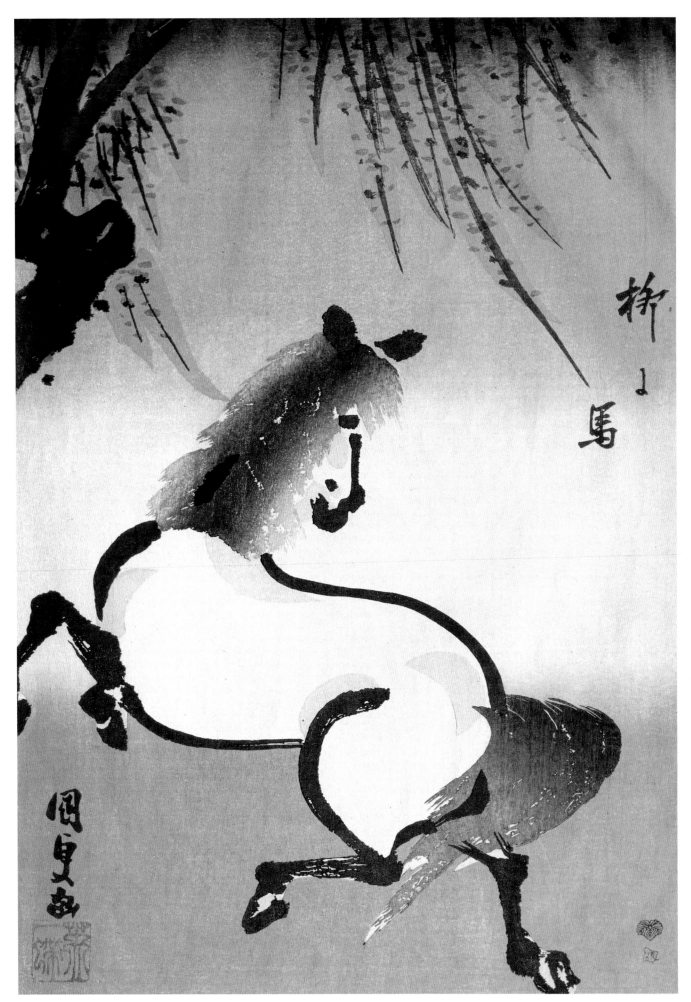

柳に馬

64 Kunisada: A Horse under a Willow. *Ōban* size, 1830s.

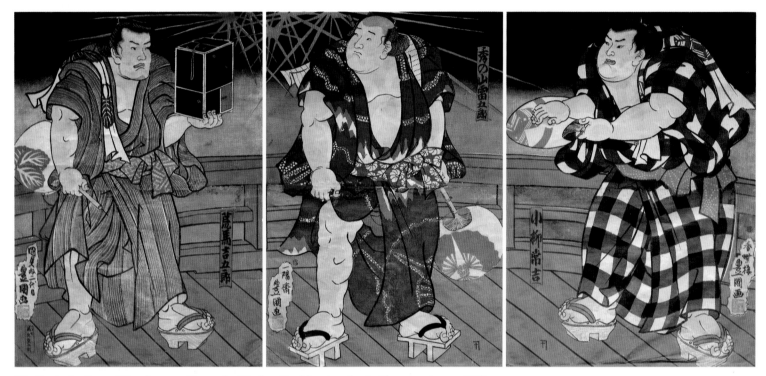

65 Kunisada: Sumo Wrestlers at a Fireworks Display. Double triptych, six ōban-size sheets, 1845.
AT RIGHT: Detail of the sumo wrestler Koyanagi Tsunekichi.

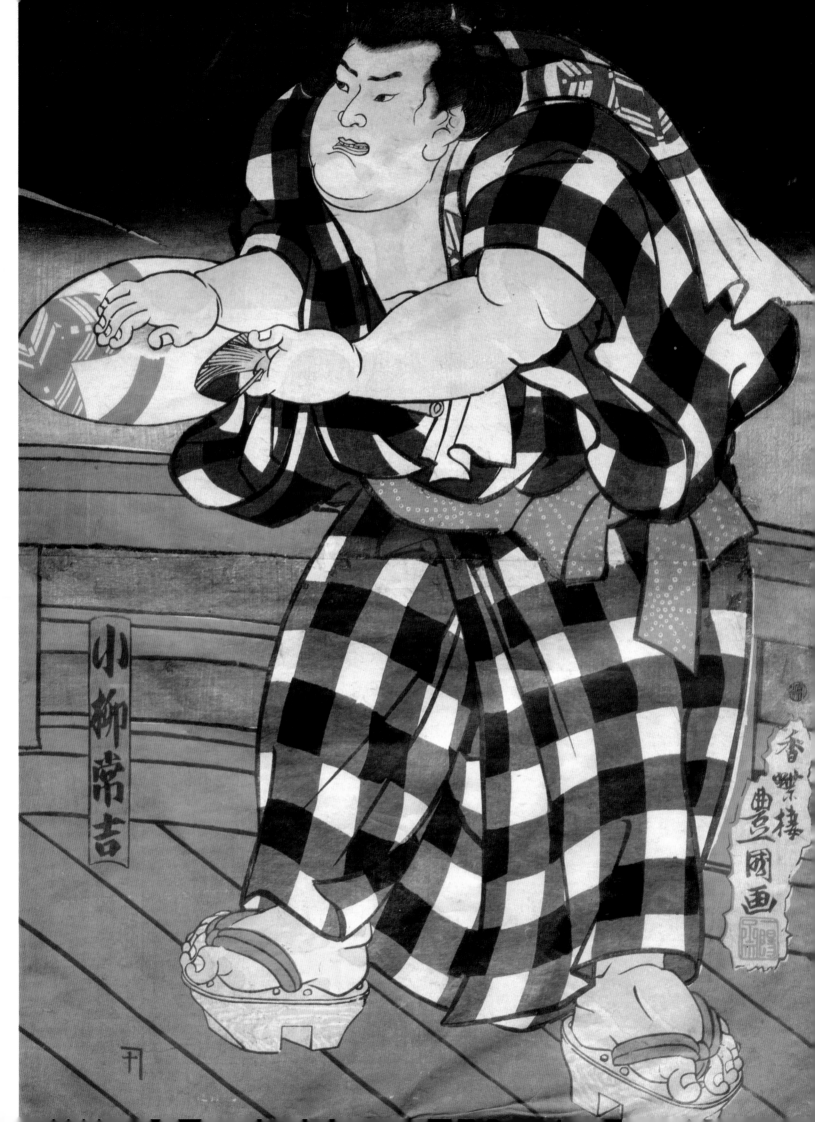

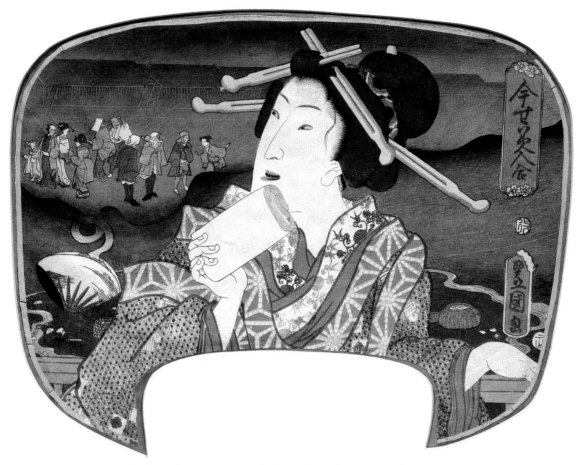

66 Kunisada: Courtesan and Mirage, from the series *Modern Beauties*.
Fan print, *aiban* size, early 1850s.

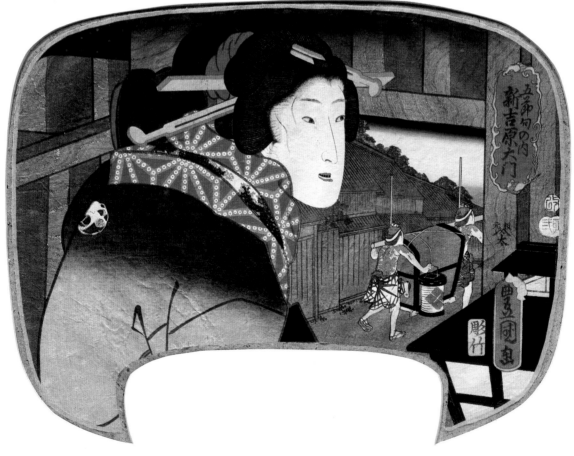

67 Kunisada: Courtesan at Ōmon, the Entrance Gate to Yoshiwara,
from the series *The Five Seasonal Festivals*. Fan print, *aiban* size, 1855.

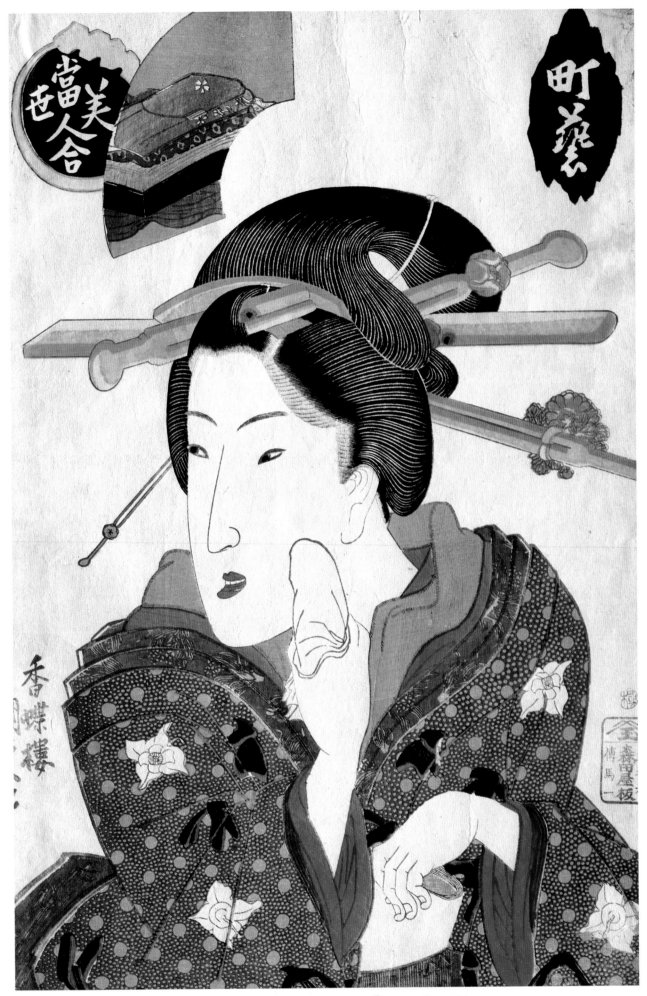

68　Kunisada: Geisha Wiping Her Face, from the series *Modern Beauties*. *Ōban* size, late 1820s.

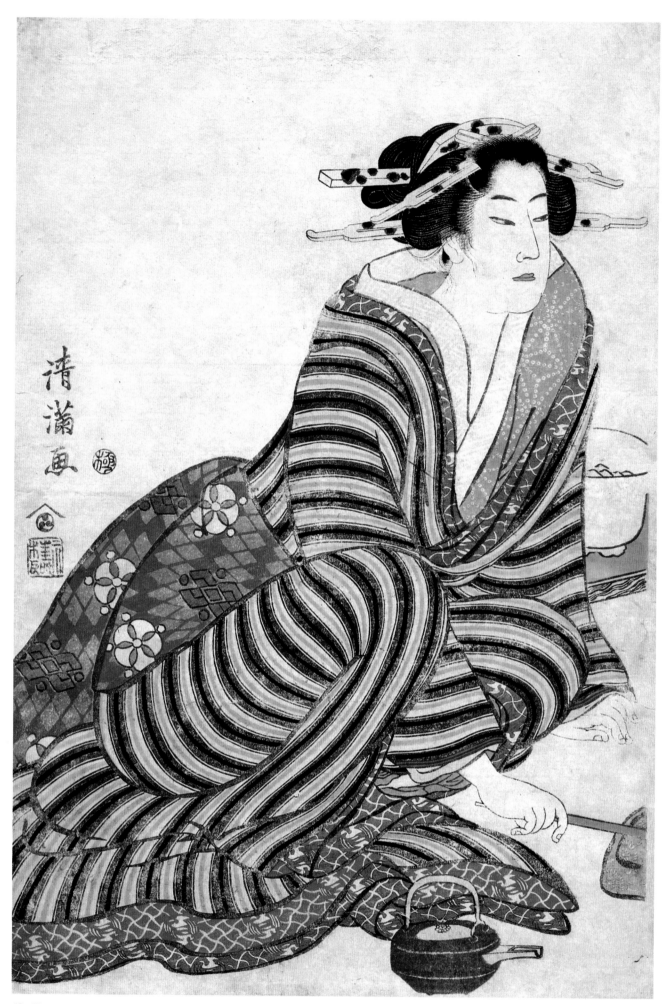

69 Kiyomitsu II (Kiyomine): The Angry Drinker. Left-hand sheet of a triptych, *ōban* size, late 1810s.

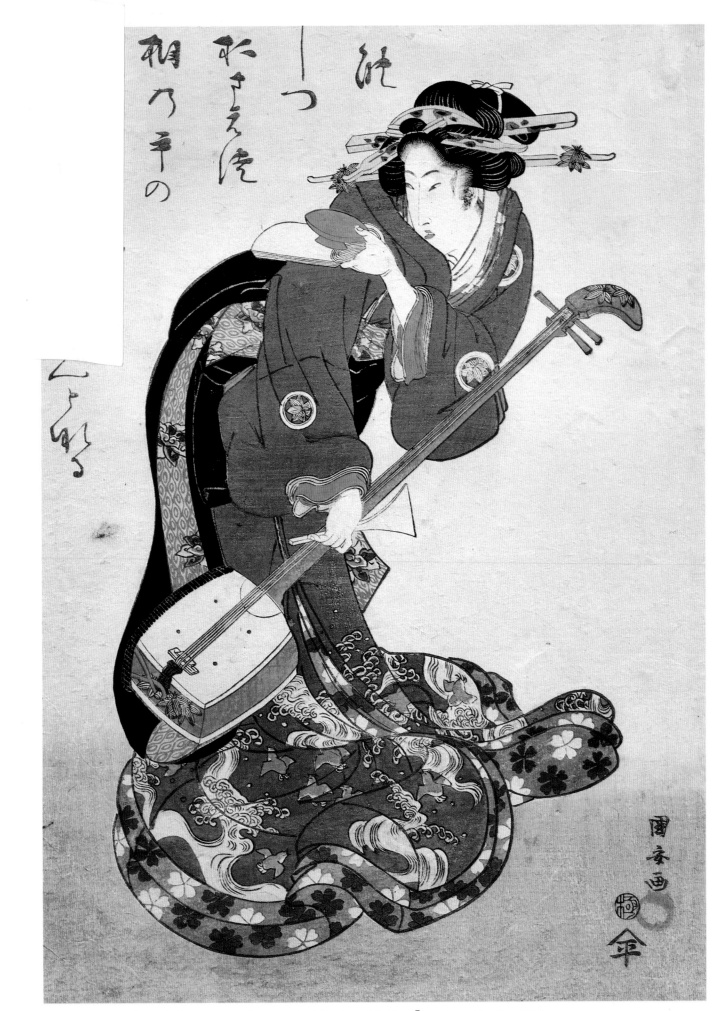

70 Kuniyasu: Geisha with *Samisen*, from the series A Collection of Geisha. *Ōban* size, mid to late 1810s.

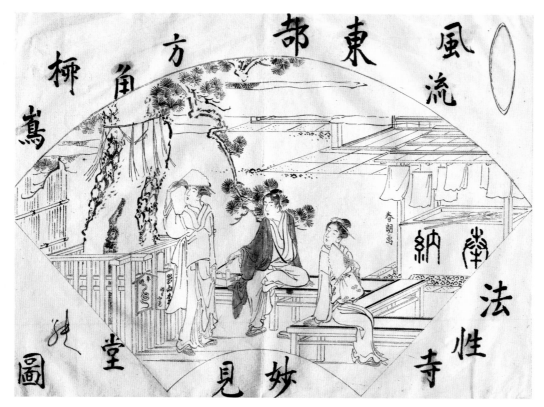

71 Hokusai: The Hōshōji Temple at Yanagishima, from the series *Fashionable Places in Edo*. Original drawing (*hanshita-e*), *chūban* size, mid-1780s.

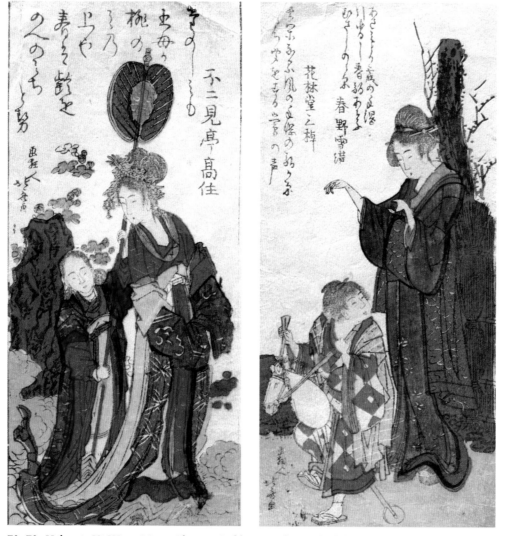

72–73 Hokusai: Xi Wang Mu, a Chinese Goddess; Mother and Child Playing with a Toy Horse. Privately commissioned woodblock color prints (*surimono*), *koban* size, early 1800s.

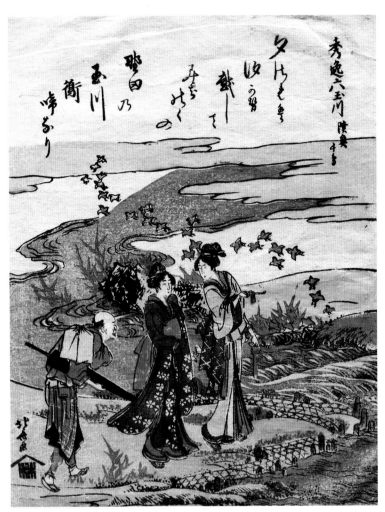

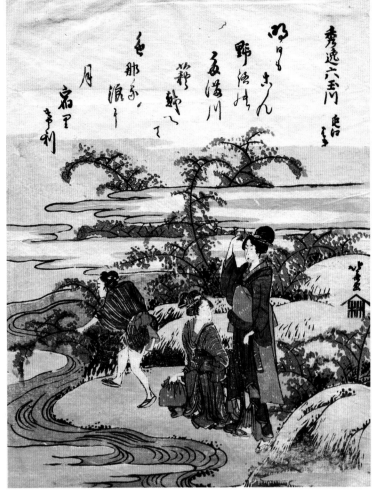

74 Hokusai: The Chidori-Tama River, from the series *Six Famous Rivers with the Name Tama*. *Chūban* size, ca. 1803.

75 Hokusai: The Hagi-Tama River, from the same series as plate 74. *Chūban* size, ca. 1803.

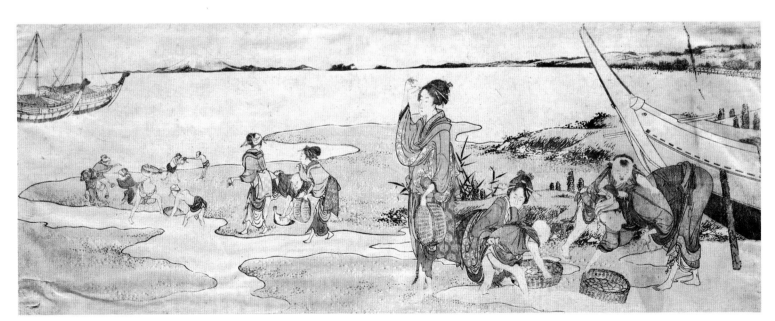

76 Hokusai: Shellfish Gathering. Privately commissioned woodblock color print (*surimono*), *nagaban* size, ca. 1800.

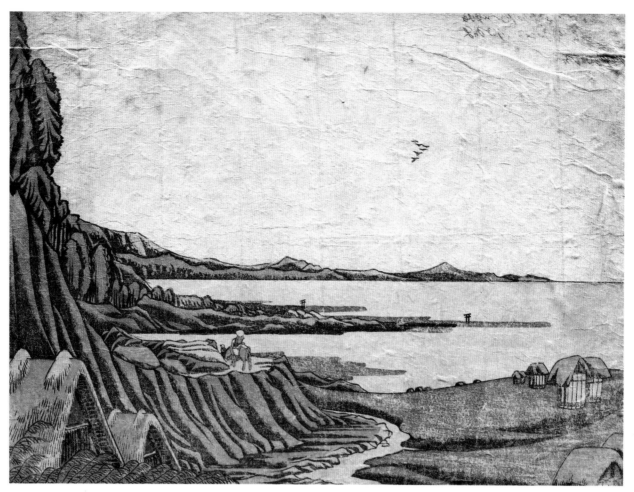

77 Hokusai: View at Gyōtoku. *Chūban* size, ca. 1805.

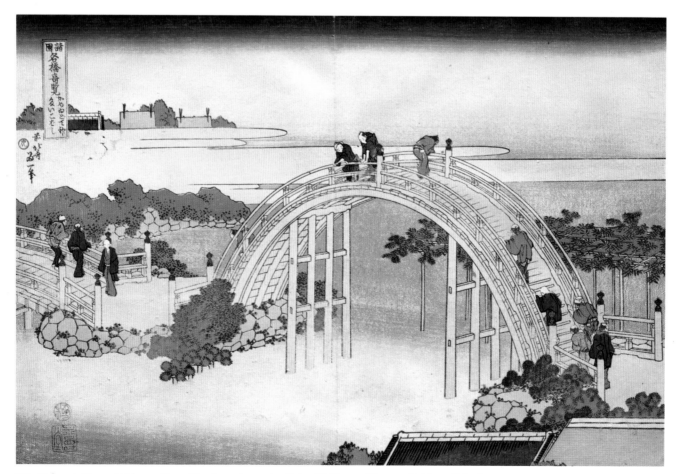

78 Hokusai: Drum Bridge at Kameido, from the series *Splendid Views of Famous Bridges of the Provinces.*
Ōban size, ca. 1834.

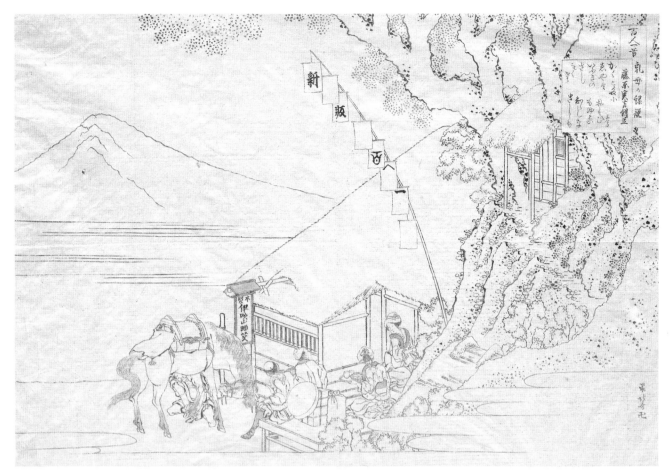

79 Hokusai: Mountain Teashop, from the series *Hundred Poems by One Hundred Poets as Explained by a Wet Nurse*. Original drawing (*hanshita-e*), *ōban* size, mid-1830s.

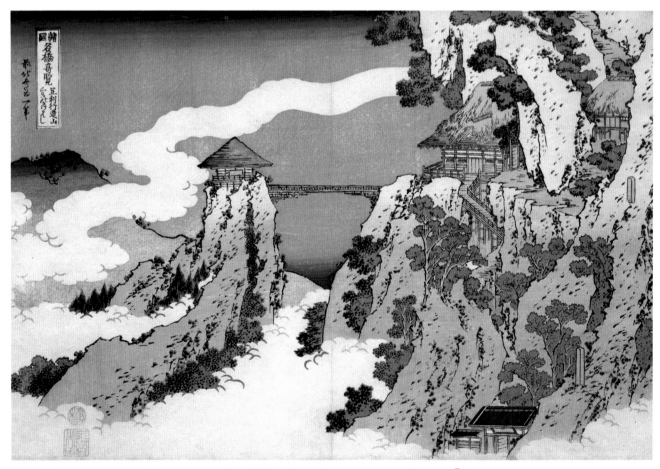

80 Hokusai: Suspension Bridge at Mt. Gyōdō, Ashikaga, from the same series as plate 78. *Ōban* size, ca. 1834.

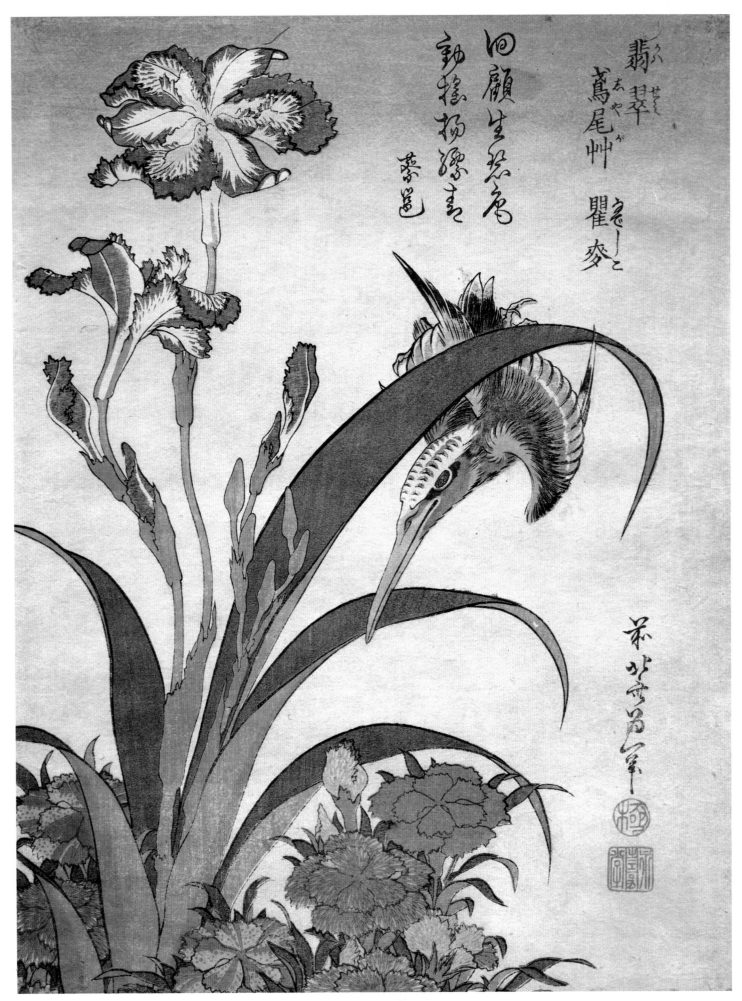

翡翠
鳶尾艸 瞿麥

回顧生慈尾
勤揺揚縣書
紫邨

81 Hokusai: Kingfisher with Irises and Wild Pinks. *Chūban* size, ca. 1834.

104

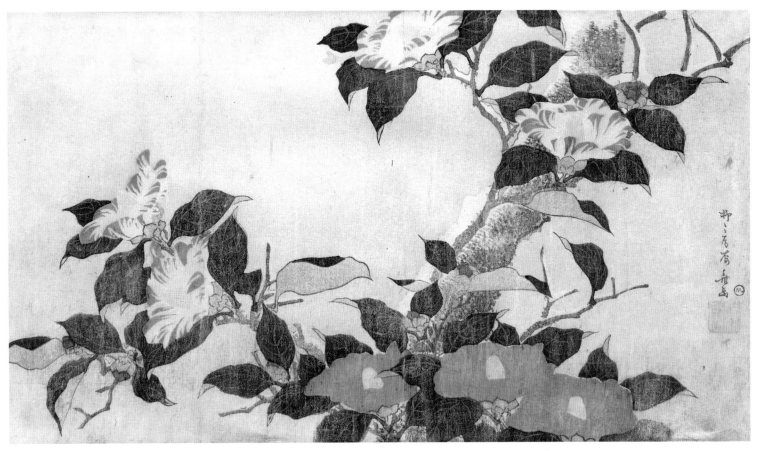

82 Shinsai: Camellias. Privately commissioned woodblock color print (*surimono*), *ōban* size, 1810s.

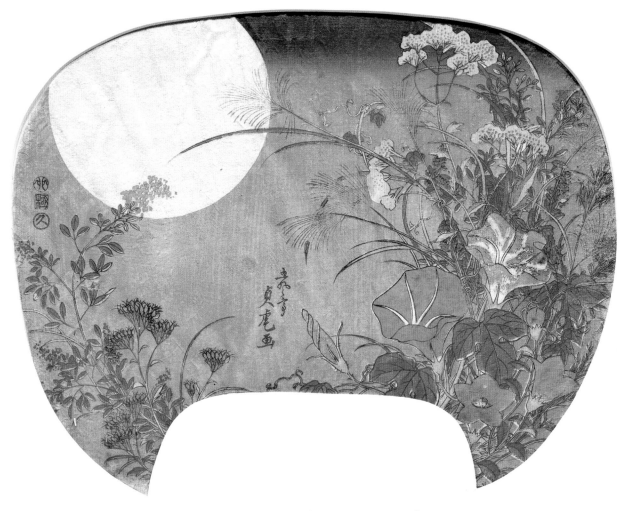

83 Sadatora: Autumn Flowers and Moon. Fan print, *aiban* size, 1831.

84 Hokkei: Dutch Ship Firing Guns off Nagasaki, from the series *Famous Views in the Provinces*. *Ō-tanzaku* size, mid-1830s.

85 Hokkei: Pilgrims on Mt. Tateyama, Etchū Province, from the same series as plate 84. *Ō-tanzaku* size, early 1830s.

86 Hokuju: View of Awaji Island. *Ōban* size, late 1820s.

87 Shuntei: View at Fukagawa Riverside in Edo. *Ōban* size, ca. 1820.

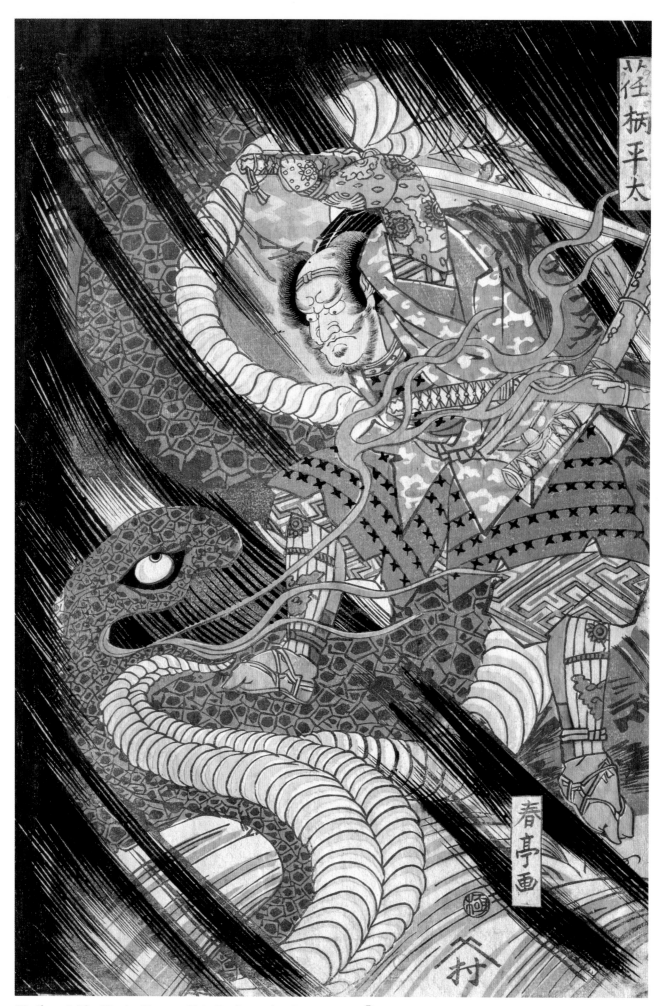

88 Shuntei: The Warrior Egara no Heita Battling with a Giant Serpent. *Ōban* size, ca. 1820.

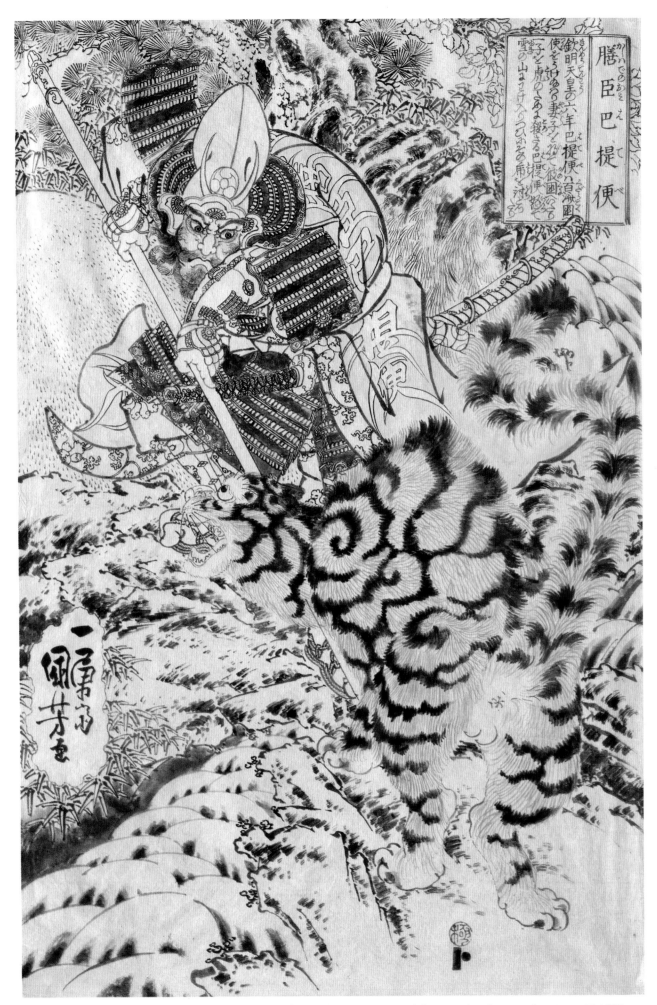

Kuniyoshi: The Warrior Kashiwade no Hatebe Battling with a Tiger. Original drawing (*hanshita-e*), *ōban* size, mid-1830s.

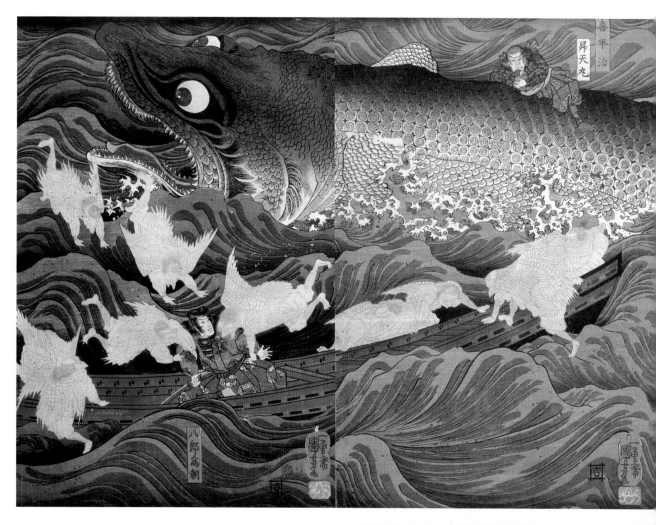

91 Kuniyoshi: Yoshihide Breaching the Main Gate at the Battle of Wada.
Triptych, three *ōban*-size sheets, 1852.

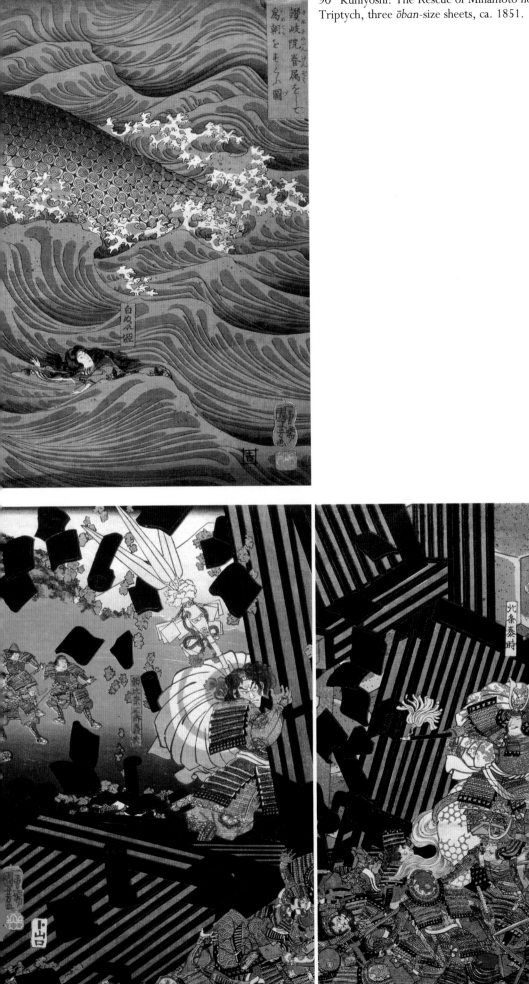

90 Kuniyoshi: The Rescue of Minamoto no Tametomo by Goblins. Triptych, three *ōban*-size sheets, ca. 1851.

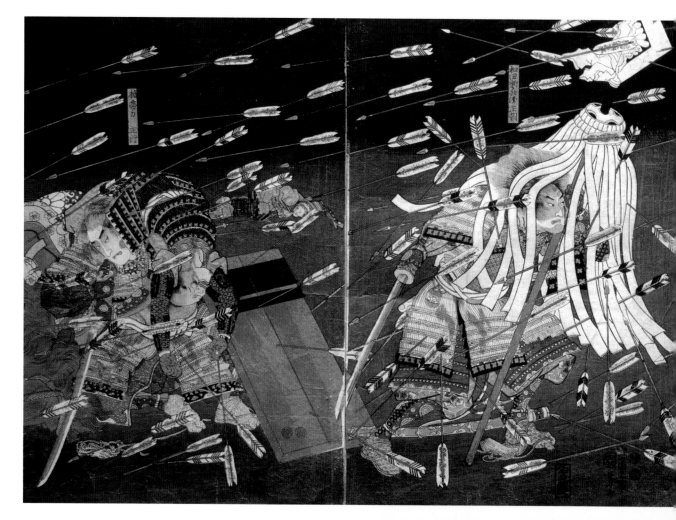

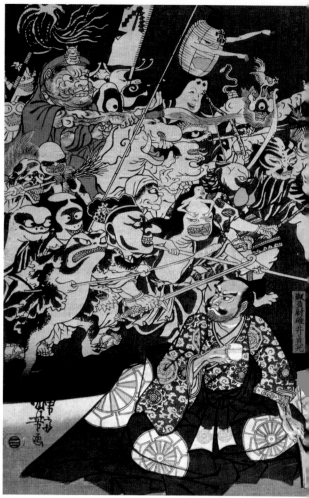

93 Kuniyoshi: The Spider Monster Creating Monsters in the Mansion of Minamoto no
Yorimitsu. Triptych, three *ōban*-size sheets, 1843.

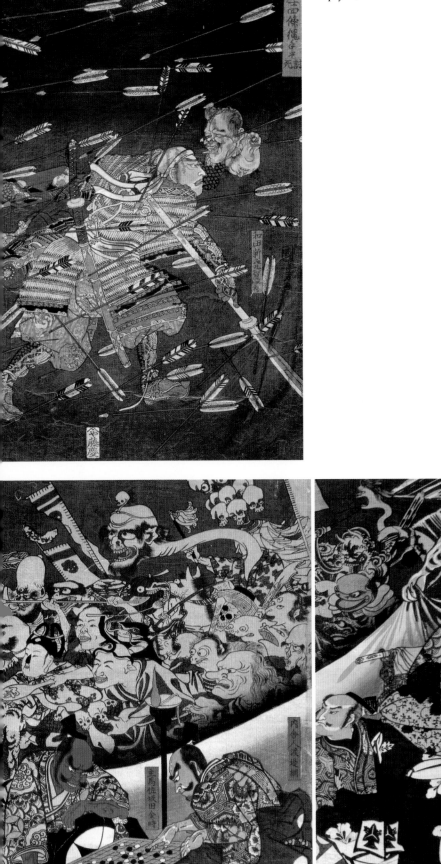

92 Kuniyoshi: The Defeat of the Kusunoki Warriors at the Battle of Shijōnawate.
Triptych, three *ōban*-size sheets, ca. 1851.

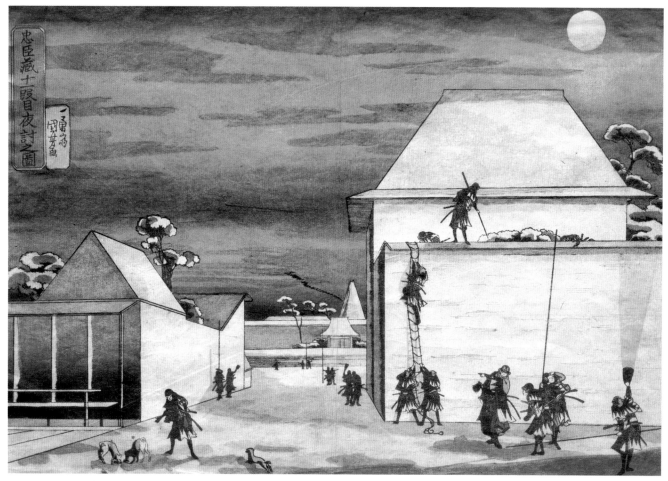

94 Kuniyoshi: *The Night Attack, Act 11*, from the series *Scenes from the Drama* Chūshingura. *Ōban* size, ca. 1830.

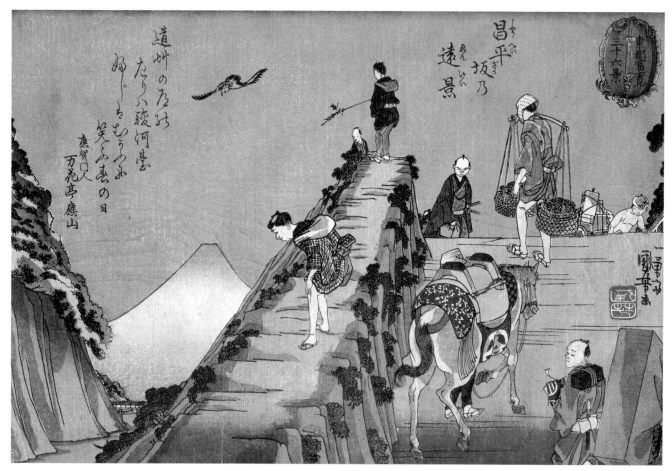

95 Kuniyoshi: Distant View of Mt. Fuji from Shōhei Hill, from the series *Thirty-Six Views of Mt. Fuji from Edo*.
Ōban size, ca. 1843.

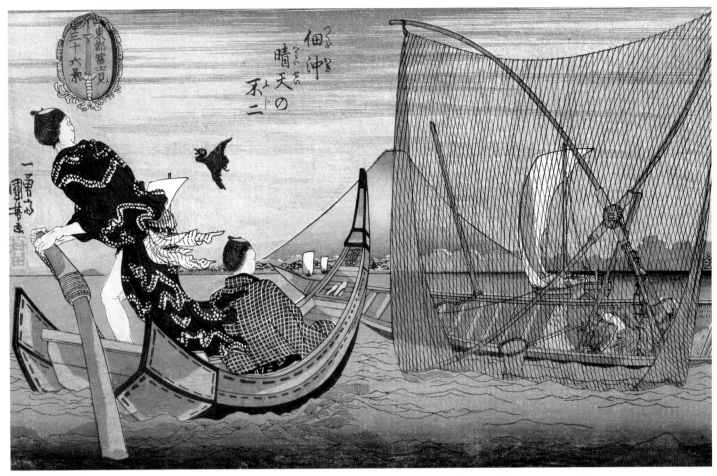

96 Kuniyoshi: View of Mt. Fuji on a Clear Day from off Tsukuda, from the same series as plate 95. *Ōban* size, ca. 1843.

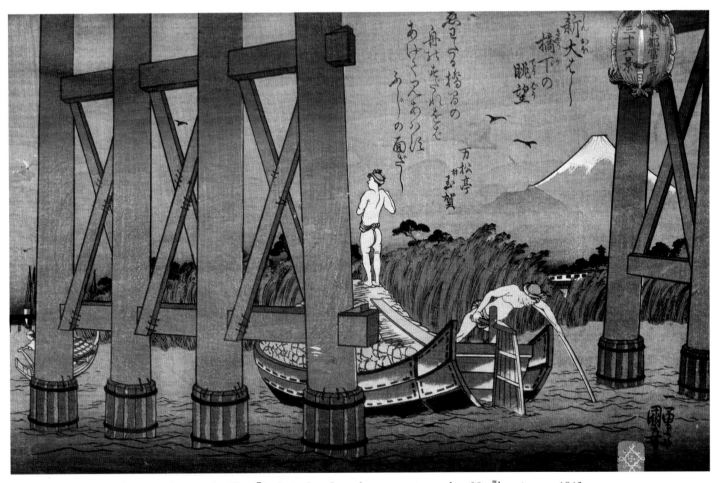

97 Kuniyoshi: View of Mt. Fuji from under Shin-Ōhashi Bridge, from the same series as plate 95. *Ōban* size, ca. 1843.

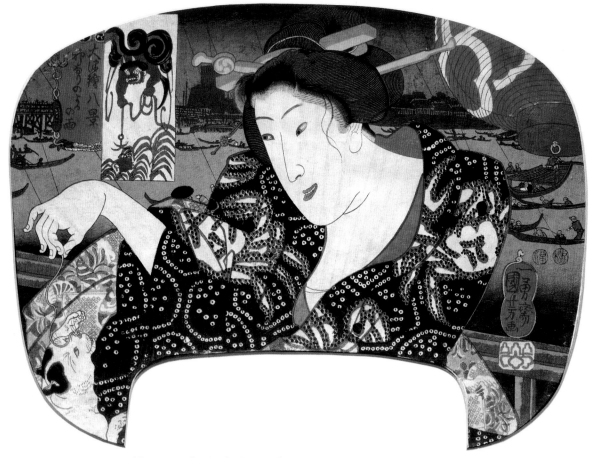

98 Kuniyoshi: *Night Rain and Thunder*, from the series *Beauties and Episodes of Ōtsu-e*. Fan print, *aiban* size, early 1850s.

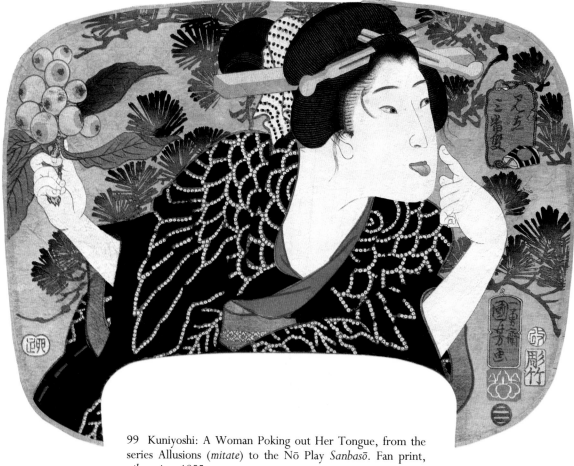

99 Kuniyoshi: A Woman Poking out Her Tongue, from the series Allusions (*mitate*) to the Nō Play *Sanbasō*. Fan print, *aiban* size, 1855.

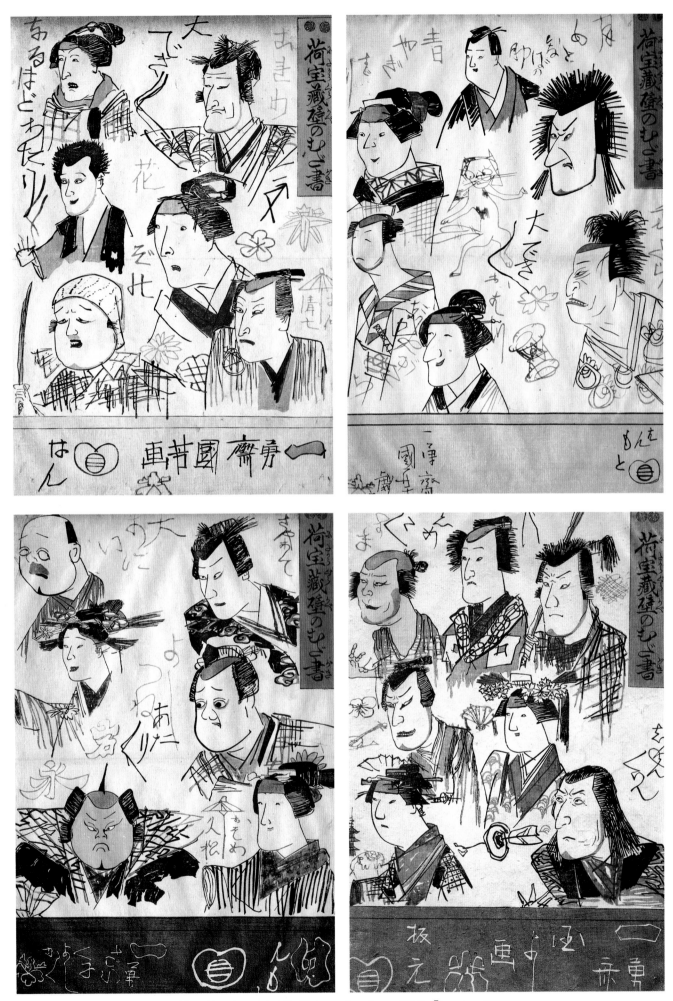

100−103 Kuniyoshi: Graffiti on a Storehouse Wall. *Ōban* size, 1847.

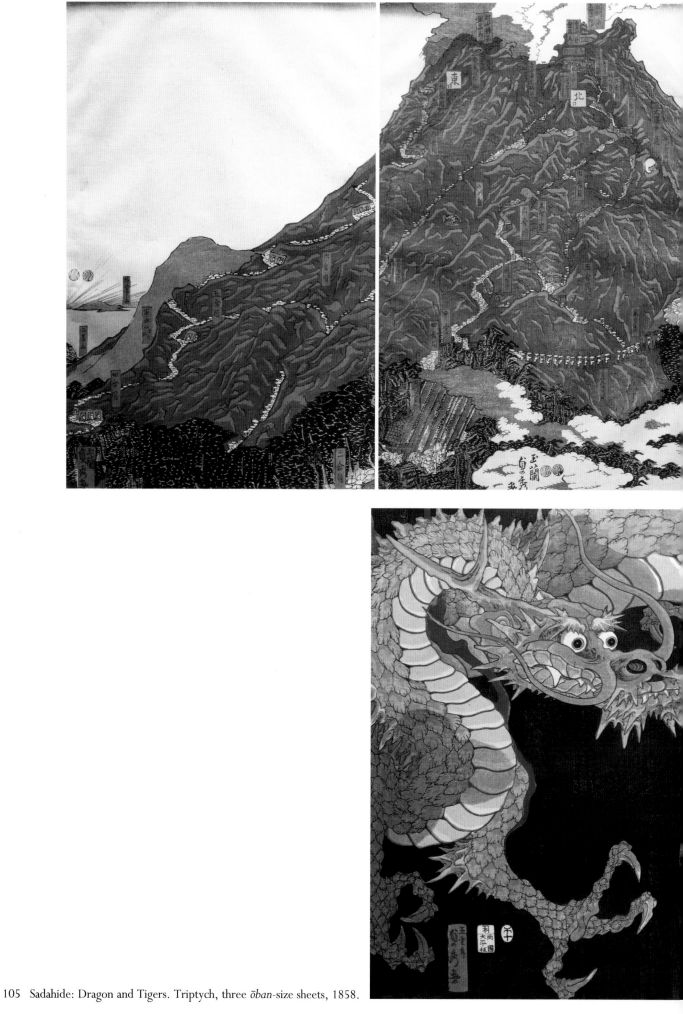

105 Sadahide: Dragon and Tigers. Triptych, three *ōban*-size sheets, 1858.

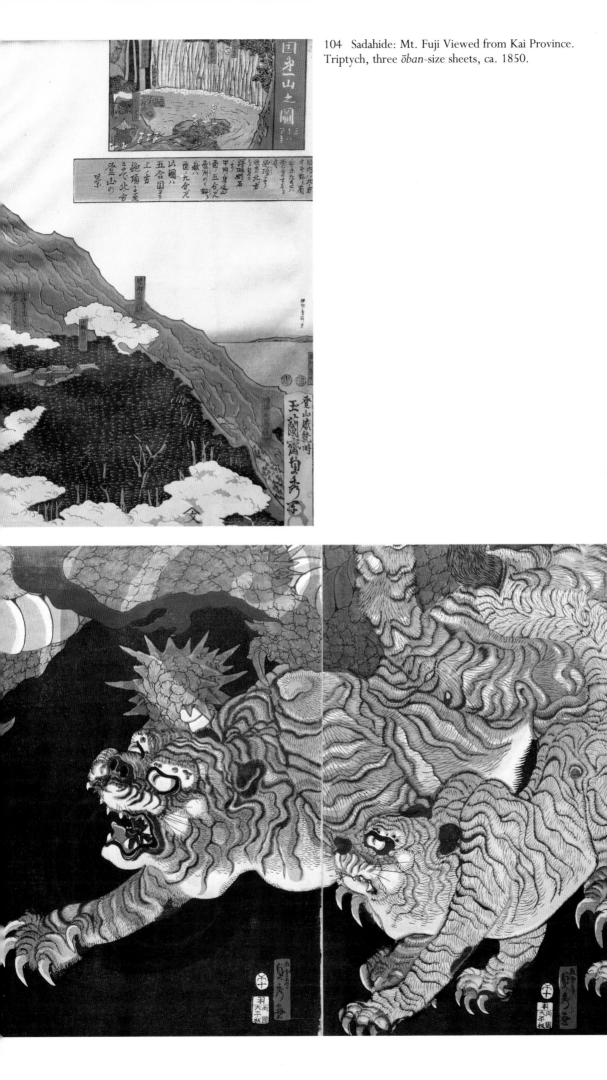

104 Sadahide: Mt. Fuji Viewed from Kai Province.
Triptych, three *ōban*-size sheets, ca. 1850.

106 Hiroshige: Peach, Plum, Chrysanthemum, a Monkey, and Chickens, from the series *Shellwork from an Exhibition at Okuyama in Asakusa*. Ōban size, 1820.

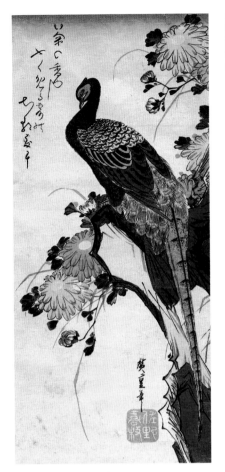

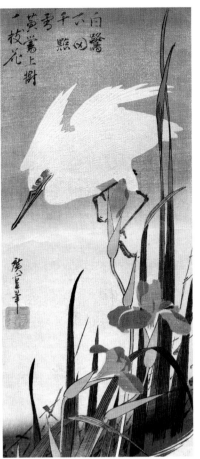

107 Hiroshige: Pheasant and Chrysanthemums. *Ō-tanzaku* size, ca. 1833.

108 Hiroshige: White Heron and Irises. *Ō-tanzaku* size, ca. 1833.

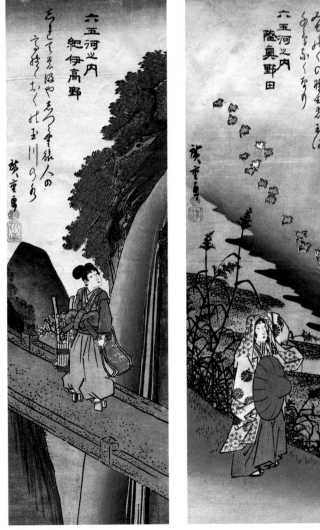

109 Hiroshige: *Kōya in Kii Province*, from the series *Six Famous Rivers with the Name Tama*. *Chū-tanzaku* size, ca. 1833.

110 Hiroshige: *Noda in Mutsu Province*, from the same series as plate 109. *Chū-tanzaku* size, ca. 1833.

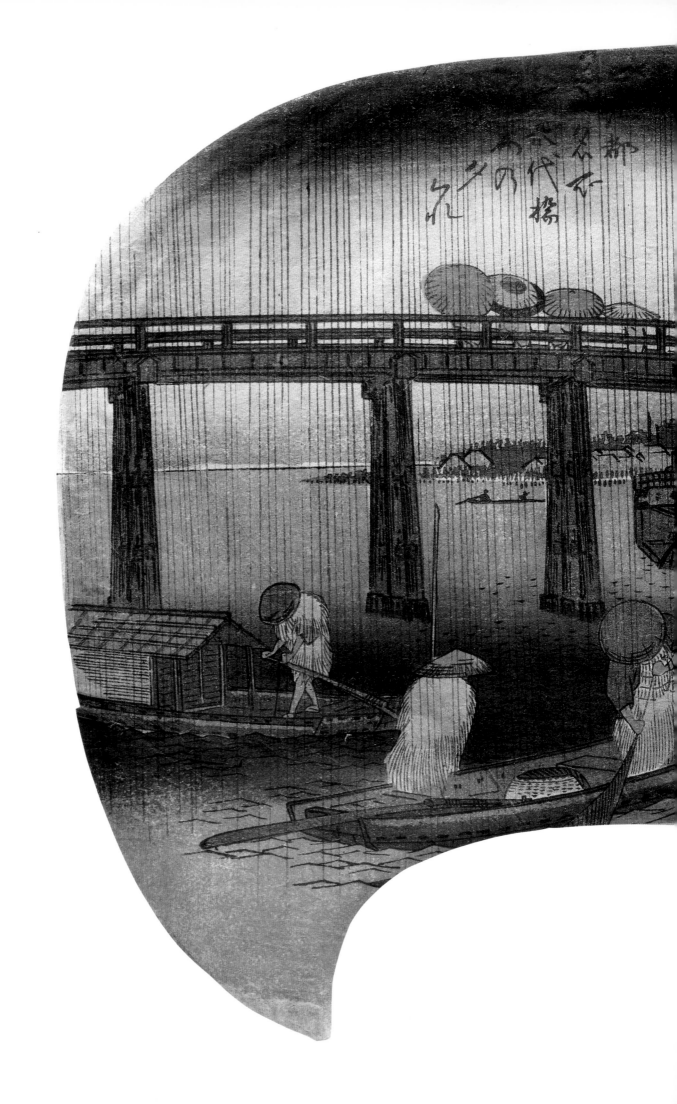

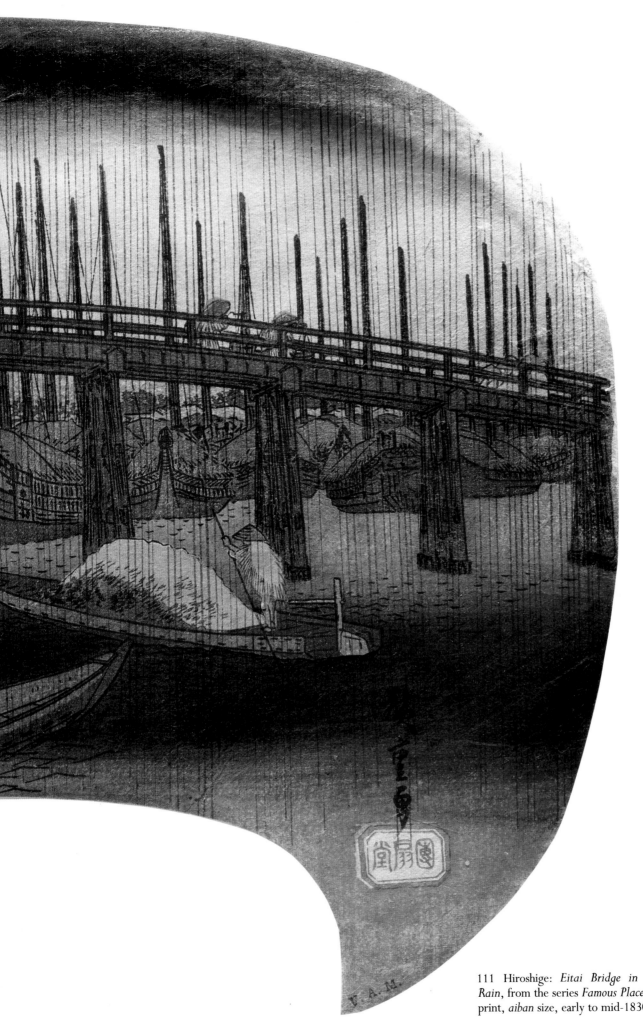

111 Hiroshige: *Eitai Bridge in the Evening Rain*, from the series *Famous Places of Edo*. Fan print, *aiban* size, early to mid-1830s.

112 Hiroshige: *Kiga Hot Springs,* from the series *Tour of Seven Hot Spring Resorts in Hakone.* Fan print, *aiban* size, ca. 1850.

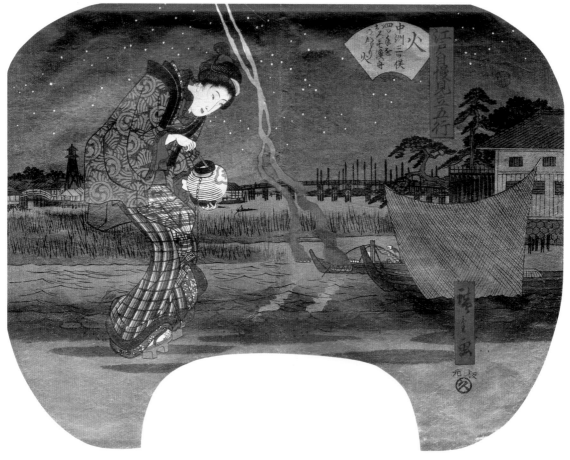

113 Hiroshige: The Theme of Fire, from the series *The Five Elements with Famous Scenes of Edo.* Fan print, *aiban* size, mid-1840s.

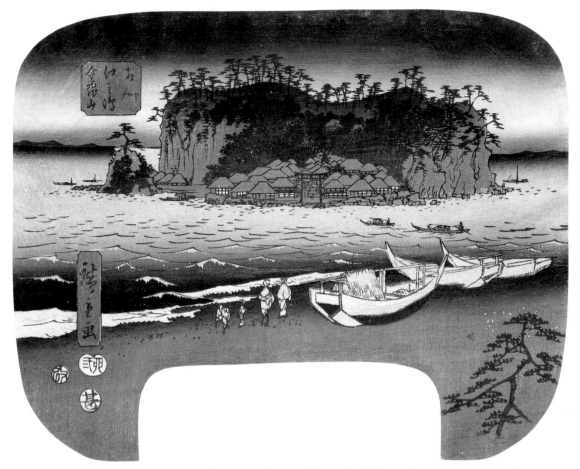

114 Hiroshige: *Kinkizan Temple on Enoshima Island, Sagami Province.* Fan print, *aiban* size, 1855.

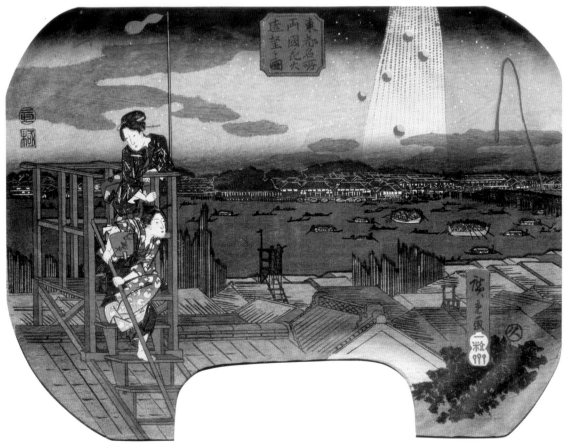

115 Hiroshige: *Distant View of Fireworks at Ryōgoku Bridge*, from the series *Famous Views of the City of Edo.* Fan print, *aiban* size, 1839.

116–117 Hiroshige: Preface, Cherry Blossoms; Swimming Carp, from *A Picture-Book Miscellany*. *Chūbon*-size book (19 x 12 cm), colors on paper, 1849.

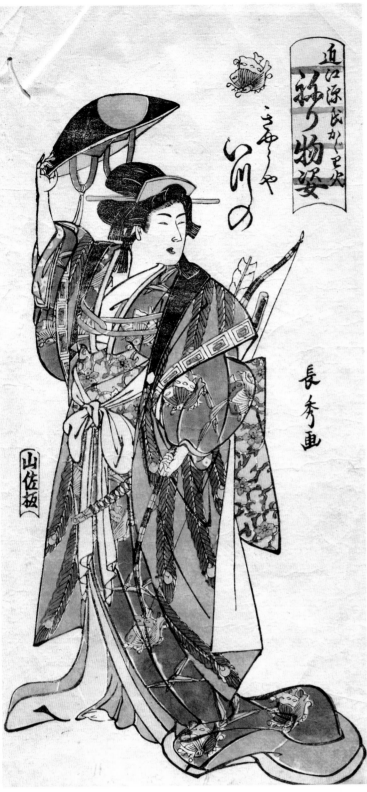

118 Nagahide: The Courtesan Itsuno as a Kabuki Actor, from the series Parade in the Gion Festival. Woodblock print with stencil coloring (*kappa-zuri*), *hosoban* size, ca. 1820.

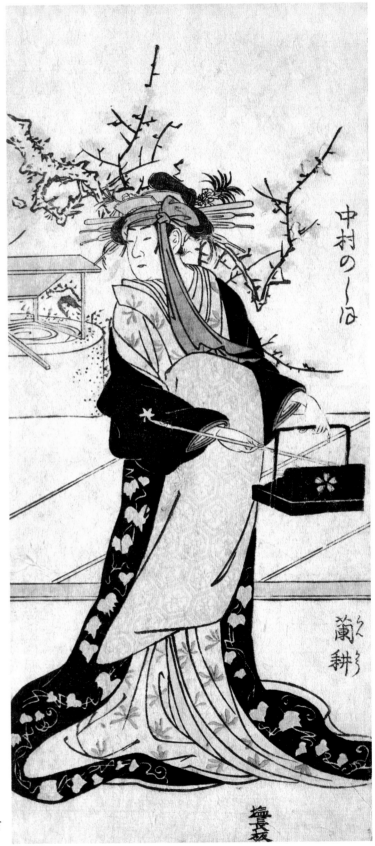

119 Style of Ryūkōsai: The Kabuki Actor Noshio II in the Role of a Courtesan. Right-hand sheet of a diptych, *hosoban* size, 1793.

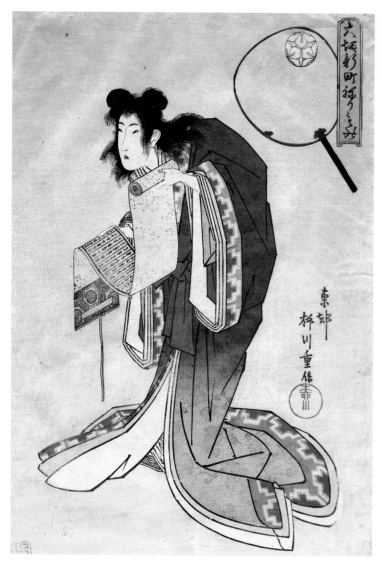

120 Shigenobu: The Courtesan Manju-dayū as a Processional Figure, from the series *Parade at Shinmachi in Osaka*. *Ōban* size, 1822.

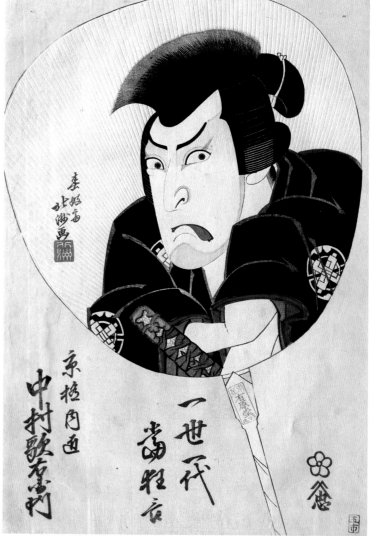

121 Hokushū: The Kabuki Actor Nakamura Utaemon III in the Role of a Samurai, from the series Famous Roles of Utaemon. *Ōban* size, 1825.

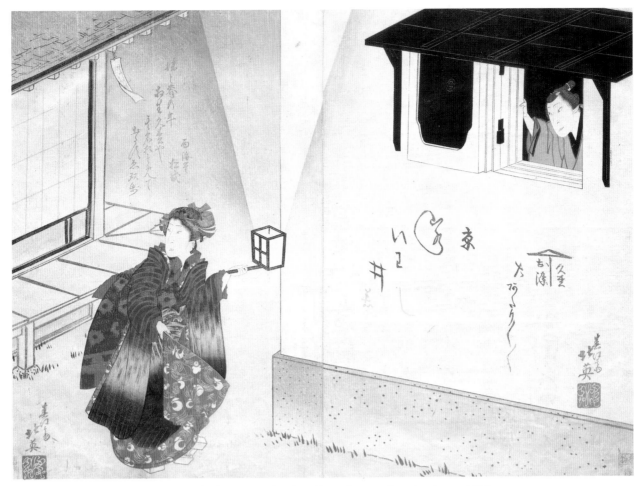

122 Hokuei: The Kabuki Actor Iwai Shijaku I in Dual Roles. Diptych, two *ōban*-size sheets, 1833.

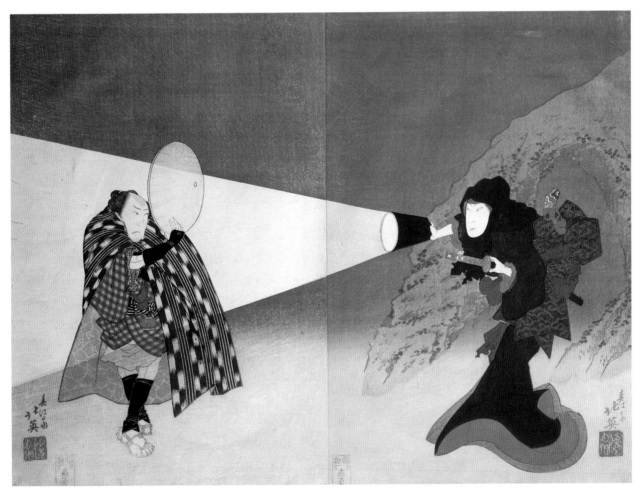

123 Hokuei: The Kabuki Actors Iwai Shijaku I and Bandō Jutarō. Diptych, two *ōban*-size sheets, 1832.

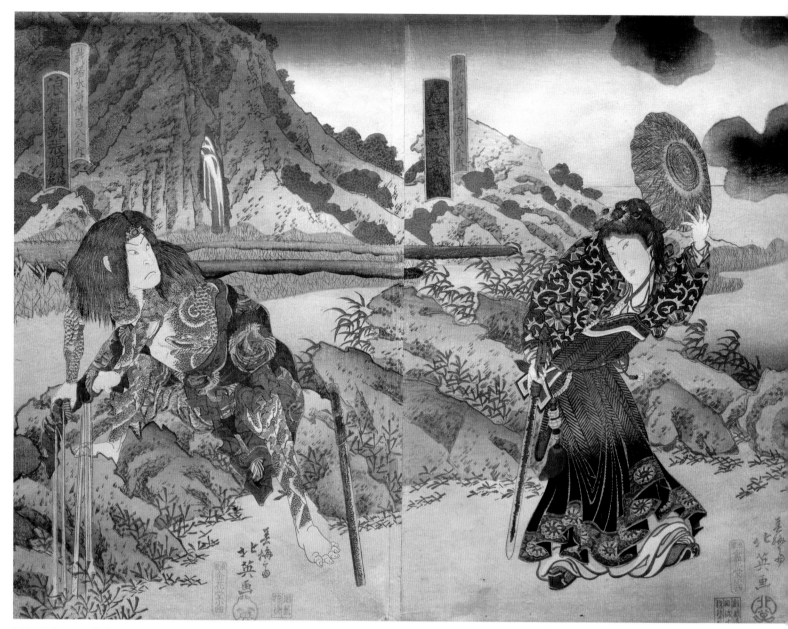

124 Hokuei: Kabuki Actors Portraying Heroes from the (*Suikoden*) Water Margin Epic. Quatroptych, four *ōban*-size sheets, ca. 1834.

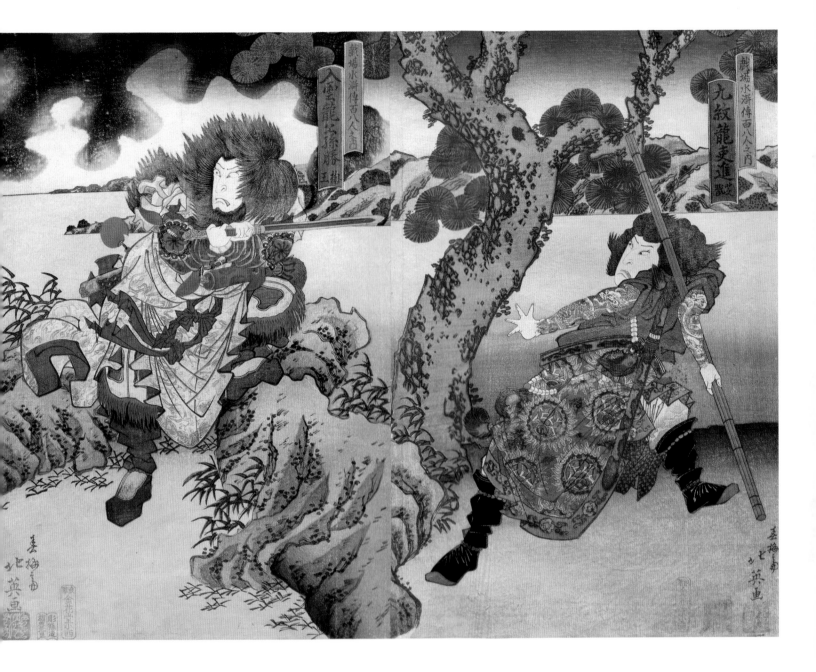

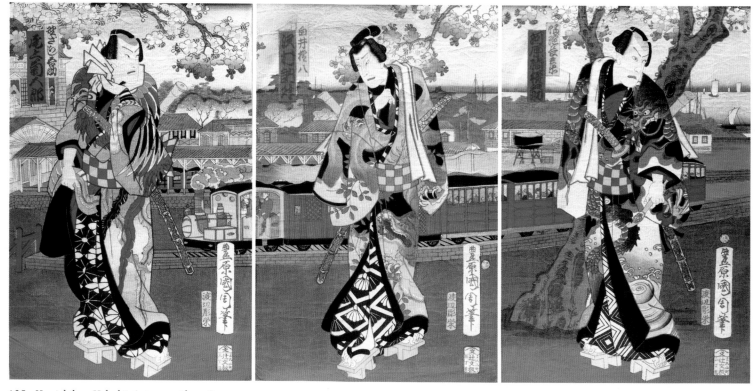

125 Kunichika: Kabuki Actors with a Steam Train in the Background. Triptych, three ōban-size sheets, 1872.

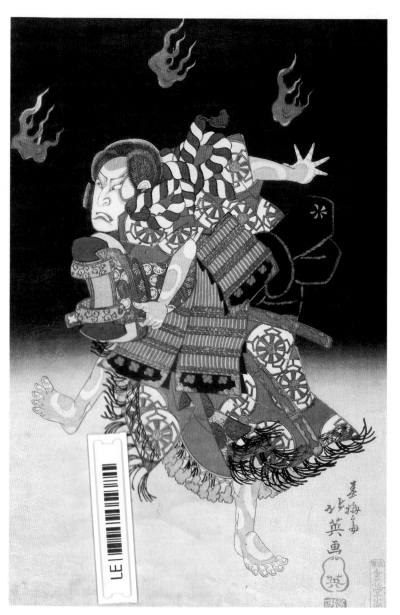

126 Hokuei: The Kabuki Actor Nakamura Shikan II. Ōban size, 1835.

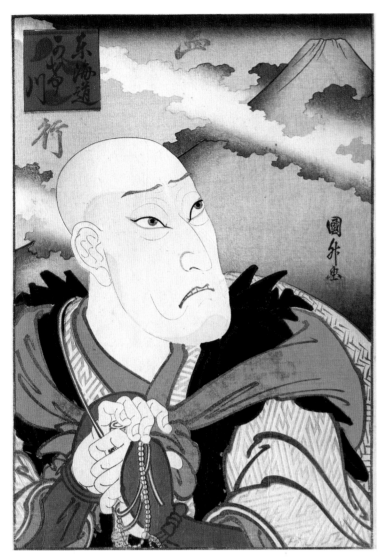

127 Kunimasu (Sadamasu): The Kabuki Actor Ōkawa Hashizō.
Chūban size, 1849.

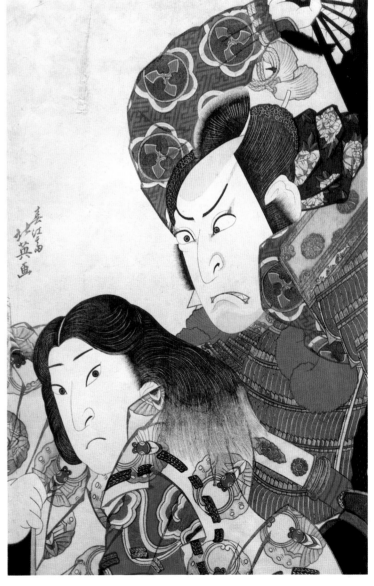

128 Hokuei: The Kabuki Actors Utaemon III and Iwai Shijaku I.
Ōban size, 1832.

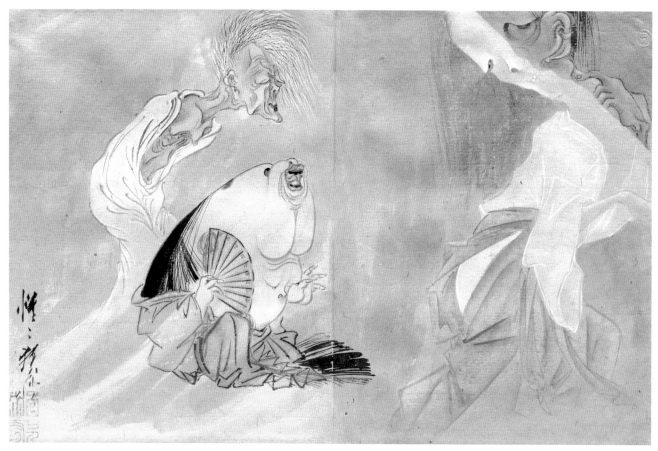

129 Kyōsai (Gyōsai): Goblins. Sketch, hand-painted colors on paper, 18.7 x 28.3 cm, mid-1860s.

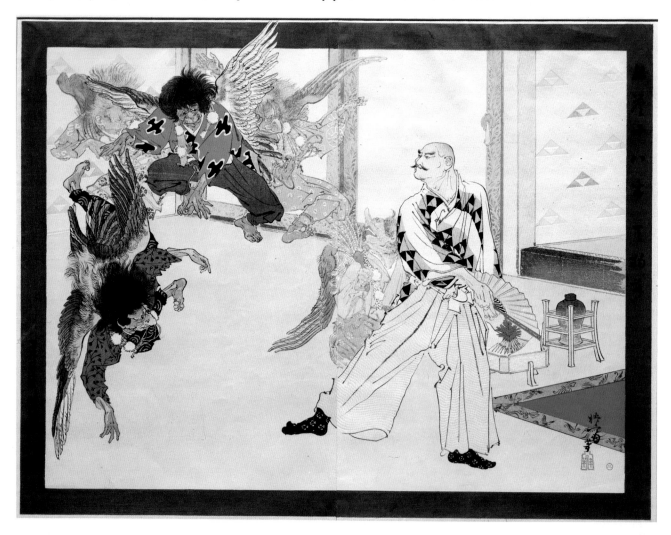

130 Toshihide: *Tengu Dance*, from the series *A Collection of Eighteen Theatrical Scenes*. Ōban size, 1898.

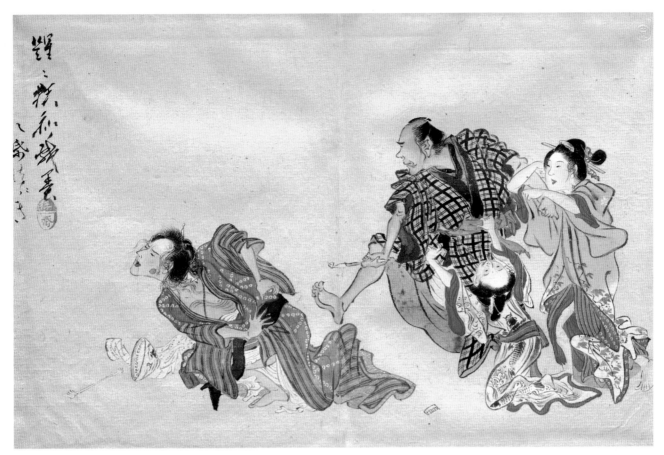

131 Kyōsai (Gyōsai): An Unfortunate Tale. Sketch, hand-painted colors on paper, 18.7 x 28.7 cm, mid-1860s.

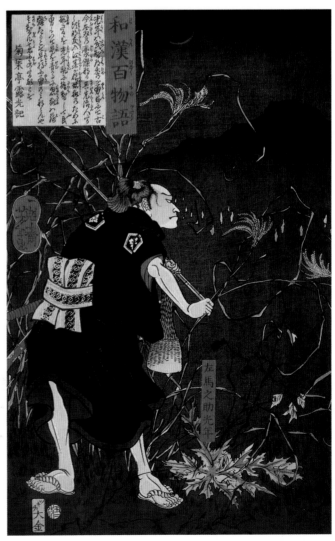

132 Yoshitoshi: The Retainer Samanosuke on a Moor at Night, from the series *One Hundred Japanese and Chinese Tales.* *Ōban* size, 1865.

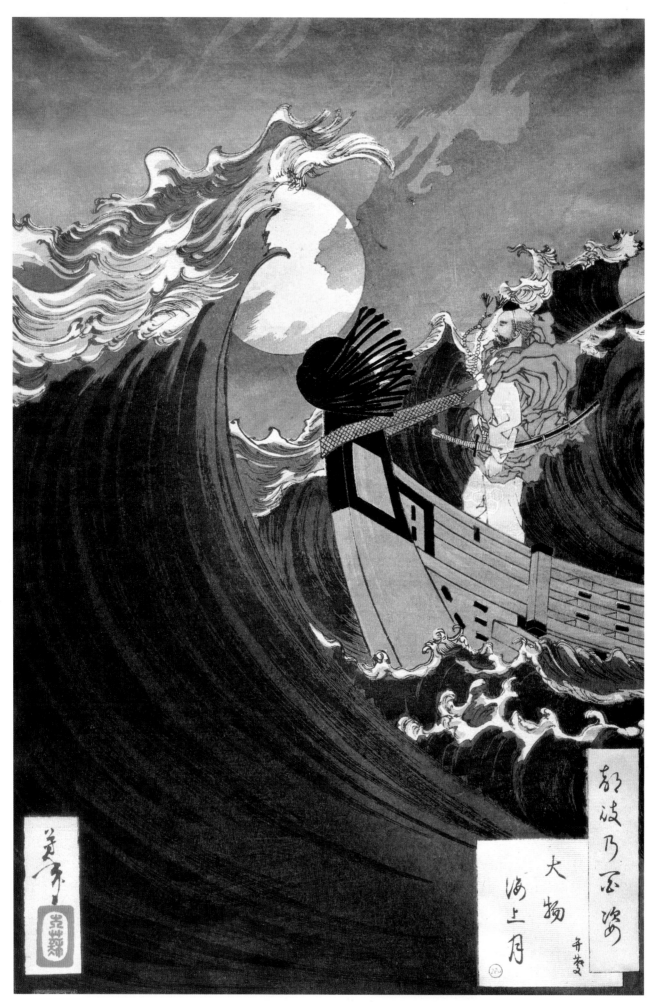

133 Yoshitoshi: The Warrior Monk Benkei, from the series *One Hundred Aspects of the Moon*. Ōban size, 1886.

Notes to the Plates

Until 1873 the Japanese dating system was based on the lunar calendar. According to this system the New Year fell on a different day each year, varying from the end of December to the end of February. In converting Japanese dates, for the purpose of simplification the months have been translated literally, the second month (ni), for example, appearing as February.

1 Unsigned. The Arrival of Europeans in Japan. Six-fold *namban* screen, hand-painted colors on paper and gold-leaf, total dimensions 142 x 350 cm, early seventeenth century.

This represents the left half of a pair of *namban-byōbu*, or screens depicting Europeans, and shows with great prominence, though doubtful authenticity, a rather small merchant vessel, the cargo of which is being unloaded on the right. We may presume that there was a matching right-hand screen possibly portraying the ship's captain leading a procession to a *namban-ji*, a Jesuit church. This painting has suffered considerable deterioration and discoloration, but still distinctive is the vivid and meticulous rendering of the goods on the ship—Ming dynasty porcelain, lacquerware, and metalware. Noteworthy also is the dynamism of the waves breaking around the ship. It is evident from the exaggeration of the facial features and expressions of the figures that this is not the work of a first-rate artist. From the shape of the pine trees and the depiction of the pine needles, it may be surmised that it is a work by an artist of the Kanō Mitsunobu line.

2 Moronobu School: Scene at Kabuki Theater in Edo. Detail of a six-fold screen, hand-painted colors on paper and gold-leaf, total dimensions 157 x 350 cm, late 1680s.

The right-hand panels of this screen show in great detail the front of the Nakamura-za, a major kabuki theater in Edo, while the left-hand panels depict the stage and the audience. Since the figures are characteristic of the style of Hishikawa Moronobu, this is considered to be a painting either by Moronobu himself or by an artist of the Moronobu School (also known as the Hishikawa School). A comparison with other similar screens in the Moronobu style leads us to believe that it was originally one of a pair. On the curtain stretched around the small tower on the roof of the theater is a picture of a crane within a circle, the *mon* (crest) of the theater. This motif also adorns the pale blue curtains hanging across the theater entrance. When the daughter of the fifth shogun, Tsunayoshi, was given the name Tsuru-hime (Crane Princess), the use of the crane in such crests was forbidden, and in 1691 the Nakamura-za adopted a motif of an inverted ginkgo leaf instead. On the left-hand side of the screen, seated at the right on the stage is a daimyo (feudal lord) wearing a tall lacquered hat and a robe decorated with large crests, accompanied by a sword-bearer. The dancing figures are the actors. The musicians are seated at the back of the stage in the same position as musicians in nō theater, evidence of kabuki's debt to nō. The audience sits before the stage, flanked on the left and right by seats for the nobility. This painting is particularly interesting for the information it reveals about early kabuki theater just before the introduction of the *hanamichi* (walkway), when the stage still had the same design as that for nō theater.

3–4 Style of Tomonobu: Korean Horseback Acrobats. Monochrome woodblock prints (*sumizuri-e*), ōban size, 1683.

During the Edo period, envoys from foreign states, such as Okinawa and Korea, and the heads of European trading companies would appear before the shogun and present aspects of their country's achievements in some form. In the case of envoys from the Korean court, it became an established custom for their mounted acrobats to put on a show. In this series there are twelve prints, eleven of which are held by the V&A. The final sheet includes an inscription giving the date of publication in Kyoto as 1683.

5 Style of Moromasa: Parading Courtesan with Attendants. Hanging scroll (*kakemono*), hand-painted colors on paper, 103 x 56 cm, 1740s.

Although it lacks any signature or seal, this work may be attributed to Furuyama Moromasa, a late follower of Moronobu, who worked mainly in the 1740s. However, some scholars have suggested that it may be the work of Engetsudō, another name used by Ishikawa Sekishin, an artist working in the Toyonobu style. Although the way the woman's face has been rendered recalls the style of Toyonobu, there is no conclusive evidence that this is by Engetsudō.

6 Torii Kiyonobu II: The Kabuki Actors Ogino Isaburō I and Sodezaki Iseno as Young Lovers. Monochrome woodblock print with hand-coloring (*urushi-e*), hosoban size, mid-1720s. Signature: Torii Kiyonobu *hitsu*. Publisher: Iseya Kinbei.

Torii Kiyonobu II is thought to have been the son of Kiyonobu I. During the final decade of Kiyonobu I's life in the 1720s, Kiyonobu II produced much of the work which bears Kiyonobu I's name. Though it is difficult to identify the exact play or roles, Ogino Isaburō I is shown here as a page with his forelock swept back, with Sodezaki Iseno as a young woman from town in a long-sleeved kimono. The man casually drapes his right arm across the girl's shoulder and takes her hand in his, conveying a subtle sensuality in this romantic scene.

7 Early Torii School: The Kabuki Actors Sawamura Sōjūrō I and Segawa Kikunojō I. Monochrome woodblock print with hand-coloring (urushi-e), hosoban size, ca. 1730.

Judging from its style, this may be a print by Torii Kiyonobu II, although this has not been verified and neither the name of the play nor the roles of the actors can be determined. After Sawamura Sōjūrō I appeared on the Edo stage in 1718, his fame grew rapidly and he was soon among the top-ranking actors. Segawa Kikunojō I was born in the Kamigata (Kyoto–Osaka) area, where he received his training and became notable as a waka-onnagata (an actor who impersonates young women). He first came to Edo in 1730, where his beautiful features and skillful dancing were received with great enthusiasm. The combination of Sōjūrō and Kikunojō was very popular in the world of kabuki theater in Edo during the latter part of the Kyōhō era (1716–36).

8 Early Torii School: A Beauty Reading a Letter. Monochrome woodblock print with hand-coloring (urushi-e). Allusion print (mitate-e), hosoban size, ca. 1730.

Hanshan and Shide were Tang-dynasty Daoist monks famous for their eccentric behavior. They were traditional subjects in both Chinese and Japanese paintings, usually depicted with Hanshan holding a sutra scroll and Shide a broom. In ukiyo-e they most commonly appear in mitate-e (pictures with an allusion to a classical theme) as a man and a woman or two women holding these objects.

9 Terushige: Young Lovers Sitting at a Kotatsu. Monochrome woodblock print with hand-coloring (urushi-e), chūban size, ca. 1720. Signature: Katsukawa Terushige. Publisher: Izumiya Gonshirō.

This print shows one of the major themes of ukiyo-e: young lovers in an intimate situation. The print provides much useful information about contemporary customs and life in Edo Japan. On the left is a standing screen-painting, while an alcove with hanging-scroll (kakemono), books, and incense-burner is depicted at right; the two lovers ensconced in a kotatsu, a blanket-covered charcoal brazier. Little is known of the artist, Katsukawa Terushige, who worked in the Kyōhō era (1716–36), but of the eleven beni-e (monochrome prints hand-colored with pink pigment) and urushi-e (hand-colored prints with lacquer-like effects) that have been identified as his, the majority are yakusha-e (actor prints) and pictures of everyday life in Yoshiwara.

10 Toshinobu: Young Lovers by Mt. Fuji. Monochrome woodblock print with hand-coloring (urushi-e), hosoban size, ca. 1720.

Signature: *Yamato-e shi* **Okumura Toshinobu** *hitsu*. **Seal: Okumura. Publisher: Izumiya Gonshiro.**

A considerable number of early ukiyo-e prints took their subjects from jōruri (puppet plays with narrative chanting accompanied by samisen). This print is based on Act 4 of the jōruri entitled Teika. In it, we see Teika and Nowaki, disguised as a packhorse driver, stealing away toward East Japan. The ingenious arrangement of the horse and figures attests to Toshinobu's genius.

11 Torii Kiyonobu II: Kabuki Scene of a Young Hero Battling with Two Warriors. Limited color woodblock print (benizuri-e), hosoban size, 1752. Signature: Torii Kiyonobu hitsu.

This work depicts a scene from a kaomise-kyōgen (an annual theatrical event in which all the actors in a company would take part) at the Nakamura-za Theater in 1752. This is a famous scene in which Matano no Gorō is about to throw a large cauldron at Sanada no Yoichi, who in turn is grappling with his enemy Yamaki Hangan.

12 Torii Kiyohiro: The Warrior Hero Minamoto no Yoshitsune. Limited color woodblock print (benizuri-e), large hosoban size, late 1750s. Signature: gakō Torii Kiyohiro. Seal: Kiyohiro. Publisher: Maruya Kohei.

This is a scene of the Battle of Yashima during the war between the Minamoto and Taira clans. According to the Heike monogatari (Tales of the Heike) and the Gen-Pei seisuiki (Rise and Fall of the Minamoto and Taira Clans), Minamoto no Yoshitsune set fire to houses in Takamatsu and then lay siege to the castle at Yashima. Yoshitsune's army appeared so formidable to the Heike that they took to the sea to escape, and here Yoshitsune is shown on the beach preparing to advance into the sea. This is probably one of the earliest depictions of a scene that was to become a common theme in ukiyo-e.

13 Harunobu: A Courtesan and Attendant on a Moonlit Veranda, from the series Genre Poets of the Four Seasons. Allusion print (mitate-e), chūban size, late 1760s. Signature: Harunobu ga.

In the upper part of this allusion print is a cloud-shaped divider inscribed with a waka verse, the mood of which is adroitly expressed in a contemporary setting, making this print and the others in the series splendid examples of mitate-e. The figures in this print are a courtesan and her attendant, who is holding a samisen (three-stringed Japanese lute) and a practice book for nagauta (ballads accompanied by the samisen). This nagauta concerning a cuckoo was popular at the time and doubtless people enjoyed the connection between the nagauta and the waka.

14 Harunobu: Parading Courtesan with Attendants. Chūban size, late 1760s. Signature: Suzuki Harunobu ga.

Some scholars have suggested that this print depicts Nokaze, a courtesan of Matsuzaka-ya, a large and famous house in the pleasure quarters in Shinagawa. However, the clothes and accouterments shown in this print are those of a courtesan from Yoshiwara, and the mon is not that believed to have been used by Nokaze. The pine motif on the large lantern is thought to indicate Matsuba-ya, a noted house in Yoshiwara, but since no depiction of a

courtesan from Matsuba-ya with the *mon* shown in this print has been discovered, it is difficult to say for certain that the courtesan depicted is Nokaze.

15 Style of Harunobu: A Cat Watching Butterflies. *Chūban* size, mid to late 1760s.

The cat has been skillfully rendered by *karazuri*, or embossing. In addition, except for the earthen bank, the begonia stems, and the young chrysanthemum leaves, the work has been executed without the usual black outlines in a technique known as *musen-zuri*.

16 Koryūsai: Mandarin Ducks in Winter. *Chūban* size, early 1770s. Signature: Koryū *ga*. Publisher: Nishimuraya Yohachi.

This work was inspired by the *haiku* (short poem) appearing in the print. While it cannot be called a *mitate-e*, it shows the close relationship between literature and Koryūsai's pictures of flowers and birds. In his youth, Koryūsai must have studied traditional painting techniques, and his rendering here of the withered reeds attests to his mastery of the brush techniques of the Kanō School.

17 Koryūsai: The Courtesan Hanaōgi with Attendants, from the series *New Fashion Designs.* *Ōban* size, mid-1770s. Signature: Koryūsai *ga*. Publisher: Nishimuraya Yohachi.

The importance of this extensive *ōban*-size *nishiki-e* series lies in the fact that it marked a switch in popularity from *chūban*-size prints, represented by the works of Harunobu, to this larger size, which allowed the designs on kimono, ornamental combs, and hairpins to be rendered in greater detail. Over a seven-year period, more than a hundred prints were issued in this series, testifying to their popularity at the time.

18 Koryūsai: Young Man Accosted by a Courtesan. Allusion print (*mitate-e*), *hashira-e* size, early 1770s. Signature: Koryūsai *ga*.

According to the nō text *Rashōmon*, one rainy night in Kyoto Watanabe no Tsuna, one of the four senior samurai of Minamoto no Yorimitsu, cut off the arm of the demon Ibaraki-dōji before the Rashōmon Gate. In this print, the moment when Ibaraki appears from the dark, thundery sky and seizes hold of Tsuna's helmet is transformed into a charming scene in which a courtesan tries to attract the attention of a young man by grabbing hold of the tip of his umbrella. The umbrella represents rain, and the pattern on the *noren* (shop curtain) symbolizes black clouds.

19 Koryusai Isoda: Beauty Dreaming of Good Luck. *Hashira-e* size, early 1770s.

This print depicts a superstition widely believed during the Edo period. A beauty is shown slumbering against a background featuring an eggplant, and a hawk soaring in front of Mt. Fuji. People believed that good luck would follow if a hawk, an eggplant, and Mt. Fuji appeared in the first dream of the new year.

20 Style of Shigemasa: Boys Carrying a Portable Shrine in the Gion Festival, *The Sixth Month,* **from the series** *Mimicry in the Twelve Months.* *Chūban* size, mid-1770s.

Shigemasa designed several series of *kodomo-e* (pictures of chil-

dren) which fall into two categories: those inscribed with *waka* and those with *haiku* verse. This print from a newly discovered series, however, is different from these two types by having neither *waka* nor *haiku*.

21, 22 Ishikawa Toyomasa: Two prints from the series *The Twelve Months of the Year.* *Chūban* size, early to mid-1770s. Signature: Ishikawa Toyomasa *ga*.

Ishikawa Toyomasa, (fl. 1770s), was an ukiyo-e artist who specialised in *kodomo-e* (pictures of children). The series *The Twelve Months of the Year*, portraying children's games in each month, is regarded as one of his representative works. In the print for the first month, the precise New Year's game being played is not known. Those of the other months are: second month, a fight during the Harvest Festival held on the first "horse day"; third month, the Doll Festival; fourth month, "tie-the-tail-on-the-devil" game; fifth month, the Boys' Festival, with a scene from the kabuki play *Tale of the Soga Brothers*; sixth month, the Gion Festival, which took place on the seventh day; seventh month, the "spinning lantern" game; eighth month, the "catch-the-child" game and moon viewing; ninth month, the game of tag and the Chrysanthemum Festival; tenth month, blowing bubbles and the Ebisu Festival; eleventh month, a *kaomise-kyōgen*; and twelfth month, children playing at cleaning the house in preparation for the New Year.

23 Bunchō: A Courtesan and Attendant by the Sumida River, from the series *The Thirty-Six Poets.* Allusion print (*mitate-e*), *chūban* size, ca. 1770. Signature: Ippitsusai Bunchō *ga*. Seal: Moriuji.

Although thirty-six prints were intended in this series, less than half are known, so the series may never have been completed. The Sumida River flows by under a moon that peeps through the clouds beyond the gate of Mimeguri Shrine. The *waka* inscribed in the cloud-shaped area in the upper part of the print is a love poem describing a girl's unwillingness to look at the moon for fear of being reminded of a past love.

24 Kitao Masanobu (Kyōden): The Poet Ton'ya no Sakefune Visiting the Pleasure District, from the series Portraits of *Kyōka* **Poets.** *Hosoban* size, mid to late 1780s. Signature: Masanobu *ga*.

The talented pupil of Kitao Shigemasa, Kitao Masanobu, produced two extremely accomplished *ehon* (picture books) of portraits of writers of *kyōka* (humorous poems) in 1786 and 1787. This print may have been designed in response to popular demand following the earlier success. However, Kitao Masanobu chose to devote most of his later life to writing fiction after he achieved literary fame with the publication of his novel *Edo umare uwaki no kabayaki* under the penname Santō Kyōden in 1785.

25 Katsukawa Shunshō: Scene from the *Tale of Genji.* Fan print, *aiban* size, early 1770s. Signature: Katsukawa Shunshō *ga*. Seal: Hayashi.

This famous scene is from Chapter 4, *Yūgao* (Moonflower), of the *Tale of Genji*, in which Prince Genji is visiting the house of a nursemaid when he notices the *yūgao* blossoms in the garden

of the house next door. Just when he sends his servant to pluck one of them, a servant girl appears and presents Genji with a blossom on a fan. The scene is represented here exactly as it is described in the novel.

26 Katsukawa Shunshō: Young Lovers Preparing Tea, from the series *The Six Poets*. Allusion print (*mitate-e*), *chūban* size, early 1770s. Signature: Shunshō *ga*.

Although this series is thought to consist of six prints, only three, including this one, have been discovered so far. The scene is reminiscent of the work of Suzuki Harunobu, who dominated the Meiwa era (1764–72). From the end of the Meiwa era, Katsukawa Shunshō, who later founded the Katsukawa School, produced innovative *mitate-e*, and this print belongs to his earliest period.

27–28 Katsukawa Shunshō: The Kabuki Actor Segawa Kikunojō III as a Mandarin Duck Spirit. *Hosoban* size, 1775. Signature: Shunshō *ga*.

Both these works depict a dance with Tomimoto-bushi music for a *kaomise-kyōgen* put on at the Nakamura-za Theater in 1775. Segawa Kikunojō III (1751–1810) was born in Osaka, but gained popularity in Edo from the Tenmei era (1781–89), becoming the leading *waka-onnagata* (an actor who impersonates young women). His performance as a beautiful young woman possessed by the spirit of a mandarin duck had a voluptuous and uncanny charm that appealed to the audience of the time.

29 Katsukawa Shunshō: Kabuki Scene with Yokobue and the Priests Saigyō and Mongaku. Diptych, two *hosoban*-size sheets, 1777. Signature: Shunshō *ga*.

This print depicts Nakamura Tomijūrō as Yokobue in a scene from *Musume Dōjōji* (The Maiden at Dōjōji Temple) performed at the Nakamura-za Theater in 1777. Although Tomijūrō was fifty-nine years old at the time, his portrayal of a cheerful, innocent maiden in a kimono with long, trailing sleeves was highly acclaimed. The actors playing the priests were also well known, and it is a tribute to Tomijūrō's greatness that such actors would serve merely as a foil to him.

30 Katsukawa Shunkō: The Kabuki Actors Ichikawa Monnosuke II and Sakata Hangorō III. *Aiban* size, mid-1780s. Signature: Shunkō *ga*.

The actor standing and holding a gem in his left hand and a fan in his right is Monnosuke, who was popularly regarded as the leading actor of young men's roles. Resting on one knee in the costume and stance of an *aragoto* (rough business character) is Hangorō, who was an active player of the *jitsu-aku* (worst villain role).

31 Utagawa Toyoharu: Interior View of a Kabuki Theater in Edo. *Ōban* size, early 1770s. Signature: Utagawa Toyoharu *kore o egaku*. Publisher: Matsumura Yahei.

The scene depicts a *kaomise-kyōgen* which included Nakamura Tomijūrō I playing in *Onna shibaraku* (The Woman Said "Wait!") at the Morita-za Theater in Edo. The print is of particular value in documenting the design of kabuki theaters in the mid-Edo period. The ceiling is lined with wooden planks from which hang

lanterns whose purpose, rather than illumination, is to show the crests of the participating actors, a feature of *kaomise-kyōgen*. At the rear of the stage are a roof and two supporting columns. The play was performed in front of this, on the large stage that juts out and faces the audience. To the upper left of the stage, hidden by a black curtain, are the musicians. Male teahouse servants thread their way among the audience, bearing food and earthenware teapots.

32 Utagawa Toyoharu: View of Mimeguri. *Ōban* size, ca. 1780.

A bird's-eye view of activity around the Mimeguri Shrine and the Sumida River in Edo is shown in one of Toyoharu's early attempts in the landscape genre. The style of drawing used in the print appears to have been influenced by Western etching techniques.

33 Utagawa Toyoharu: Boating and Fireworks on the Sumida River. *Ōban* size, 1770s. Signature: Utagawa Toyoharu *ga*. Publisher: Nishimuraya Yohachi.

Ryōgoku Bridge was completed in 1661, and public squares were built to the east and west of it. The street performances and sideshows that flourished there resulted in its becoming the most popular amusement center in Edo, particularly during the summer months. During that period the river was thronged with pleasure boats which converged on the area from all over Edo, and each night customers on the boats would compete to launch the most spectacular fireworks. In this print, the liveliness of the area is skillfully conveyed, while in the upper right part, the moon looms boldly against a background of silver-gray and red. The five naked figures in the water near the rocks by the far end of the bridge may be pilgrims, since it was here that pilgrims about to set out for Mt. Ōyama purified their minds and bodies.

34 Torii Kiyonaga: An Arranged Introduction at a Shrine. Diptych, two *ōban*-size sheets, mid-1780s. Signature: Kiyonaga *ga*.

This *ōban*-size *nishiki-e* is famous as an exemplary work of Kiyonaga, an artist who established his own distinctive style. The designs on each kimono and the color tonality are carefully executed. This group of figures is an excellent portrayal of the manners of the time. The woman with the Shimada-style coiffure wearing the long-sleeved kimono is the prospective bride of the young man who is seated.

35 Torii Kiyonaga: A Young Girl Reading a Letter as a Woman Looks On, from the series *Eight Famous Interior Scenes*. Allusion print (*mitate-e*), *chūban* size, mid-1770s. Signature: Kiyonaga *ga*.

Popular with the urban middle classes were prints which depicted the daily lives of women and children with wit and parody. Many prints were produced based on the well known series of Chinese paintings *Eight Famous Views of Xiao Xiang*. One example of such a series is Suzuki Harunobu's highly acclaimed series *The Eight Famous Interior Scenes*. This was followed by Torii Kiyonaga's *chūban*-size series with the same title, to which this print belongs. In this print, allusion is made to the evening snow of the Chinese print by the cotton on the lacquered pail. As shown in this picture, stretching the cotton wadding over a lacquered pail before

it was made into something was one of the many jobs that women did by hand.

36 Katsukawa Shunchō: The Kabuki Actors Hanshirō IV, Sōjūrō III, and Kikunojō III. *Ōban* size, 1789. Signature: Shunchō *ga*. Seal: Nakabayashi. Publisher: Fushimiya Zenroku.

This print shows a performance of a dance with Tomimoto-bushi music, which was performed at New Year at the Ichimura-za Theater. It is a *degatari-zu* (a print depicting a dance scene with *degatari* [appearance of *jōruri* chanters and *samisen* players on stage] in the background), a genre made popular during the Tenmei era (1781–89) by Kiyonaga, who also introduced the innovative composition evident in this print. Although the artist, Katsukawa Shunchō, was a pupil of Katsukawa Shunshō, the composition, the facial expressions, and the figures themselves are depicted more in the style of Kiyonaga.

37 Katsukawa Shunchō: The Courtesan Hanaōgi. *Ōban* size, ca. 1790. Signature: Shunchō *ga*. Publisher: Tsuruya Kiemon.

Hanaōgi, a famous courtesan who embodied the essence of the Kansei era (1789–1801), was the subject of many ukiyo-e. In this unusual *ōkubi-e* (close-up portrait) by Katsukawa Shunchō, the well-rounded face reflects the true beauty of Hanaōgi.

38 Kitagawa Utamaro: Rolling Up a Blind for Plum Blossom Viewing. Privately commissioned woodblock color print (*suri-mono*), *nagaban* size, late 1790s.

This print is a good example of Utamaro's early work showing graceful women depicted with a fine, careful line. In particular, the facial expression of the girl who has just finished playing the *koto* and the upper body of the woman rolling up the blind show his skill at delicate and detailed depiction. The scene is most probably based on some story, but in general it shows two popular leisure activities during the Edo period—playing musical instruments and holding parties for viewing plum or cherry blossoms.

39 Kitagawa Utamaro: The Ebisu Festival. Triptych, three *ōban*-size keyblock impressions, or "proofs" (*kyōgōzuri*), 1790s.

This print is a rare example of *kyōgōzuri*, or "proofs," the first impressions taken from the keyblock. The print is all the more important for the fact that the indication of colors to be used in the printing was marked by Utamaro himself. The print depicts the Ebisu Festival, which merchants held twice a year in January and October for the purpose of praying for prosperous trade.

40 Kitagawa Utamaro: Summer Bath, from the series *Seven Episodes of Ono no Komachi and Children*. Allusion print (*mitate-e*), *ōban* size, early 1800s. Signature: Utamaro *hitsu*. Publisher: Tsuruya Kiemon.

A mother is about to give her child a bath when an older girl comes to show her a goldfish. The color scheme of the clothing against a light gray background is refreshingly appropriate for summer. Although the connection between this scene and the life of Ono no Komachi is not readily apparent, it is a pleasant depiction of a mother, child, and girl.

41 Kitagawa Utamaro: The Prim Type, from the series Physiognomy of Courtesans. *Ōban* size, early 1800s. Signature: Utamaro *hitsu*. Publisher: Tsutaya Jūzaburō.

This print is one of a series in which each print shows the head and shoulders of a courtesan, with a description of her facial features and character inscribed on the white background. The name of the courtesan here is not mentioned, but it has been suggested that she was a courtesan from the Ōgi-ya house, judging from the fan and hollyhock pattern on her kimono.

42 Kitagawa Utamaro: Three Beauties. *Ōban*-size, mid-1790s. Signature: Utamaro *hitsu*. Publisher: Tsutaya Jūzaburō.

This print show the courtesans Ohisa and Okita and the singer Toyohina in a pyramidal formation, an innovation of Utamaro's which was copied by many other ukiyo-e artists.

43 Kitagawa Tsukimaro: The Courtesan Takao Displaying New Bedclothes. Triptych, three *ōban*-size sheets, 1804. Signature: *kaimei* Tsukimaro (change of name to Tsukimaro) *hitsu*. Publisher: Tsutaya Jūzaburō. Censorship seal: *kiwame*.

This print depicts a celebration taking place on the occasion of the display of new bedclothes given to a courtesan by her patron. In the center is the courtesan Takao with her guest Sawamura Gennosuke I, one of the three most popular kabuki actors in Edo at the time. On the right a young courtesan is wrapping congratulatory money in paper while an attendant is holding a tray with a finished, decorated paper package. The man drinking *sake* is the actor Iwai Kiyotarō IV. On the left are two geisha and an attendant bringing in stacked trays of *soba* (noodles). The figures form a well-balanced composition.

44 Chōbunsai Eishi: Kiyomori's Daughter Painting A Self-Portrait to Send to Her Mother. *Ōban* size, late 1790s. Signature: Eishi *zu*. Publisher: Nishimuraya Yohachi. Censorship seal: *kiwame*.

According to Klaus J. Brandt's book *Hosoda Eishi* (Stuttgart, West Germany, 1977), this print is the middle sheet of a triptych. The right sheet shows a court lady, a representation of the female poet Koshikibu, standing with a cypress fan in her hand admiring a framed cuckoo picture, while the left sheet represents the daughter of calligrapher Fujiwara no Yukinari, sitting and showing a hanging scroll of flowers and butterflies to a cat. The three works were connected by a yellow cloud configuration, with the right and middle sheets being joined by a frame and a curtain. Although this print may be appreciated independently of the others in the triptych, the compositional device of having a serialized story connected by the backgrounds was often seen in Eishi's work during the latter part of the Kansei era (1789–1801), when he depicted beauties with increasingly slender proportions.

45 Gokyō: Courtesans on Promenade at New Year. One sheet of a triptych, *ōban* size, late 1780s. Signature: Eishi *monjin* (disciple of Eishi) Gokyō *ga*.

This work is a good example of a *beni-girai* print which uses no pink or red pigments, its main colors being yellow, purple, and black. Unusual among works showing a parading courtesan is the presence of a young man, apparently the courtesan's guest. This

bijin-ga follows the style of the artist's master, Eishi, so closely that if it were not for the signature, one might easily mistake it for the master's work. Nothing is known about Gokyō except that he signed all his works "disciple of Eishi."

46 Katsukawa Shunsen: Parading Courtesan. Vertical diptych, two ōban-size sheets, ca. 1810. Signature: Katsukawa Shunsen ga. Seal: Shun.

This depiction of a parading courtesan has been mounted in a hanging-scroll format. The woman's coiffure is characteristic of the first half of the Bunka era (1804–18) in shape. The fashion and the fact that the print follows the style of the later period of Utamaro allow it to be identified as a work from the relatively early part of Shunsen's career.

47 Style of Eishō: In Front of a Toothbrush Shop. *Hashira-e* size, ca. 1800.

In the Edo period there were many toothbrush shops located around the precincts of the Sensōji Temple. The shops drew large crowds of people because of the owners' custom of hiring beautiful girls as shop assistants in order to attract customers. One particular shop assistant renowned for her beauty was a girl called Ofuji. As a result of her popularity she was frequently depicted in ukiyo-e prints and her character was incorporated into kabuki plays. This print shows a handsome customer visiting Ofuji, who is depicted holding a hammer as if busy making a small pouch for the toothbrush. A hammer was commonly used to stick the glued parts of the carrying-case firmly together.

48 Eishō: The Courtesan Yosooi. Ōban size, late 1790s.

Yosooi was one of the courtesans at Matsuba-ya in Yoshiwara, the pleasure quarters of Tokyo. The artist has succeeded well in capturing the beauty and freshness of the woman at the moment when she turned her head and caught his eye. The extent to which the techniques of carving and printing had advanced are evident in the superior depiction of the courtesan's diaphanous fan.

49 Kikukawa Eizan: Geisha Playing the Hand-Game *Kitsune-ken*. Triptych, three ōban-size sheets, ca. 1820. Signature: Kikukawa hitsu. Publisher: illegible. Censorship seal: *kiwame*.

Kitsune-ken was a game played with the hands rather like "stone-paper-scissors": a fox (*kitsune*) was formed by raising both hands and imitating a fox's ears, as shown in the middle sheet; a village headman was made by placing both hands on the knees, as shown in the left-hand sheet; and a gun was made by extending both arms as though shooting a gun, as shown in the right-hand sheet. The fox beats the headman, the headman beats the gun, and the gun beats the fox. A *sake* container is placed in the center, and to the right is a *sake* cup; the person who loses a game has to take a drink as a forfeit. In the room behind the three women, a party is in full swing, as shown by the shadows of the dancing revelers on the *shōji* (sliding papered doors). One can almost hear the lively *samisen* music and the laughter.

50 Kikukawa Eizan: The *Jōruri* Character Ohan with a Doll, from the series Heroines of Double-Suicide Stories. Ōban size, ca. 1810.

Signature: Kikukawa Eizan *hitsu*. Publisher: Wakasaya Yoichi.

During the Kyōhō era (1716–36), two lovers committed suicide at the Katsura River in Kyoto, and the incident became famous because of the difference in age between the middle-aged man, Chōemon, and the teen-age girl, Ohan. The story was eventually adopted in a number of kabuki plays and *jōruri* (puppet plays with narrative chanting accompanied by *samisen*). The elopement scene is the most famous in ukiyo-e. Chōemon is frequently depicted standing beneath a willow tree, his head wrapped in a towel, carrying Ohan on his back. This print, however, depicts Ohan in everyday life in the *Jōruri* Drama *Katsuragawa Renri no Shigarami*. She conveys an air of innocence as she gazes tenderly at the doll she is holding in her lap.

51 Kikukawa Eizan: Woman at a Mirror, from the series Edo Beauties. Ōban size, ca. 1820. Signature: Kikukawa Eizan *hitsu*. Publisher: Mikawaya Heihachi.

Some scholars have suggested that this series takes the *Tale of Genji* as its theme, and thus it is surmised that there may have been fifty-four sheets in it, to correspond to the number of chapters in the novel. However, apart from this work, only four others are known, and many may not have been published. The woman depicted here with a side comb in her hair may be about to apply her makeup. On the mirror stand is a packet of famous face power.

52 Keisai Eisen: Geisha with *Samisen*, from the series *Beauties of the Floating World*. Ōban size, early 1820s. Signature: Keisai Eisen ga. Publisher: Wakasaya Yoichi. Censorship seal: *kiwame*.

This is one of a series of eight *ōkubi-e* (close-up portrait) and is considered to be a masterpiece of the period when Eisen was at the height of his artistic creativity. Unlike the works of Utamaro thirty years earlier, which presented an idealized feminine beauty, this series consists of graphic, realistic portrayals that seek to penetrate below the surface of a woman's beauty. In each portrait the woman holds some object, and the placement of the hands is exquisite, producing a composition overflowing with tension.

53 Keisai Eisen: *The Kōya-Tama River*, from the series Six Famous Rivers with the Name Tama. Ōban size, early 1820s. Signature: Keisai Eisen ga. Publisher: illegible. Censorship seal: *kiwame*.

In this print the *koma-e* (small framed picture within a print) depicts one of the six rivers with the name Tama, but since the main picture is of current fashion bearing no relation to the series title, it would be better designated as *bijin-ga*. This quintessential Edo woman is clothed according to the latest fashion: her *obi* is decorated with representations of toys, while the pattern on her kimono depicts mice nibbling at red peppers.

54 Utagawa Toyohiro: Geisha Standing in the Wind. *Aiban* size, ca. 1805. Signature: Toyohiro ga. Publisher: Matsuyasu.

This print brilliantly captures the geisha's expression when her black outer kimono and red-patterned inner kimono are stirred by a sudden gust of wind. The breeze pushes the lower part of her kimono against her legs and causes her sleeves to billow. The woman is perhaps waiting for a pleasure boat.

55 Utagawa Toyokuni: Fireworks at Ryōgoku Bridge. Double triptych, six ōban-size sheets, mid-1820s. Signature: Toyokuni *ga*. Publisher: Yamamotoya Heikichi. Censorship seal: *kiwame*.

Ryōgoku Bridge spanned the Sumida River in Edo, and in this print it is shown dangerously crowded with people watching the fireworks. Most of the figures facing the viewer are beautiful women, but especially effective is the way in which only the backs of the men's heads are depicted as they gaze up at the fireworks display.

56 Style of Toyokuni: Famous Kabuki Actors in a Mélange of Scenes from the Drama *Chūshingura*. Triptych, three ōban-size sheets, mid-1810s.

This is a collection of representative scenes from *Kanadehon Chūshingura* (The Treasury of the Forty-Seven Loyal Retainers). The artist has not added his signature but this is unmistakably by Toyokuni. The figures are small and though the actors cannot be conclusively identified, they appear to be Matsumoto Kōshirō V as Moronō, Onoe Kikugorō III as Hangan, Nakamura Utaemon III as Honzō, Ichikawa Danjūrō VII as Kanpei, Segawa Kikunojō V as Okaru, Bandō Mitsugorō III as Yuranosuke, and Iwai Hanshirō V as Ōishi. It has not been ascertained whether a performance with this cast ever took place, but since it would have been difficult to bring together such an illustrious group of actors, it most likely represents an idealized performance which the artist would have liked to have seen. It is uncertain exactly when this print was made, but it may have been 1815 or 1816, a time when *Chūshingura* was frequently performed, and when Utaemon III, who is depicted here, was in Edo or had just left.

57 Utagawa Toyokuni: The Kabuki Actor Onoe Matsusuke I. Ōban size, ca. 1799. Signature: Toyokuni *ga*. Publisher: Tsuruya Kinsuke.

This is thought to be a print depicting a performance of a play based on the *Tale of the Soga Brothers*, which opened at the Ichimura-za Theater on 15 January 1799. The ferocity of the actor's glare is achieved by the impressive sureness of Toyokuni's lines.

58 Utagawa Toyokuni: The Kabuki Actor Ichikawa Omezō I in the Drama *Shibaraku*. Ōban size, ca. 1810. Signature: Toyokuni *ga*.

This is most likely a depiction of a production at the Morita-za Theater in November 1810. In the Meiji period (1868-1912), the script of the play *Shibaraku* (Wait!) became fixed and the name of the main character was designated as Kamakura no Gongorō Kamemasa. Originally, however, the plot and the characters were created anew each time it was performed. Virtuous men and women, about to be cut down by an evil lord and his servants, are saved by a man with superhuman strength who kills the villains. When this hero appears on stage, he utters the words, "Wait! Wait!," which at first was the only part of the play that was fixed.

59 Utagawa Toyokuni: Ladies-in-waiting with Male Entertainers in Female Attire. Triptych, three ōban-size sheets, ca. 1825.

Signature: Toyokuni *ga*. Publisher: Yamamotoya Heikichi. Censorship seal: *kiwame*.

The scene shows the upper floor of the women's quarters, where a lady-in-waiting has summoned a male entertainer as her companion for the evening. The woman on the right, calmly picking her teeth and listening to the *samisen*, seems in age and rank to be the most senior of the three ladies-in-waiting present. The other ladies-in-waiting are the woman in the center panel wearing a colorful kimono sitting by the serving girl, and the woman in the left-hand panel lounging in a slovenly way and looking down the corridor. The *samisen* player and the two standing figures are male entertainers.

60 Utagawa Kunisada: Girls Dancing, *The Seventh Month*, from the series *The Five Festivals*. Ōban size, 1830s.

In this print Kunisada creates a remarkable feeling of movement through the depiction of a combination of dance poses. The women are shown dancing at the Tanabata Festival. This festival takes place once a year and celebrates the annual meeting between two stars, Vegas and Altair. According to Chinese legend, the two stars were separated by the Milky Way and could only meet once a year on the seventh night of the seventh lunar month. In modern Japan the festival is still held, the cities of Sendai and Hiratsuka being particularly well-known for their elaborate celebrations.

61 Utagawa Kunisada: Backstage View of Kabuki Theater in Osaka. Triptych, three ōban-size sheets, early 1820s. Signature: Gototei Kunisada *ga*. Publisher: Nishimuraya Yohachi. Censorship seal: *kiwame*.

A large group of Edo kabuki stars performed in Osaka in 1821 and 1822. Kunisada was in Osaka at that time and designed these prints to be sold in Edo. This work provides valuable information on the actors backstage and the structure of theaters in Osaka, which were relatively simple two-storied buildings, unlike those in Edo.

62 Utagawa Kunisada: A Kabuki Scene of Women at a Bathhouse. Triptych, three ōban-size sheets, 1815. Signature: *hanmoto no konomi ni tsuki* (by publisher's order) Kunisada *ga*. Publisher: Suzui. Censorship seal: *kiwame*.

This work is based on the second play in the *kaomise-kyōgen* (an annual theatrical event in which all the actors in a company would take part) put on at the Kawarasaki-za Theater in Edo in 1815. The play was written by Tsuruya Namboku and featured an arrangement of *onnagata* (actors who impersonate women) costumed to look naked. This erotic scene caused a sensation and the play met with great success.

63 Kunisada: The Kabuki Actors Ichikawa Kodanji IV and Bandō Kamezō. Diptych, two ōban-size sheets, 1856. Signature: Toyokuni *ga*. Publisher: Daikokuya. Censorship seals: *aratame* and Tatsu shichi (July 1856).

This work is based on the final scene in Act 4 of *Yoshitsune senbon zakura* (Yoshitsune and the Thousand Cherry Trees), put on at the Ichimura-za Theater in July 1856. Toward the end of this scene, Ichikawa Kodanji IV as Fox-Genkurō reports an imminent

attack by the priests from Mt. Yoshino and then uses his magic powers to fight off the priests in repayment of a favor from Yoshitsune, who had let him have a drum made from his parents' skin. This print depicts the fight between Fox-Genkurō and Kakuhan (Bandō Kamezō), the last of the priests, among drifting will-o'-the-wisp.

64 Utagawa Kunisada: A Horse under a Willow. Ōban size, 1830s. Signature: Kunisada *ga*. Seal: Hanabusa Ittai and illegible.

This *nishiki-e* is an unusual print, not only among Kunisada's works but among ukiyo-e prints in general. It uses three ink blocks and four Prussian blue blocks to capture the brushstrokes of the original. The seal appears to have been stamped in later by hand, rather than being printed by woodblock. This extremely rare work may have been produced as an experiment or a gift, rather than to be sold.

65 Kunisada: Sumo Wrestlers at a Fireworks Display. Double triptych, six ōban-size sheets, 1845. Signatures: Kōchōrō Toyokuni *ga* (right sheet), Ichiyōsai Toyokuni *ga* (center sheet) and Kunisada *aratame nidaime* Toyokuni (Kunisada changed his name to Toyokuni II) *ga* (left sheet). Publisher: Yorozuya Jūbei. Censorship seal: Hama (Hama Yahei).

This print depicts three popular sumo wrestlers of the period, Arauma Kichigorō, Hidenoyama Raigorō, and Koyanagi Tsunekichi. In one famous incident in February 1854, during the second visit to Japan of the "Black Ships," or Western ships, Koyanagi wrestled with three American sailors and defeated them easily.

66 Kunisada: Courtesan and Mirage, from the series *Modern Beauties*. Fan print, aiban size, early 1850s. Signature: Toyokuni ga. Publisher: Iseya Sōemon. Censorship seals: *aratame* and illegible.

67 Kunisada: Courtesan at Ōmon, the Entrance Gate to Yoshiwara, from the series *The Five Seasonal Festivals*. Fan print, aiban size, 1855. Signature: Toyokuni *ga*. Publisher: illegible. Censorship seals: *aratame* and U ni (February 1855)

68 Utagawa Kunisada: Geisha Wiping Her Face, from the series *Modern Beauties*. Ōban size, late 1820s. Signature: Kōchōrō Kunisada *ga*. Publisher: Moritaya Hanzō. Censorship seal: *kiwame*.

This series comprises ten prints, five of which are signed "Gototei Kunisada" and the others "Kōchōrō Kunisada." This particular print has the Kōchōrō signature that Kunisada used later. The woman whose hair is styled in a Shimada coiffure is probably a geisha. She appears to be adjusting her makeup with a tissue she is holding in her right hand, while replacing the remaining tissues in her kimono front with her left hand.

69 Torii Kiyomitsu II (Kiyomine): The Angry Drinker. Left-hand sheet of a triptych, ōban size, late 1810s. Signature: Kiyomitsu *ga*. Publisher: Nishimuraya Yohachi. Censorship seal: *kiwame*.

As she leans on one knee, tapping her pipe, with her eyes glaring and slanted in anger, this commanding depiction of a geisha contains a power that almost bursts out of the picture frame. The sinuous curve of her body is accentuated by the bold, striped pattern of her kimono. The complete triptych, housed in the Allen Memorial Museum of Art, Ohio, is considered a representative work of Torii Kiyomitsu II.

70 Utagawa Kuniyasu: Geisha with *Samisen*, from the series A Collection of Geisha. Ōban size, mid to late 1810s. Signature: Kuniyasu *ga*. Seal: toshidama-in. Publisher: Ōmiya Heihachi. Censorship seal: *kiwame*.

Each of the five prints known from this series shows a geisha in daily life, with a *kyōka* (humorous poem) written with distinctive calligraphy below the figure.

71 Katsushika Hokusai: The Hōshōji Temple at Yanagishima, from the series *Fashionable Places in Edo*. Original drawing (*hanshita-e*), chūban size, mid-1780s. Signature: Shunrō *ga*.

Hokusai's phase of practice works, when he used the signature "Shunrō" and which is consequently known as his Shunrō period, extended for about fifteen years from 1779 to 1794. These recently discovered *hanshita-e* (final drawings for an engraving) are valuable in that they represent the earliest signed paintings by him during his Shunrō period. Moreover, since the style of the signature found here was used by Hokusai from 1784, these are the only extant examples of Hokusai's drawings produced when he was in his twenties.

72–73 Katsushika Hokusai: Xi Wang Mu, a Chinese Goddess; Mother and Child Playing with a Toy Horse. Privately commissioned woodblock prints (*surimono*), koban size, early1800s.

74, 75 Katsushika Hokusai: Two prints from the series *Six Famous Rivers with the Name Tama*. Chūban size, ca. 1803.

The series *Six Famous Rivers with the Name Tama* was a popular theme in ukiyo-e prints. The series was based on six classical *waka* poems which described six different Tama rivers. The Chidori River was famous for its plovers and the Hagi River was well known for its luxuriant growth of bush-clover. It appears that attempts were made by Hokusai to create a classical elegant atmosphere in this series, although the figures are depicted wearing Edo fashions.

76 Katsushika Hokusai: Shellfish Gathering. Privately commissioned woodblock color print (*surimono*), nagaban size, ca. 1800. Signature: *saki no* Sōri (following letters illegible).

A painting on silk entitled *Shellfish Gathering* is in the collection of the Osaka Municipal Museum of Art and is recognized as one of Hokusai's masterpieces. This *surimono* was produced about ten years before the painting and the composition is almost identical to it.

77 Katsushika Hokusai: View at Gyōtoku. Chūban size, ca. 1805. Signature: Hokusai *egaku*.

Although the total number of pictures in this series is not known, five prints in addition to this work have been authenticated. The series has long been prized because the landscapes in it are heavily influenced by Western painting and because the title and the artist's signature are written in *kana* (Japanese syllabary) but in

a Westernized style; that is, from left to right across the top of the picture.

78 Katsushika Hokusai: Drum Bridge at Kameido, from the series *Splendid Views of Famous Bridges of the Provinces*. Ōban size, ca. 1834. Signature: *Zen* Hokusai Iitsu *hitsu*. Publisher: Nishimuraya Yohachi.

79 Katsushika Hokusai: Mountain Teashop, from the series *Hundred Poems by One Hundred Poets as Explained by a Wet Nurse*. Original drawing (*hanshita-e*), ōban size, mid-1830s. Signature: *saki no* Hokusai Manji.

This series is the largest produced by Hokusai in his later years, and twenty-seven *nishiki-e* sheets and one *kyōgōzuri* (monochrome proof for coloring) sheet are known. Hokusai seems to have prepared altogether one hundred *hanshita-e*, and Peter Morse, an American expert on Hokusai, confirms that known *nishiki-e* and *hanshita-e* total approximately ninety sheets. The plate shown here reveals the outstanding detail of Hokusai's sketches.

80 Katsushika Hokusai: Suspension Bridge at Mt. Gyōdō, Ashikaga, from the same series as plate 78. Ōban size, ca. 1834. Signature: *Zen* Hokusai Iitsu *hitsu*. Publisher: Nishimuraya Yohachi.

With the suspension bridge high up on Mt. Gyōdō appearing majestically out of swirling mist, Hokusai created an intriguing scene redolent with the feeling that we are deep in a mountain area. A bridge is still to be found at Mt. Gyōdō although it is now made of iron.

81 Katsushika Hokusai: Kingfisher with Irises and Wild Pinks. Chūban size, ca. 1834.

Kachō-ga, or "bird-and-flower prints," were a common subject for Hokusai, usually appearing in the *chūban* or horizontal *ōban* format. In the former size, the Chinese influence is particularly evident from the static depiction of birds and flowers combined with a Chinese poem or a *waka* poem. In this print Hokusai portrays a kingfisher, perhaps making a quick descent toward a river which appears to be flowing beneath the flowers.

82 Ryūryūkyo Shinsai: Camellias. Privately commissioned woodblock color print (*surimono*), ōban size, 1810s.

The camellias in the print were depicted using the technique of *tsuketate*, whereby a shape is drawn without the use of contour lines. The influence of Shinsai's teacher, Hokusai, is evident in the dynamic composition of the flowers.

83 Utagawa Sadatora: *Autumn Flowers and the Moon*. Fan print, aiban size, 1831. Signature: Gofūtei Sadatora *ga*. Publisher: Ibaya Kyūbei. Censorship seals: U (1831) and *kiwame*.

For this print Sadatora adopted an autumnal subject from traditional Japanese painting. A full moon is depicted above the seven autumnal flowers: morning glory, Chinese bellflower, bush clover, eulalia, creeper, *ominaeshi*, and boneset.

84, 85 Totoya Hokkei: Two prints from the series *Famous Views in the Provinces*. Ō-tanzaku size, early 1830s. Signature: Aoigaoka

Hokkei *ga*. Publishers: Nishimuraya Yohachi and Nakamuraya Katsugorō. Censorship seal: *kiwame*.

Few examples of *nishiki-e* by Hokkei are known, and this series is regarded as representative of his work. Twelve prints in addition to the two shown here have been verified. Plate 84 depicts a foreign ship leaving Nagasaki port. Mt. Inasayama can be seen to the right. Hokkei's originality is evident in his treatment of the whitecaps and the clouds of smoke billowing up around the ship in great columns. It is a work full of a taste for the exotic. Mt. Tateyama, depicted in Plate 85, is one of Japan's three sacred mountains together with Mt. Fuji and Mt. Hakusan. At the beginning of the Edo period worship of Mt. Tateyama increased greatly, with Ashikura Temple, which contained over thirty shrines and pilgrims' lodgings, being the center of the cult. In one month as many as three thousand pilgrims would go there to worship. Spirits of the dead from all over Japan were believed to gather in the nearby valley, from which clouds of smoke can be seen rising in this depiction. The figures here are proceeding toward the valley to meet again with departed souls and to pray for their attainment of Nirvana in memorial services. The use of dark blue conveys the feeling of a sacred site deep in the mountains.

86 Shōtei Hokuju: View of Awaji Island. Ōban size, late 1820s. Signature: Shōtei Hokuju *ga*. Publisher: Yamamotoya Heikichi. Censorship seal: *kiwame*.

Although only a few paintings and book illustrations by Hokuju are extant, many superb examples of *uki-e* (perspective pictures) and Western-style landscape prints remain. Hokuju was strongly influenced by the Western-style drawing technique of his teacher, Hokusai. In this print the triangles of shaded colors of the mountains and cliffs almost evoke cubist techniques, and the unique color scheme and depiction of the sky and mist show that Hokuju was developing his own style and not simply imitating that of his teacher.

87 Katsukawa Shuntei: View at Fukagawa Riverside in Edo. Ōban size, ca. 1820.

This print shows a view of reclaimed land at Fukagawa in Edo depicted using techniques of perspective. The shaft of light streaming through the sky also indicates the considerable influence of Western techniques of landscape painting.

88 Katsukawa Shuntei: The Warrior Egara no Heita Battling with a Giant Serpent. Ōban size, ca. 1820. Signature: Shuntei *ga*. Publisher: illegible. Censorship seal: *kiwame*.

The warrior Egara no Heita, a famous archer, was killed in battle in 1213, when he was thirty-one years of age and in the army of his father's elder brother, Wada no Yoshimori. This print depicts a well-known episode in June 1203 when he accompanied Minamoto no Yoriie on a hunt and slew an enormous snake deep in a mountain cave. In this excellent example of the *musha-e* genre from the Bunka and Bunsei eras (1804–30), the bravery of the warrior is magnificently conveyed by the bold, dynamic lines.

89 Utagawa Kuniyoshi: The Warrior Kashiwade no Hatebe Battling with a Tiger. Original drawing (*hanshita-e*), ōban size,

mid-1830s. Signature: Ichiyūsai Kuniyoshi *ga*. Publisher: Yamaguchiya Tōbei. Censorship seal: *kiwame*.

This is probably one of the earliest extant *hanshita-e* (final drawings for an engraving) by Kuniyoshi. This picture, which was never published as a *nishiki-e*, is a valuable example of Kuniyoshi's consummate skill in design.

90 Utagawa Kuniyoshi: The Rescue of Minamoto no Tametomo by Goblins. Triptych, three *ōban*-size sheets, ca. 1851. Signature: Ichiyūsai Kuniyoshi *ga*. Seal: yoshikiri-in. Publisher: Sumiyoshiya Masagorō. Censorship seals: Mera (Mera Taichirō) and Watanabe (Watanabe Shōemon).

Together with his father, Minamoto no Tametomo fought in support of the retired emperor Sutoku and was defeated in the Hōgen Disturbance of 1156. The theme here is taken from an episode in the sequel to the long novel about Tametomo, *Chinsetsu yumiharizuki* (Crescent Moon: The Adventures of Tametomo), written by Takizawa Bakin. In 1176, as Tametomo and his followers leave Higo Province on two boats, a typhoon hits them. When Tametomo is about to commit ritual suicide in despair, *karasu-tengu* (goblins) sent by the spirit of Sanuki-in (the retired emperor Sutoku) stop him and stabilize the boat.

91 Utagawa Kuniyoshi: Yoshihide Breaching the Main Gate at the Battle of Wada. Triptych, three *ōban*-size sheets, 1852. Signature: Ichiyūsai Kuniyoshi *ga*. Seal: yoshikiri-in (center and left sheets). Publisher: Yamaguchi-ya Tōbei. Censorship seals: Murata (Murata Heiemon), Kinugasa (Kinugasa Fusajirō) and Ne shi (April 1852).

Yoshihide was the third son of General Wada Yoshimori of the early Kamakura period, and was known for his unrivaled strength. He joined his father in attempting a coup in 1213 to protest the ruling Hōjō family's abuses of power. The historical work *Azuma kagami* (Mirror of Eastern Japan) describes how he exercised his tremendous strength to break open the main gate of the shogun's estate.

92 Utagawa Kuniyoshi: The Defeat of the Kusunoki Warriors at the Battle of Shijōnawate. Triptych, three *ōban*-size sheets, ca. 1851. Signature: Ichiyūsai Kuniyoshi *ga*. Seal: yoshikiri-in (right sheet). Publisher: Fujiokaya Keijirō. Censorship seals: Mera (Mera Taichirō) and Watanabe (Watanabe Shōemon).

According to the *Taihei-ki* (Chronicle of the Great Peace), on 5 January 1348, during the period of the Northern and Southern Courts, General Kusunoki Masatsura led 3,000 troops from the Southern Court in battle against 60,000 Northern Court soldiers at Shijōnawate in Kawachi Province. Vastly outnumbered, the Southern Court had no chance of winning, and in the end Masatsura and his brother Masatoki committed ritual suicide while their soldiers fought to the death.

93 Utagawa Kuniyoshi: The Spider Monster Creating Monsters in the Mansion of Minamoto no Yorimitsu. Triptych, three *ōban*-size sheets, 1843. Signature: Ichiyūsai Kuniyoshi *ga*. Publisher: Ibaya Senzaburō.

This work deals with a legend about Minamoto no Yorimitsu that was adopted by the nō theater. Yorimitsu is attacked by a spider monster when he is ill in bed, but slays it with the help of his four senior samurai. A rumor spread that this picture was, in fact, meant to satirize the Tempō Reforms being carried out at the time. Neither the artist nor the publisher was punished, however.

94 Utagawa Kuniyoshi: *The Night Attack, Act 11*, from the series *Scenes from the Drama* Chūshingura. *Ōban* size, ca. 1830. Signature: Ichiyūsai Kuniyoshi *ga*.

95, 96, 97 Utagawa Kuniyoshi: Three prints from the series *Thirty-Six Views of Mt. Fuji from Edo*. *Ōban* size, ca. 1843. Signature: Ichiyūsai Kuniyoshi *ga*. Seals: Kuniyoshi (Pl. 95), and Kuni (Pl. 97). Publisher: Murataya Jirobei. Censorship seal: Mura (Murata Heiemon) (Pls. 95, 97).

The series *Thirty-Six Views of Mt. Fuji from Edo* is one of three masterful landscape series by Kuniyoshi dating from the Tempō era (1830–44). Despite the series title, only five prints, including the three presented in this volume, seem to have been published.

98 Utagawa Kuniyoshi: *Night Rain and Thunder*, from the series *Beauties and Episodes of Ōtsu-e*. Fan print, *aiban* size, early 1850s. Signature: Ichiyūsai Kuniyoshi *ga*. Seal: yoshikiri-in. Publisher: illegible. Censorship seals: Muramatsu (Muramatsu Genroku) and Fuku (Fukushima Saburōemon).

Each print in this series shows a famous scene with a beauty in the foreground representing an *Ōtsu-e* (a simple comical picture sold as a good-luck charm in Ōtsu, east of Kyoto). These scenes are combined with an *Ōtsu-e* shown as a *koma-e* (small framed picture within a print). In the *Ōtsu-e* of Plate 98, a thunder god on a cloud is trying to pick up a drum he had dropped with an anchor. In the foreground, this theme is echoed in the woman teasing a cat with a piece of string.

99 Utagawa Kuniyoshi: A Woman Poking out Her Tongue, from the series Allusions (*mitate*) to the Nō Play Sanbasō. Fan print, *aiban* size, 1855. Signature: Ichiyūsai Kuniyoshi *ga*. Seal: yoshikiri-in. Publisher: Ibaya Senzaburō. Censorship seals: *aratame* and U shō (January 1855).

This series was jointly designed by the three representative ukiyo-e artists of the Utagawa School of the time: Toyokuni III (Kunisada), Kuniyoshi, and Hiroshige. Toyokuni III produced the print of Okina, and Hiroshige designed the print featuring Senzai. Kuniyoshi has depicted Sanbasō with charming and lively expression to create a figure which stands in striking contrast to those designed by the other two artists.

100–103 Utagawa Kuniyoshi: Graffiti on a Storehouse Wall. *Ōban* size, 1847. Signature: Ichiyusai Kuniyoshi *ga*. Publisher: Ibaya Senzaburō. Censorship seals: Kinugasa and Hama.

Kuniyoshi was an extremely versatile artist and was known to be eager to study techniques from a variety of different schools. The influence of Western-style line drawing is evident in the fluid lines of his caricatures of popular kabuki actors.

104 Hashimoto Sadahide: Mt. Fuji Viewed from Kai Province. Triptych, three *ōban*-size sheets, ca. 1850. Signatures: Gyokuransai

Sadahide *utsusu* (right sheet) and Gyokuran Sadahide *ga* (center and left sheets). Publisher: Tsujiokaya Bunsuke. Censorship seals: Magome (Magome Kageyu) and Hama (Hama Yahei).

This distorted and exaggerated portrayal of Mt. Fuji stands in complete contrast to traditional depictions, perhaps because it was meant as a guide for pilgrims, or perhaps because of Kuniyoshi's stylistic influence.

105 Hashimoto Sadahide: Dragon and Tigers. Triptych, three *ōban*-size sheets, 1858. Signature: Gountei Sadahide *ga*. Publisher: Daikokuya Heikichi. Censorship seal: Uma jū (October 1858).

The dynamism and power of this somewhat humorous work fully exhibits the skill of Sadahide, an esteemed *musha-e* (warrior print) artist. It dates from the period in which Sadahide attempted powerful designs over three whole sheets. However, after Yokohama was opened to the West in 1858, Sadahide started to concentrate on producing prints depicting foreigners and contemporary scenes.

106 Utagawa Hiroshige: Peach, Plum, Chrysanthemum, a Monkey, and Chickens, from the series *Shellwork from an Exhibition at Okuyama in Asakusa*. Ōban size, 1820. Signatures: *motome ni ōji* (as requested) Hiroshige *utsusu*. Publisher: illegible. Censorship seal: *kiwame*.

Shellwork is said to have proved the most popular item at a joint exhibition of a shellwork maker, a paste-doll maker, and a miniature landscape maker, held in the spring of 1820. The first part of the show featured some thirty kinds of plants and ten shellwork birds and animals, all artistically arranged. The second part consisted of a miniature landscape model of Enoshima, incorporating paste dolls and a shellwork dragon. This print illustrates the first part, and is a good example of the use of a topical theme by Hiroshige, who was twenty-four years old at the time.

107 Hiroshige: Pheasant and Chrysanthemums. *Ō-tanzaku* size, ca. 1833.

The pheasant perched on a rock is depicted in fine detail. In contrast with the delicate lines of the pheasant's feathers, the rock is depicted in an undramatic manner. The simplicity of the rock's design heightens the powerful effect of the total composition, giving the pheasant the appearance of standing regentlike on the rock.

108 Hiroshige: White Heron and Irises. *Ō-tanzaku* size, ca. 1833.

A heron is depicted in mid-flight behind a luxurious growth of irises, as if about to dive down to a river to catch its prey. The use of *kimedashi*, or embossing, on the body of the heron not only creates a feeling of softness by lending an extra depth to the print, but also serves to emphasize the whiteness of the bird.

109, 110 Utagawa Hiroshige: Two prints from the series *Six Famous Rivers with the Name Tama*. Chū-tanzaku size, ca. 1833. Signature: Hiroshige *ga*. Publisher: Kawaguchiya Shōzo. Censorship seal: *kiwame*.

Most ukiyo-e based on the theme of the six famous Tama rivers depict contemporary scenes. Here, however, the scenes are quite

faithful to the original poems or events. Plate 109 shows the Kōya Tama River, a river made famous in a poem by Kōbō Daishi. An apprentice priest is depicted standing on a stone bridge associated with Mt. Kōya. Plate 110 shows the Noda Tama River, which is also called the Chidori (Plovers) Tama River. A poem by the priest Nōin is combined with a scene of a noble lady viewing the river from the bank.

111 Utagawa Hiroshige: *Eitai Bridge in the Evening Rain*, from the series *Famous Places of Edo*. Fan print, *aiban* size, early to mid-1830s. Signature: Hiroshige *ga*. Publisher: Ibaya Senzaburō.

This is a relatively early *uchiwa-e* (fan print) by Hiroshige.

112 Utagawa Hiroshige: *Kiga Hot Springs*, from the series *Tour of Seven Hot Spring Resorts in Hakone*. Fan print, *aiban* size, ca. 1850. Signature: Hiroshige *ga*. Publisher: Ibaya Senzaburō. Censorship seals: Kinugasa (Kinugasa Fusajirō) and Murata (Murata Heiemon).

Hakone was already popular in the Edo period as a sightseeing and hot spring resort. All the works in the series *Tour of the Seven Hot Spring Resorts in Hakone*, including Plate 112, are printed in blue alone, except for the red panels containing the series title and place names. As it is cool in feeling, blue appears to have been favored for fan prints.

113 Utagawa Hiroshige: The Theme of Fire, from the series *The Five Elements with Famous Scenes of Edo*. Fan print, *aiban* size, mid-1840s. Signature: Hiroshige *ga*. Publisher: Ibaya Kyūbei (?). Censorship seal: Muramatsu (Muramatsu Genroku).

The stars, the bonfires, and the lantern the woman holds illustrate the theme of fire. Only one other work, on the theme of wood, is known from this series. The remaining works, possibly on the themes earth, metal, and water have yet to be discovered.

114 Utagawa Hiroshige: *Kinkizan Temple on Enoshima Island, Sagami Province*. Fan print, *aiban* size, 1855. Signature: Hiroshige *ga*. Publisher: Maruya Jinpachi. Censorship seals: *aratame* and U ni (February 1855).

This landscape is printed in blue, with a considerable area of darker tones, perhaps to emphasize the sacredness of Enoshima.

115 Utagawa Hiroshige: *Distant View of Fireworks at Ryōgoku Bridge*, from the series *Famous Views of the City of Edo*. Fan print, *aiban* size, 1839. Signature: Hiroshige *ga*. Seal: Ichiryūsai. Publisher: Ibaya Kyūbei (?). Censorship seals: I (1839) and *kiwame*.

The fireworks at Ryōgoku have just started, and the girl is climbing down the stairs to summon her family. The brightly lit sky is unusual, as are the fireworks of red and yellow balls and the white outlines of the houses below.

116–117 Utagawa Hiroshige: Preface, Cherry Blossoms; Swimming Carp, from *A Picture-Book Miscellany*. Chūbon-size book (19 x 12 cm), colors on paper, 1849.

118 Yūrakusai Nagahide: The Courtesan Itsuno as a Kabuki Actor, from the series Parade in the Gion Festival. Woodblock print with

stencil coloring (*kappa-zuri*), *hosoban* size, ca. 1820. Signature: Nagahide *ga*. Publisher: Yamashiroya Sahei.

In Kyoto and Osaka, it was the custom for courtesans to parade in elaborate costumes at summer festivals. These courtesans were frequently the subjects of ukiyo-e prints. Many prints featuring the parades were produced in Kyoto using the technique known as *kappa-zuri* (stencil coloring). The stencils, which were made of tanned paper, were placed upon the inked outlines while colors were applied with a brush. Although Plate 118 bears no signature, its style indicates the artist is Nagahide, who was virtually the sole producer of *kappa-zuri* prints depicting parades in Kyoto during this period.

119 Style of Ryūkōsai Jokei: The Kabuki Actor Noshio II in the Role of a Courtesan. Right-hand sheet of a diptych, *hosoban* size, 1793. Publisher: Shioya Chōbei.

This work is based on a play performed at the Kado-za Theater in Osaka in November 1793, which dealt with a love affair between the courtesan Yūgiri and a rich merchant's son, Izaemon. This unsigned work has been attributed to Ryūkōsai from the style of Noshio's features.

120 Yanagawa Shigenobu: The Courtesan Manju-dayū as a Processional Figure, from the series *Parade at Shinmachi in Osaka*. *Ōban* size, 1822. Signature: Tōto Yanagawa Shigenobu. Seal: Yanagawa. Publisher: illegible.

The Edo-based ukiyo-e artist Yanagawa Shigenobu went to Osaka in 1822 and produced some works there before returning to Edo in the spring of 1823. This series seems to contain fourteen pictures in total, all of which are extant. Characteristic of Shigenobu's portrayal of women are their Edo-style features as well as sharp and rigid outlines. Many Kyoto and Osaka artists, including Yoshikuni, Hokuei, Shigeharu, Sadahiro, and Sadamasa adopted these annual parades as themes. Comparison of their works with Shigenobu's clearly reveals the differences between the ukiyo-e of the Osaka–Kyoto area and Edo.

121 Shunkōsai Hokushū: The Kabuki Actor Nakamura Utaemon III in the Role of a Samurai, from the series *Famous Roles of Utaemon*. *Ōban* size, 1825. Signature: Shunkōsai Hokushū *ga*. Seal: Hokushū. Publisher: Yūgendo.

Nakamura Utaemon III played four roles in his farewell performance at the Kado-za Theater in Osaka in March 1825, and the great success of this led to the publication of many prints featuring this performance. In this series, Hokushū made prints of all four roles. Nakamura Utaemon as the master swordsman Kyōgoku Takumi murders Yoshioka Ichimisai after the latter defeats him in a test of swordsmanship. Eventually, Yoshioka's daughter Osono is able to avenge her father's death. Utaemon gave this farewell performance because he was ill. He recovered, however, and resumed his theatrical career until January 1838.

122 Shunbaisai Hokuei: The Kabuki Actor Iwai Shijaku I in Dual Roles. Diptych, two *ōban*-size sheets, 1833. Signature: Shunkōsai Hokuei. Seal: *Fumoto no yuki*.

This work is based on a scene from a play performed at a theater in Shijō in Kyoto in November 1833. Iwai Shijaku played

seven roles in this, including the roles of Hisamatsu and Osome. The highlight of this scene is the actor's quick costume change between the two roles.

123 Shunbaisai Hokuei: The Kabuki Actors Iwai Shijaku I and Bandō Jutarō. Diptych, two *ōban*-size sheets, 1832. Signature: Shunkōsai Hokuei. Seal: *Fumoto no yuki*.

This work is based on a play performed at the Naka-za Theater in Osaka in September 1832, dealing with the conflicts in the Tsunaboshi family partly caused by the scheming of the villainous retainer Karahashi Daisuke. The hero of the play, Kowari Dennai, is the twin brother of Tsunaboshi's eldest son, Uhyōnosuke. Sasa-ya Hanbei (Bandō Jutarō), who sides with Daisuke, kills Dennai's fiancée and throws her over a cliff. Witnessing this, Lady Osuma, Uhyōnosuke's wife, emerges from a cave and shines her torch on Hanbei. This moment is dramatically depicted in Hokuei's print. In the play, Hanbei throws some star-shaped throwing knives at her before running away.

124 Shunbaisai Hokuei: Kabuki Actors Portraying Heroes from the *Suikoden* (Water Margin) Epic. Quatroptych, four *ōban*-size sheets, ca. 1834. Signature: Shunbaisai Hokuei *ga*. Seals: *Fumoto no ume* (two sheets on the right) and Hokuei (two sheets on the left). Publisher: Kinkadō Konishi.

This work is not a depiction of an actual stage scene but represents popular actors as heroes of the *Water Margin*, the classical Chinese novel which had a great influence on the fiction and drama of the Edo period.

125 Toyohara Kunichika: Kabuki Actors with a Steam Train in the Background. Triptych, three *ōban*-size sheets, 1872. Signature: Toyohara Kunichika *hitsu*. Publisher: Tsujiokaya Bunsuke. Censorship seal: Mizunoe saru ku (September 1872).

The first Japanese railway line opened between Shimbashi and Yokohama on 12 September 1872. This event is commemorated in the background here, together with the depiction of Kawarasaki Gonnosuke VII (later Ichikawa Danjūrō IX) as Chōbei and two other popular kabuki stars, Sawamura Tosshō II and Onoe Kikugorō V, who appeared in a performance at the Morita-za Theater in May of the same year.

126 Shunbaisai Hokuei: The Kabuki Actor Nakamura Shikan II. *Ōban* size, 1835. Signature: Shunbaisai Hokuei *ga*. Seal: Hokuei. Publisher: Kinkadō Konishi.

This print most likely depicts the end of the Fushimi-Inari Shrine scene in Act 2 of a play staged at the Naka-za Theater in Osaka in May 1835. The play seems to have been a clumsy version of the *Yoshitsune senbon zakura* (Yoshitsune and the Thousand Cherry Trees). Yoshitsune parts with Lady Shizuka at the shrine and leaves with his party. A sorrowful Lady Shizuka leaves the stage, and finally Nakamura Shikan II as Tadanobu makes his exit by the *hanamichi* (walkway). Tadanobu here is actually a fox who will loyally accompany Lady Shizuka to Mt. Yoshino.

127 Gochōtei Kunimasu (Sadamasu): The Kabuki Actor Ōkawa Hashizō. *Chūban* size, 1849. Signature: Kunimasu *ga*. Seal: illegible. Publisher: Kinkadō.

This print depicts Ōkawa Hashizō as the Priest Saigyō at Kakegawa Post-Station on the Tōkaidō road, the highway that ran from Edo to Kyoto.

128 Shunbaisai Hokuei: The Kabuki Actors Utaemon III and Iwai Shijaku I. Ōban size, 1832. Signature: Shunkōsai Hokuei *ga*. Publisher: Honya Seishichi.

This powerful *ōkubi-e* (close-up portrait) may be regarded as representative of Hokuei's early work. It is based on the Gojō Bridge scene from a play about the conflict between the Minamoto and Taira clans, which was performed at the Kado-za Theater in Osaka in March 1832. After the Taira families fled Kyoto, Taira no Atsumori (Iwai Shijaku I) hides in a fan shop in Gojō disguised as the maiden Kohagi. When Minamoto soldiers find the shop, the owner's daughter Katsurako, who is in love with Atsumori, sacrifices herself to let Atsumori escape. Later, as Atsumori is praying by Gojō bridge for the dead Katsurako, a Minamoto warrior named Kumagai (Nakamura Utaemon III) comes upon him. This work shows Atsumori giving a fan to Kumagai and promising to meet him again at the Ichi no Tani battlefield.

129 Kawanabe Kyōsai (Gyōsai): Goblins. Sketch, hand-painted colors on paper, 18.7 x 28.3 cm, mid-1860s. Signature: Shōjō Kyōsai. Seal: illegible.

The goblins are a ghost disguised as a shrine maiden, a monster clad as a court lady, with its eyes and nose on its stomach and its mouth above its breasts, and an old woman who waits for the dead at the River Styx.

130 Migita Toshihide: *Tengu Dance*, from the series *A Collection of Eighteen Theatrical Scenes*. Ōban size, 1898. Signatures: Gosai *hitsu*. Seals: Toshihide. Publisher: Akiyama Buemon.

This series of the most popular scenes of eighteen kabuki and nō stories was started in 1893. The theme of this print is the extravagance of Hōjō Takatoki, regent during the Kamakura shogunate, described in the *Taihei-ki* (Chronicle of the Great Peace). Takatoki was so fond of *dengaku* (ritual dancing and music) that he spent enormous amounts of time and money on it. Takatoki is shown drinking one evening and enjoying the performance of some *dengaku* entertainers, who are really *tengu* (goblins) in disguise.

131 Kawanabe Kyōsai (Gyōsai): An Unfortunate Tale. Sketch, hand-painted colors on paper, 18.7 x 28.7 cm, mid-1860s. Signatures: Shōjō Kyōsai *giga*. Seal: Kyōsai.

An unfortunate woman weeps as she is kicked out of the house by the man with a pipe. This work belongs to a set of studies probably intended for a picture scroll or a woodblock-printed book concerning this wretched middle-aged woman.

132 Tsukioka Yoshitoshi: The Retainer Samanosuke on a Moor at Night, from the series *One Hundred Japanese and Chinese Tales*. Ōban size, 1865. Signature: Ikkaisai Yoshitoshi *ga*. Publisher: Daikokuya. Censorship seal: Ushi ni (February 1865) *aratame*.

This print is based on the story of Akechi Mitsuhide's retainer Akechi Samanosuke. Learning that his friend's daughter is being held by a fox monster, young Samanosuke fights the fox and saves the girl.

133 Tsukioka Yoshitoshi: The Warrior Monk Benkei, from the series *One Hundred Aspects of the Moon*. Ōban size, 1886. Signature: Yoshitoshi. Seal: Taiso. Publisher: Akiyama Buemon.

The moon is an essential element in the works of Yoshitoshi and it almost unfailingly appears in the uniquely tense scenes depicted in his prints. This series consists of a hundred prints based on a hundred stories related to the moon. This print relates a scene from the nō play *Funa Benkei* (Benkei on the Boat). Benkei, a popular character in Japanese history who appears in many plays and works of art, was the loyal retainer of Minamoto no Yoshitsune. After defeating the Heike clan in 1185, Yoshitsune and his group sought to escape to Northern Japan by sea. According to legend the raging waters were stirred up by the revengeful ghosts of Heike warriors that Yoshitsune and his men had killed. The picture shows Benkei praying to exorcise the ghost of Taira no Tomomori, who attacks the boat on the raging sea. The seething waves soon subsided and the boat was able to continue its passage in peace. The brooding darkness of large areas of the print emphasizes the moon and the lone figure in the prow. However, it is interesting to note that, although Benkei was known to be a giant of a man, and is usually depicted in an exaggerated fashion, he appears here to be almost dwarfed by the tempestuous seas.

List of Artists by School

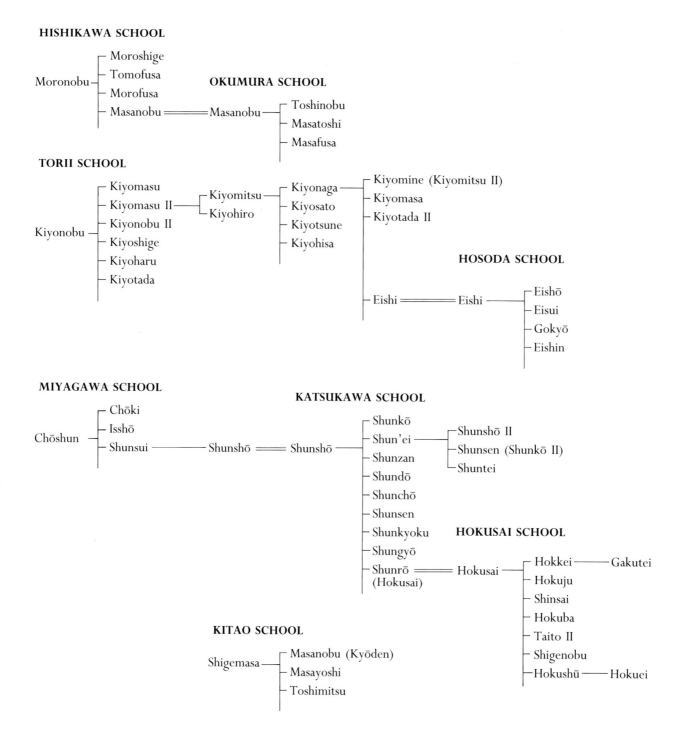

HISHIKAWA SCHOOL

Moronobu
- Moroshige
- Tomofusa
- Morofusa
- Masanobu

OKUMURA SCHOOL

Masanobu — Masanobu
- Toshinobu
- Masatoshi
- Masafusa

TORII SCHOOL

Kiyonobu
- Kiyomasu
- Kiyomasu II
- Kiyonobu II
- Kiyoshige
- Kiyoharu
- Kiyotada

Kiyomitsu
- Kiyomitsu
- Kiyohiro

- Kiyonaga
- Kiyosato
- Kiyotsune
- Kiyohisa

Kiyonaga
- Kiyomine (Kiyomitsu II)
- Kiyomasa
- Kiyotada II

HOSODA SCHOOL

Eishi — Eishi
- Eishō
- Eisui
- Gokyō
- Eishin

MIYAGAWA SCHOOL

Chōshun
- Chōki
- Isshō
- Shunsui — Shunshō

KATSUKAWA SCHOOL

Shunshō — Shunshō
- Shunkō
- Shun'ei
- Shunzan
- Shundō
- Shunchō
- Shunsen
- Shunkyoku
- Shungyō
- Shunrō (Hokusai)

Shun'ei
- Shunshō II
- Shunsen (Shunkō II)
- Shuntei

HOKUSAI SCHOOL

Shunrō (Hokusai) — Hokusai
- Hokkei — Gakutei
- Hokuju
- Shinsai
- Hokuba
- Taito II
- Shigenobu
- Hokushū — Hokuei

KITAO SCHOOL

Shigemasa
- Masanobu (Kyōden)
- Masayoshi
- Toshimitsu

NISHIMURA/ISHIKAWA GROUP

Shigenaga
— Toyonobu — Toyomasa
— Fusanobu
— Harunobu
 — Harushige
 — Koryūsai
 — Yoshinobu

UTAGAWA SCHOOL

Toyoharu
— Toyokuni
— Toyoharu II
— Toyohisa
— Toyomaru
— Toyohiro — Hiroshige

— Kunimasa
— Kuninaga
— Kunimitsu
— Kunisada (Toyokuni III)
 — Sadatora
 — Sadakage
 — Sadahide
 — Kuniteru
 — Kunisada II
 — Kunichika
 — Kuniaki
 — Kunimasu (Sadamasu)
— Kuniyasu
— Kunimaru
— Kuninao
— Kunitora
— Kuniyoshi
 — Yoshitsuya
 — Yoshikazu
 — Yoshitora
 — Yoshinao
 — Yoshiiku
 — Yoshitoshi
 — Kyōsai
— Toyokuni II

SEKIEN GROUP

Sekien
— Shunchō
— Toyoharu
— Utamaro
— Shikō

KITAGAWA SCHOOL

Utamaro — Utamaro
— Utamaro II
— Tsukimaro
 — Shikimaro
 — Yukimaro
— Hidemaro
— Bokusen

KIKUKAWA SCHOOL

Eizan — Eisen — Eiri

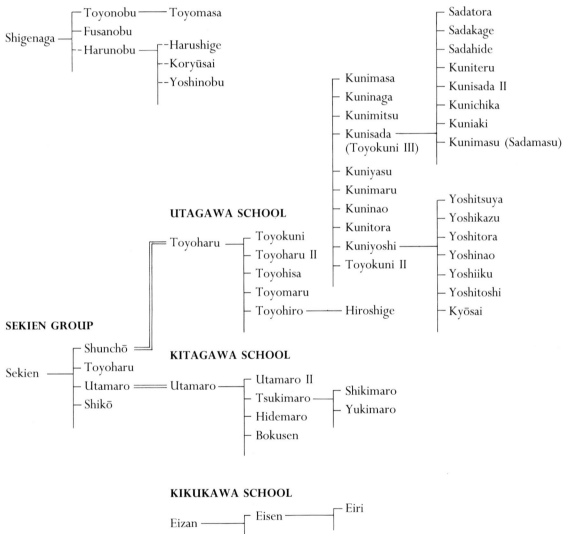

NOTE: The list of artists is based on print designers working in Edo (now Tokyo). A number of ukiyo-e print designers were also active in the Kyoto–Osaka area, including Yūrakusai Nagahide in Kyoto and Ryūkōsai Jokei in Osaka.

Selected Bibliography

Crighton, R. A. *The Floating World of Japanese Popular Prints: 1700–1900*. London: Victoria and Albert Museum, 1973.

Hillier, J. *Japanese Masters of the Colour Print*. London: Phaidon Press, 1954.
———. *The Japanese Print: a New Approach*. London: G. Bell and Sons, 1960. (Reissued by Tuttle, 1975)

Keyes, Rogers. *The Male Journey in Japanese Prints*. Berkeley, Los Angeles, London: University of California Press, 1989.
———. *Surimono: Privately Published Prints in the Spencer Museum of Art*. Tokyo and New York: Kodansha International, 1984.

Kikuchi, Sadao. *A Treasury of Japanese Woodblock Prints* (translated by Don Kenny). New York: Crown Publishers, 1969.

Lane, Richard. *Masters of the Japanese Print: Their World and Their Work*. London and New York: Thames and Hudson, 1962.
———. *Images from the Floating World: The Japanese Print—Including an Illustrated Dictionary of Ukiyo-e*. New York: G. P. Putnam's Sons, 1978.
———. *Hokusai: Life and Work*. London and New York: Dutton, 1989.

Michener, James A. *The Floating World: The Story of Japanese Prints*. New York: Random House, 1954.
———. *Japanese Prints from the Early Masters to the Modern*. Notes on the prints by Richard Lane. Tokyo and Rutland, Vt.: Tuttle, 1959.

Miller Kanada, Margaret. *Color Woodblock Printmaking—The Traditional Method of Ukiyo-e*. Tokyo: Shufunotomo, 1989.

Munsterberg, Hugo. *The Japanese Print: A Historical Guide*. Tokyo: Weatherhill, 1982.

Narazaki, Muneshige. *The Japanese Print: Its Evolution and Essence*. (English Adaptation by C. H. Mitchell), Tokyo and Palo Alto, California: Kodansha International, 1966.

Robinson, B. W. *Kuniyoshi: The Warrior Prints*. Ithaca, New York: Cornell University Press, 1982.

Stern, Harold P. *Master Prints of Japan: Ukiyo-e Hanga*. New York: Harry N. Abrams, 1969.

Various. *Masterworks of Ukiyo-e*. 11 vols. Tokyo and Palo Alto, California: Kodansha International, 1968–70.